IMAGES
of America

MADEIRA BEACH

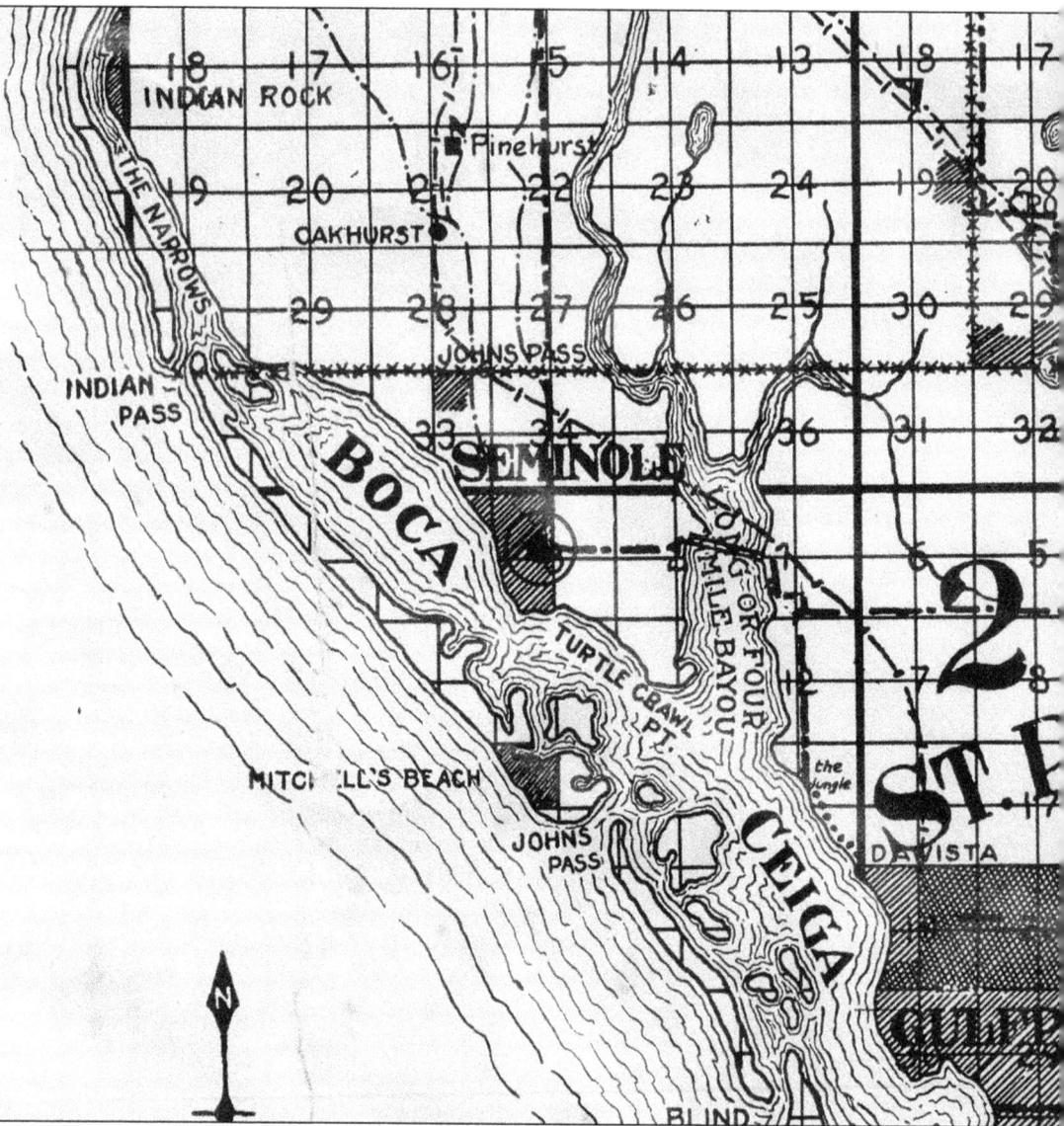

This 1914 map of the Madeira Beach area shows the small Mitchell's Beach development on the north end of Johns Pass, as well as Indian Pass, a channel that once existed in the area near the Redington Shores-Indian Shores town line. Albert Archibald and David Welch began their efforts to develop the island in the 1920s. (Courtesy of the Archives and Library, Heritage Village.)

ON THE COVER: Yachting along the Gulf Beaches became a popular recreational activity during the land boom of the 1920s, long before condominiums rose along the coastline of Madeira Beach. (Courtesy of the Nelson Poynter Memorial Library, University of South Florida St. Petersburg.)

IMAGES
of America

MADEIRA BEACH

James Anthony Schnur

ARCADIA
PUBLISHING

Published by Arcadia Publishing
Charleston, South Carolina

Library of Congress Control Number: 2013933072

For all general information, please contact Arcadia Publishing:
Telephone 843-853-2070
Fax 843-853-0044
E-mail sales@arcadiapublishing.com
For customer service and orders:
Toll-Free 1-888-313-2665

Visit us on the Internet at www.arcadiapublishing.com

*To the members of the Pinellas County Historical Society
for their efforts to preserve our community's history*

CONTENTS

ACKNOWLEDGMENTS

This book project began when one of my graduate students, Ronn Raszetnik, asked about doing archival fieldwork at his place of employment, the Gulf Beaches Public Library. I had fond memories of my childhood at that library, and during the late 1990s I even served as its assistant director. Ronn had located some old and brittle scrapbooks and within them a treasure trove of photographs. Working with Maggie Cinnella, the library's director, Ronn organized and preserved these images. Maggie and others at the library supported Ronn throughout this project.

The staff, volunteers, and docents at Heritage Village, as well as Ellen Babb, the Village's operations manager, have also provided immeasurable support during the research and writing of this book. My colleagues at the Nelson Poynter Memorial Library, University of South Florida St. Petersburg, offered their encouragement as well. I am fortunate to work with Dean Carol Hixson and the rest of my library "family."

Others deserve special praise for their efforts. Members of the Archibald family, especially Alex M. "Arch" Archibald Jr., shared their many stories, as did John Messmore, a longtime resident of the beaches. Bob Griffin of Griffin Directories provided assistance at critical moments and shared his archive of the *Madeira Beach Communicator*. Maggie Tiller Bullwinkel and Liz Gurley at Arcadia Publishing guided and motivated me, while Carolyn Schnur Hoffman relived memories and provided editorial suggestions. Phuongdung Schnur tolerated my many late nights on the computer.

The memories shared by friends and family have enriched this book. I owe a deep debt of gratitude to Christopher Ateek, Becki Bailey, Jinelle Gibson Boyd, Jack Brawner, Lisa Pelamati Creswell, Susan Donoff, Daun Fletcher, Sandy Holloway, Sandy Luger, Nancy Millichamp, Cindy Brawner Nagel, Nina Nicholson, Luc Poirier, Nathan Powell, Daniel Schnur, Sudsy Tschiderer, and Sandra Varry.

Except for those supplied by the author or otherwise noted, all images in this volume appear courtesy of the Archives and Library of Heritage Village (HV), the Gulf Beaches Public Library (GBPL), the Burgert Brothers Photographic Collection of the Tampa-Hillsborough County Public Library System (THPL), the University of South Florida St. Petersburg (USFSP), and the University of South Florida (USF).

INTRODUCTION

Although visitors have walked along the Madeira Beach shoreline for hundreds of years, all attempts to develop the islands for permanent settlement have happened within the last century. Archaeologists have located pre-Columbian Indian mounds in Bay Pines and in western St. Petersburg. The indigenous peoples harvested seafood along the barrier islands but probably did not live there for long periods of time. In the 1700s and 1800s, Spaniards and others also established itinerant fishing rancheros along the Pinellas shoreline.

A powerful hurricane in September 1848 forever altered the shoreline. In June 1843, John (Juan) Levique homesteaded near the Jungle area of western St. Petersburg, along Boca Ciega Bay, after receiving a permit to settle the area under the Armed Occupation Act of 1842. Joseph Silva lived on lands adjacent to Levique and also settled under that act. In the late summer of 1848, Levique and Silva sailed a shipment of turtles to New Orleans. While they were away, the so-called Gale of '48—the most destructive hurricane to hit the Pinellas peninsula in recorded history—carved the channel at Johns Pass. When the two men returned shortly thereafter, they encountered the pass, which was later named in honor of Levique.

Noel A. Mitchell attempted to turn the northern shore of Johns Pass into a signature development in 1914. Known as the "Sand Man" for his real estate gimmickry in St. Petersburg, Mitchell acquired this tract of land from George Roberts, an early homesteader. Mitchell built a wooden hotel and ran boat excursions between Johns Pass and the Jungle area of western St. Petersburg after the streetcars reached that mainland destination.

Always a promoter, he advertised his Mitchell's Beach development and tried to secure a bridge between Johns Pass and the mainland. Mitchell even brought in a sponge diver from Tarpon Springs, Nicholas Corfias, who claimed that he had found excellent sponge beds a short distance into the Gulf in March 1914. In what may have been the earliest use of the name Treasure Island for a Pinellas beach development, Mitchell referred to his settlement in present-day Madeira Beach as Treasure Island in a January 1917 paid advertisement that appeared after William Furlong, a visitor at Mitchell's Beach, claimed to have found a bundle of money.

Albert Archibald and David Welch, the two most notable developers of Madeira Beach, had their earliest beach developments on the Treasure Island side of Johns Pass. While high tides washed away the Sand Man's dreams on Mitchell Beach, Archibald and Welch hoped that a causeway connecting their island holdings with the St. Petersburg mainland would bring them wealth. After other developers, such as St. Petersburg's Perry Snell, persuaded voters to deny bonds to fund projects to open up the Gulf Beaches at Treasure Island, Welch secured separate financing to construct a free causeway between Madeira Beach and the mainland.

By the time Welch Causeway opened in July 1926, Welch had acquired lands reaching into present-day Indian Shores, and Archibald had plans for a casino and bathhouse near where the causeway met the sandy path that became Gulf Boulevard. Archibald and Welch lobbied for the United States Veterans Administration (VA) to build a soldiers' home and promised to provide a beachfront recreational park for veterans to enjoy. County commissioners approved a $100,000

financing plan in July 1931 to acquire parts of the site. In February 1932, the VA took possession of deeds to the land, and construction began. In June 1934, the VA hospital's location became known as Bay Pines.

While Archibald developed his Madeira Casino during the 1930s, Welch sold some of his holdings north of Madeira to Charles Redington in 1935. Welch also partnered with Virgil Almand, a developer who operated Kill Kare Kottage at Johns Pass, and Thomas J. Rowe, the architect of the Don CeSar in Pass-a-Grille, to lead a countywide anti-mosquito campaign aimed at ridding coastal areas of the swarming menace. Commercial and recreational fishing increased with the opening of the original Johns Pass Bridge in 1927, as speculators planned to develop both sides of the pass; meanwhile, Bill and Leon Walsh, the proprietors of a Johns Pass fishing camp near Almand's cottage, decided to start a duck farm to attract new business.

New developments came to the area after World War II. The Rice family opened the Kingfish Restaurant on the Treasure Island side and later expanded their operations to both sides of Johns Pass. The Gulf Shores subdivision, halfway between Johns Pass and Archibald's Madeira Beach—an area that had languished during the late 1930s—boomed after World War II, as evidenced by a statement in an October 1947 *St. Petersburg Times* claiming that Gulf Shores was "a brand new village . . . as modern as the atomic bomb."

Madeira Beach incorporated as a town in May 1947. Voters living between 140th and 155th Avenues assembled at the Bay Palms Trailer Park, along Welch Causeway, and voted in favor of the measure. At that time, the area south of 140th Avenue remained unincorporated. By 1950, residents in the Mitchell Beach area, near Johns Pass, agreed to form a separate municipality, South Madeira Beach. A year later, in August 1951, the separate communities of Madeira Beach and South Madeira Beach accepted a charter to reincorporate and merge into a single city. The municipality continued to grow during the 1950s through dredging operations that created new subdivisions such as Crystal Island, as well as through the 1955 annexation of mainland areas, where the Madeira Shopping Center and schools soon took shape.

Although most dredging operations had ended by the 1960s, the last half-century has brought continued growth to Madeira Beach. The expansion of Gulf Boulevard in the late 1970s encouraged developers to acquire smaller parcels and older cottages and build high-profile condominiums in their place. Homeowners remodeled or replaced smaller single-story homes along many of the finger islands with larger, multistory residences. Members of the Rice and Hubbard families, along with other merchants, have reinvigorated Johns Pass Village, as the boardwalk and shops remain a popular tourist destination.

Since the Sand Man arrived in the early 1900s, changing tides, shifting sands, and strong currents have transformed Madeira Beach. While most of the original landmarks have disappeared, a strong sense of community remains. Residents and visitors alike continue to enjoy the beaches and postcard sunsets that have defined the Pinellas Gulf Beaches. For many, the nickname the city used a decade ago continues to ring true: "An island two miles long and a smile wide."

Please note that throughout the book, references are made to the Madeira Beach Causeway by the three different names given to it throughout its history. Originally known as Welch Causeway after its completion in 1926, the road is also known as 150th Avenue within Madeira Beach city limits. The Florida Legislature renamed this 1.52-mile roadway Tom Stuart Causeway in 1973, though old-timers continue to honor David Welch's legacy by referring to its earlier name or the more generic Madeira Causeway. The official state designation for this road, Route 666, appears on a few signs but is not commonly used.

One

THE SHORELINE, THE "SAND MAN," AND MOSQUITOES

1800s–1945

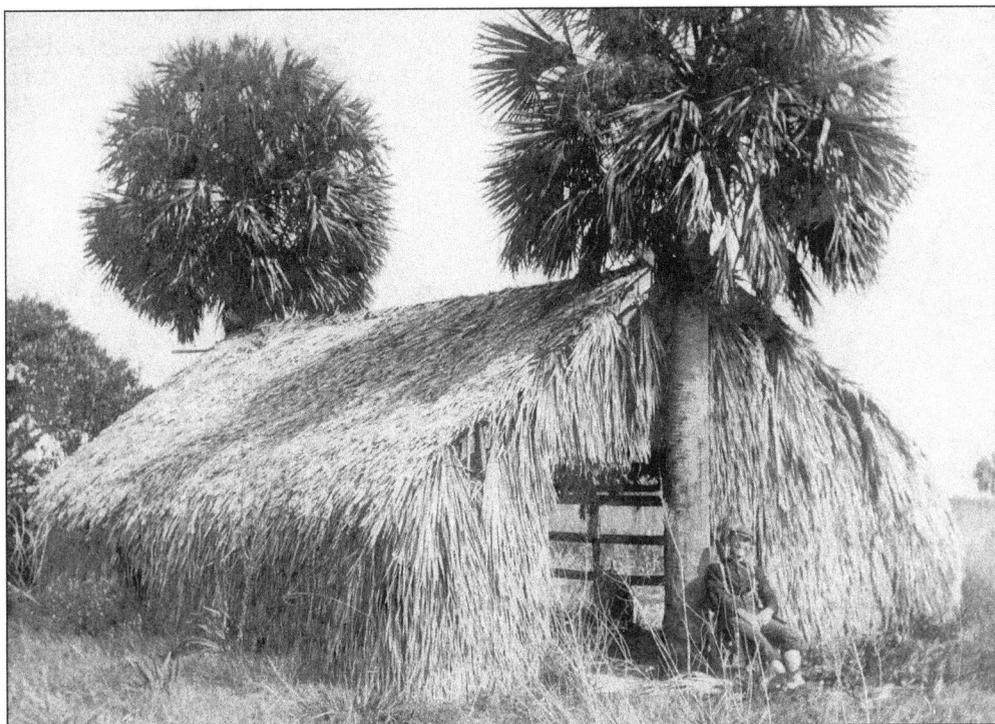

Early visitors to the island enjoyed million-dollar views that came with millions of mosquitoes. Homer Mohr, seen here sitting outside a palm-thatch hut near Johns Pass in 1901, visited the area before any homes existed on this portion of Long Key. This structure resembled the temporary dwellings assembled at fishing rancheros during the 1700s and 1800s, where Cubans and others set up camps and caught fish. (HV.)

Homer Mohr and others sailed along the waters near Johns Pass around 1900, a time when few ventured to Long Key. Although small settlements existed at Pass-a-Grille to the south and the Indian Rocks/Anona area to the north, few visited the portion of the Gulf Beaches where Madeira Beach later took shape. (HV.)

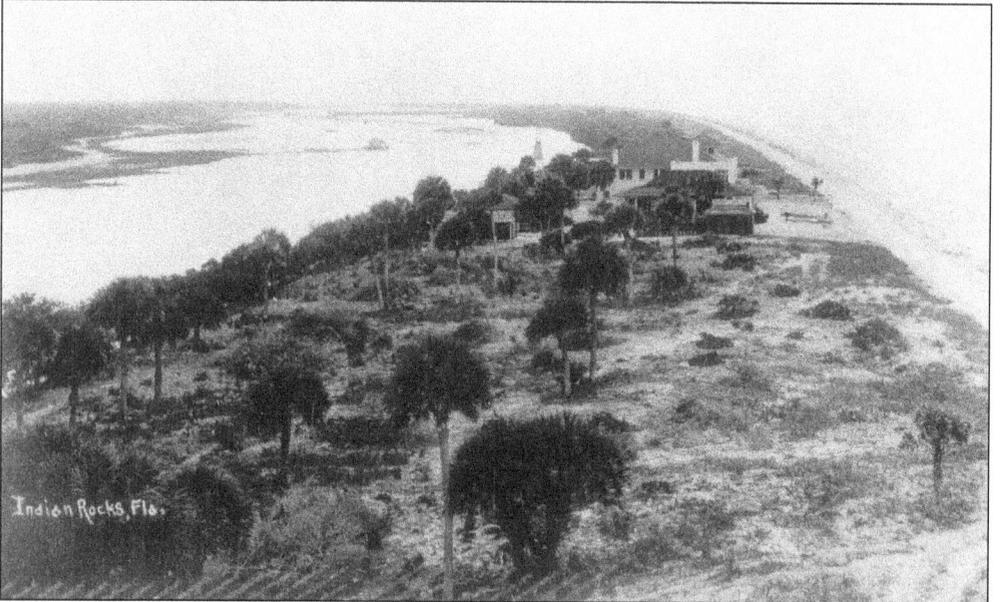

This view looking towards the south from Indian Rocks—one of the few developed areas along the Gulf Beaches—shows that both the mainland and the beach remained unoccupied during the first decade of the 20th century. Indian Pass, an opening that once existed between present-day Indian Shores and Redington Shores near the site of the Park Boulevard Bridge, appears in the distance. (HV.)

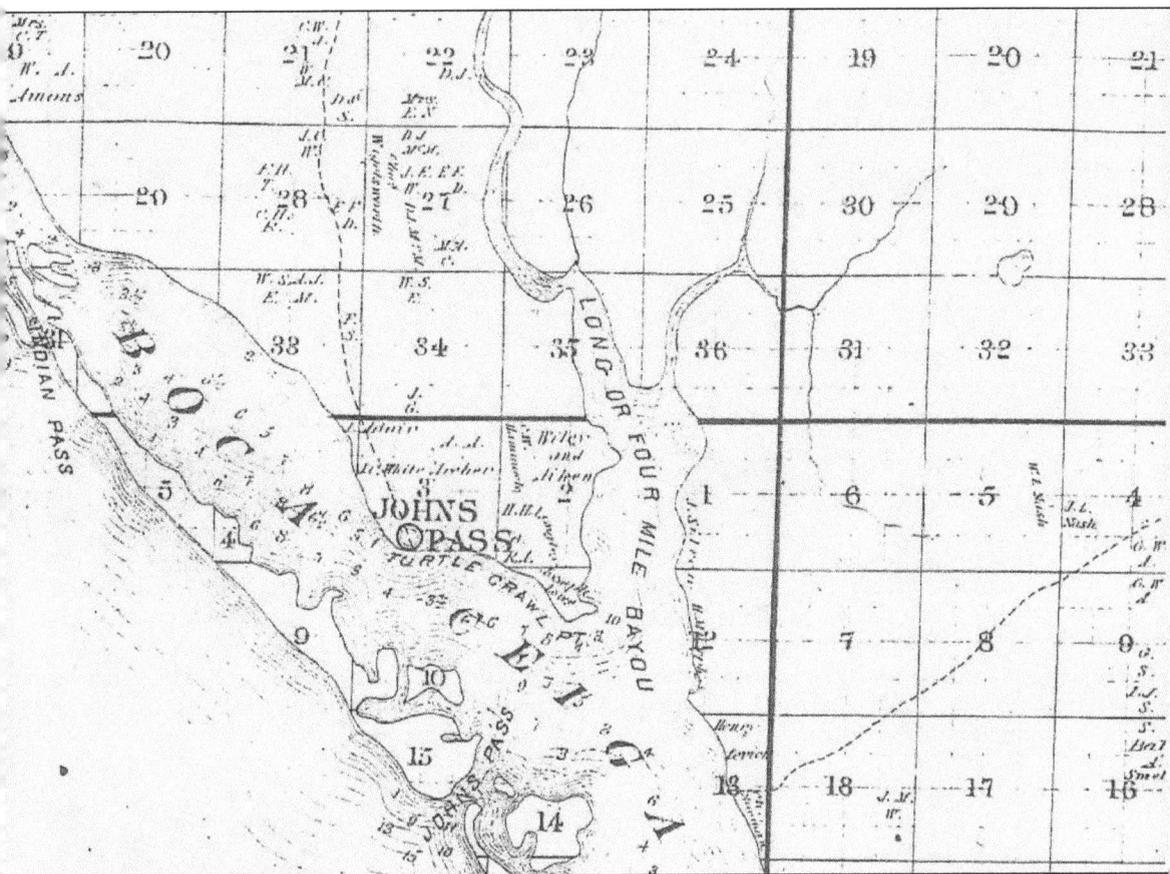

This view of part of a larger map printed in November 1882 offers one of the earliest accurate outlines of Madeira Beach. Drawn for Hamilton Disston, an investor who purchased four million acres of Florida land for $1 million in February 1881, the map shows the Johns Pass settlement on the mainland, near Hurricane Hole (which appears as a circle). Albert S. Meares had opened a post office with the name Johns Pass at Oakhurst, in the area of Seminole City Park, in 1879. During the 1880s, a time when the Pinellas peninsula was still part of Hillsborough County, tax records referred to the handful of residents who lived on the mainland in the Seminole area as residents of Johns Pass. No permanent residents lived on the beach near the actual pass, however, due to a lack of fresh water, few trees, frequent floods, and millions of mosquitoes. Note the lack of "finger islands" before dredging. (USFSP.)

Hartman's Point, located along the side of War Veterans' Memorial Park and the VA Hospital site facing Madeira Beach, had a sawmill, a freight dock, and a turtle kraal, or pen, in the late 1800s. Early fishing expeditions kept sea turtles they had captured there in pens until they shipped them. Still known as Turtle Crawl Point, this area of the mainland sits in close proximity to Johns Pass. (Author.)

This view at the mouth of Hurricane Hole looks from the Bay Pines VA Medical Center property towards Madeira Beach Fundamental School. Capt. George Arthur grew oranges nearby. Gus Archer became postmaster when Seminole's post office opened just north of Hurricane Hole in 1886. John White ran a fish camp and had a boat landing near the present-day school, and White's Landing became an early picnic area for pioneers. (Author.)

With no bridges connecting the mainland to the Gulf Beaches, visiting barrier islands required access to a boat. As St. Petersburg started to take shape, the city's expanding streetcar line provided residents living in the "Sunshine City" an easier way to get to the beaches. One spur of the streetcar railway reached Gulfport, known then as Veteran City, in April 1905, allowing residents access to boats to travel to Pass-a-Grille at St. Pete Beach. Another spur traveled west along Central Avenue towards the Davista area, ultimately reaching Jungle Prada along Park Street in western St. Petersburg in December 1913. The view above shows the Jungle line near Fifty-eighth Street in the mid-1910s, while the postcard below shows the lack of development in the Jungle area even in the early 1920s. (Both, HV.)

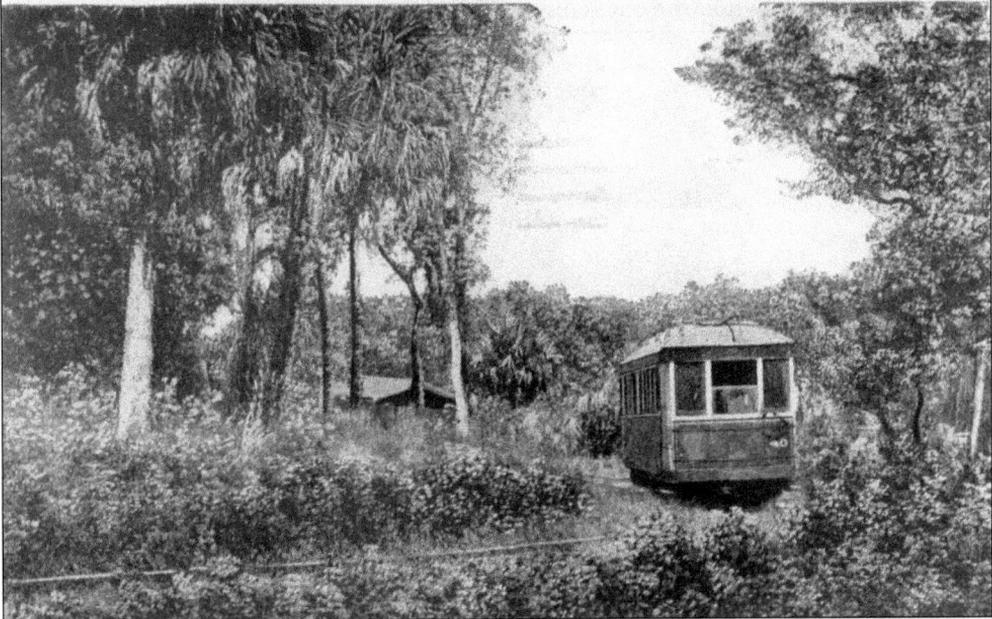

Scene in the Jungle at Davista, St. Petersburg, Fla.—6

While the extension of the Jungle line promoted settlement in western St. Petersburg by Walter Fuller and other speculators, the railway's terminus near Jungle Prada also connected the past with the future. Pánfilo de Narváez, the second notable Spanish conquistador to arrive in La Florida after Juan Ponce de León, landed in this area in April 1528 on an expedition with at least 350 men. Although Narváez failed to find gold, he did encounter the Tocobaga Indians at a settlement on this site. By early 1914, this area of the Jungle, ripe for development, also provided a mainland destination near Johns Pass. The dock at this site (above) marks the point where another St. Petersburg developer, Noel Mitchell, launched ambitious plans to transform Johns Pass. The view below shows Johns Pass from directly across the Boca Ciega Bay. (Both, author.)

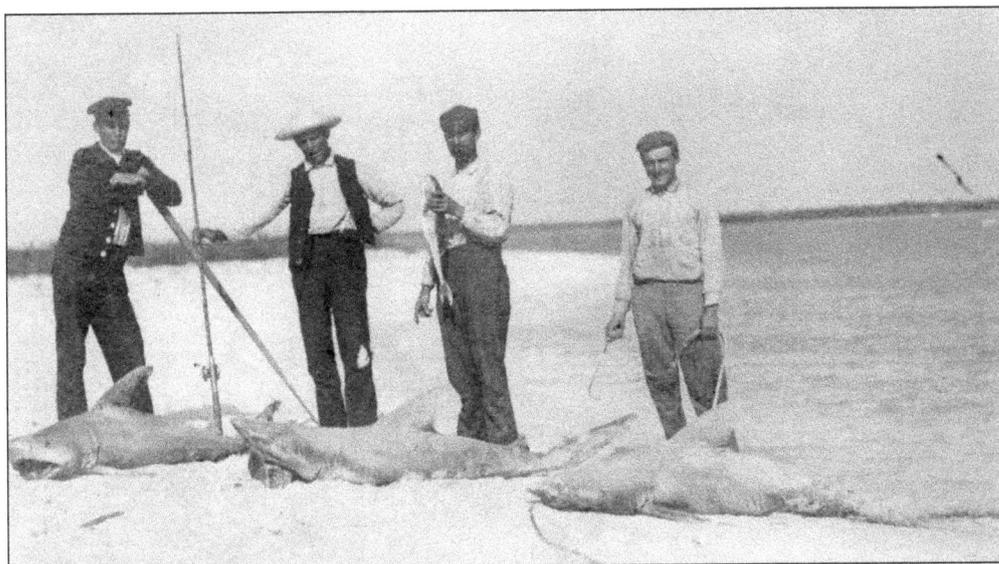

George Roberts (above, right) traveled by boat from Maximo Point to Pass-a-Grille after George Lizotte opened a hotel. During the first decade of the 20th century, while in his early twenties, Roberts led fishing parties and brought seafood back to Lizotte's hotel. In 1912, he became the first regular homesteader along present-day Madeira Beach when he claimed title to nearly 140 acres on the north side of Johns Pass up to about 140th Avenue, an area called Olive Island at that time. Roberts constructed a small dwelling and a boat dock. Noel Mitchell (below in 1921) bought the Olive Island tract from Roberts and constructed Mitchell's Beach Hotel in 1914 on the site where Roberts briefly lived. After the land boom ended, Roberts left Florida and moved to Texas. (Both, HV.)

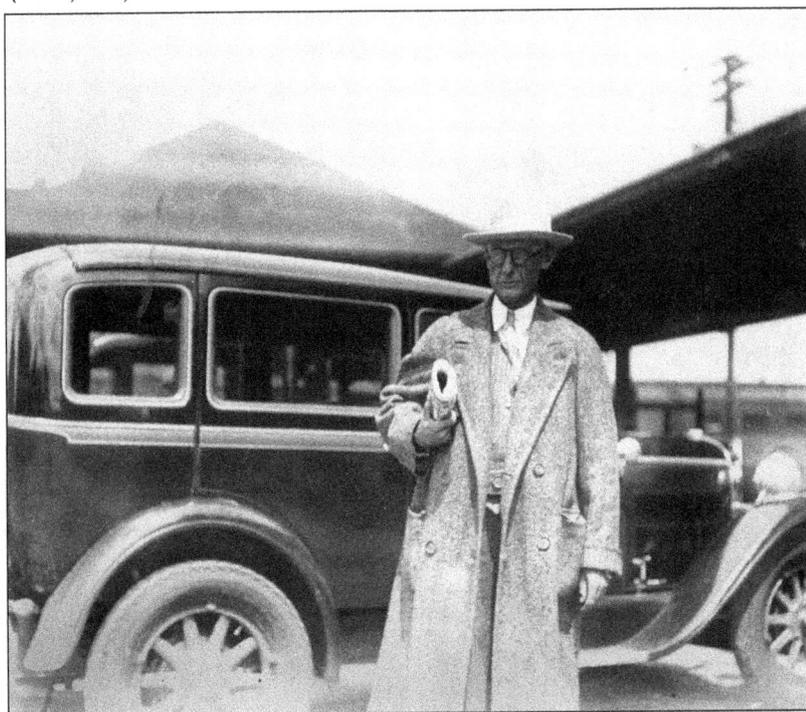

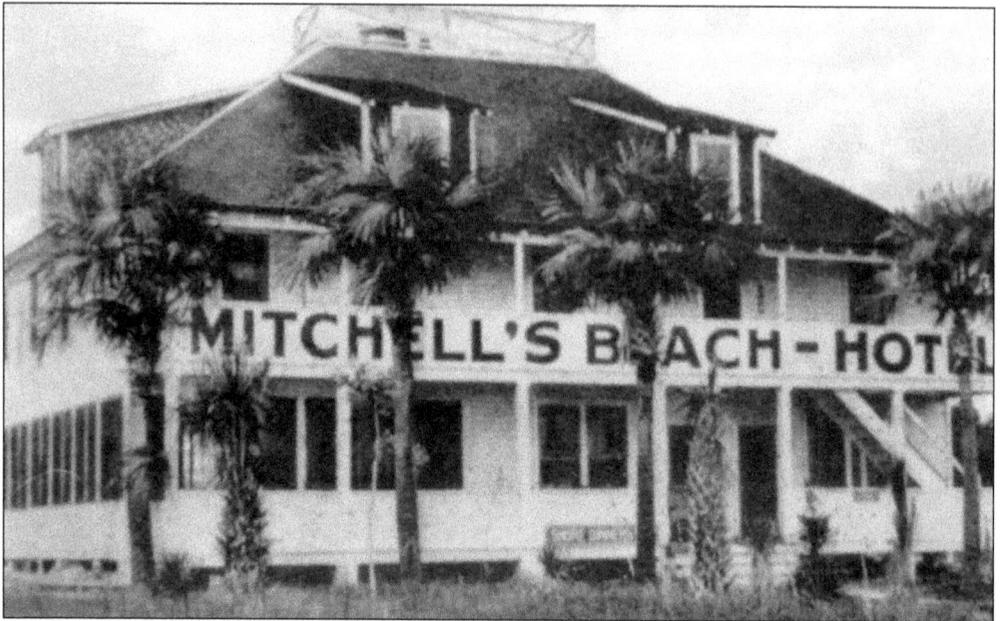

A Rhode Island native born in 1874, Noel Mitchell had established a saltwater taffy company by the age of 18. Arriving in the small town of St. Petersburg in December 1903, he became known as the first person to pay $1,000 for a lot. Within a few years, he became heavily involved in real estate, and his antics attracted curious onlookers. Known as the "Sand Man," he played a role in the establishment of St. Petersburg's fabled green benches as the Sunshine City started to grow. By early 1914, Mitchell had acquired George Roberts's holdings at Johns Pass and other parcels up to 140th Avenue. He built Mitchell's Beach Hotel facing the beach on the site where Roberts had lived and lost no time with his ambitious—some might say outrageous—efforts to promote the beach. (Above, Bob Griffin collection; below, USFSP.)

16

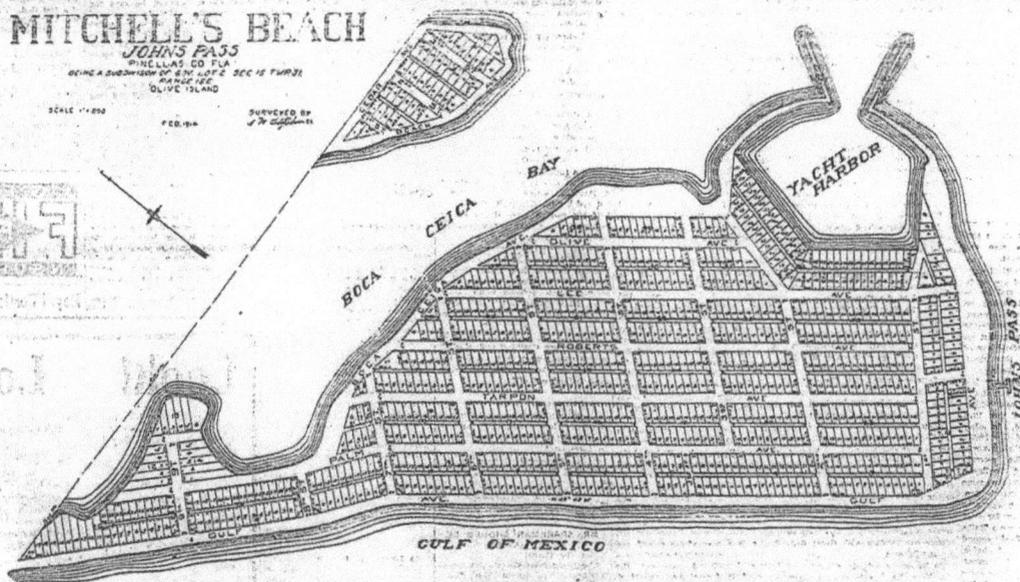

MITCHELL'S BEACH
JOHNS PASS
PINELLAS CO FLA
BEING A SUBDIVISION OF GOV LOT E SEC 15 TWP 31
RANGE 15E
OLIVE ISLAND
SCALE 1"=200'
FEB 1914
SURVEYED BY
J W Clifton

BOCA CEICA BAY

YACHT HARBOR

JOHNS PASS

GULF OF MEXICO

The Tarpon Season is now in full blast at Johns Pass—the finest Fishing Grounds in the South.
The Hotel at Mitchell's Beach is under new management and is conducted in a thoroughly up-to-date manner. The Finest Beach. Swept by Gulf Breezes. A Summer Resort for the People of the South. A Winter Resort for the people of the North. For Plats and Prices call on

NOEL A. MITCHELL, Owner.

Mitchell ran regular 10-minute boat excursions from the Jungle in western St. Petersburg, usually for 20¢ round-trip. Those visiting the island enjoyed "shore" dinners with a variety of seafood delicacies. By April 1914, Mitchell talked about the possibility of connecting the north end of Johns Pass directly to St. Petersburg by constructing a bridge from the Jungle area to Mitchell Beach. Before the end of May, he heavily peppered newspapers with maps that platted a city of thousands of residents, as seen here, even though fewer than two dozen regularly stayed on the island overnight. Johns Pass is on the right side of this map. Lots on Mitchell Beach ranged from $150 to $750 in 1915, with terms of a $10 down payment and $5 per month. Mitchell abandoned his beach development plans after the end of World War I. He was briefly the mayor of St. Petersburg in 1921 before running afoul of the law after police busted a booze party in the mayor's office. He died penniless in 1936, and a storm washed away his hotel long before then. (USFSP.)

Between 1914 and 1916, John Sturgis Bradbury and Thomas F. Pearce started the Seminole Beach development. A small store, a post office, a hotel, and a dock were built about a mile north of present-day Madeira Beach, with plans to establish a 12-block settlement along the narrow portion of the island south of Indian Pass. Despite their ambitious plans, the 1916 view above of Seminole Beach looking across Boca Ciega Bay reveals little progress. Storms and mosquitoes halted the settlement, though it remained on maps well into the land boom of the mid-1920s, as seen in part of the full-page advertisement below in the September 20, 1925, issue of the *St. Petersburg Times*. David Welch later acquired tracts of this land. This area remained largely unoccupied until Charles E. Redington began developing it in the mid-1930s. (Above, THPL; below, USFSP.)

THE FINAL DEFINITE LIMIT

MONDAY MIDNIGHT

PREPARE TODAY TO TAKE ADVANTAGE OF THE ONE AND LAST OPPORTUNITY TO SECURE A HOME-SITE IN *SEMINOLE ESTATES* AT INTRODUCTORY PRICES GOVERNING SALE OF FIRST UNIT

GULF OF MEXICO

SEMINOLE BEACH

BOCA CIEGA BAY

CAUSEWAY TO BEACH

Seminole Estates

ST. PETERSBURG — MISSOURI AVENUE — TO CLEARWATER

DRIVE OUT TODAY

Born in Iowa in 1880, David Sewall Welch enlisted for service during the Spanish-American War and spent 1898 in the Tampa area providing supplies for future president Theodore Roosevelt's "Rough Riders." One assignment had him and others fetching fresh water from St. Petersburg's Mirror Lake and hauling it back for troops in Tampa. Welch returned to Iowa, but he came back to the Oldsmar area in 1913 and worked with Ransom Olds, the settlement's founder and the developer of the Oldsmobile. By the 1920s, Welch had moved to St. Petersburg and started the Lone Palm Corporation. Soon, he acquired Noel Mitchell's former holdings along the north end of Johns Pass, other land in present-day Treasure Island from Albert Archibald, and much of the beach from 150th Avenue through Indian Shores, including all of the Redingtons. With no bridges connecting his holdings to the mainland at the time, he and his family took yachting excursions to their island property. (Bob Griffin collection.)

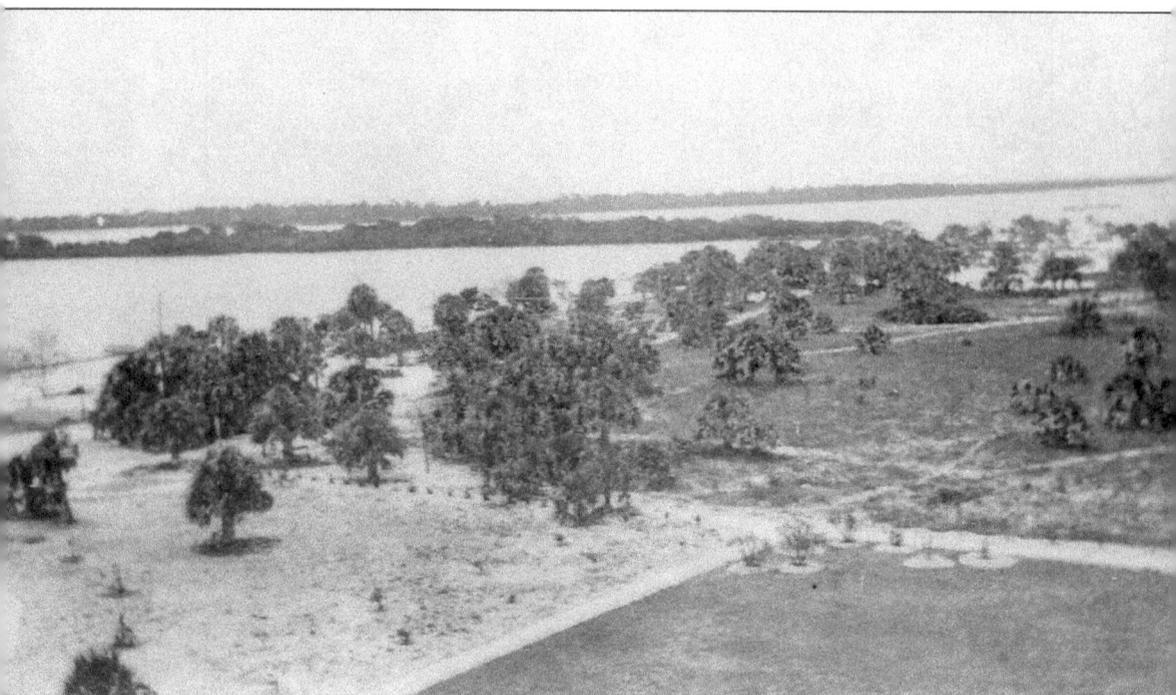

An early resident of Davista, in western St. Petersburg, David Welch could see his substantial landholdings in Treasure Island from his home and knew of their great potential. Along with other investors, he devised plans to construct a causeway between Central Avenue in St. Petersburg and what later became Treasure Island. At that time, the Causeway Isle and Paradise Island developments did not exist, so the causeway would have required a substantial dredge-and-fill operation. The view from his home would have been similar to this 1910s aerial view looking towards the central Pinellas Gulf Beaches. After voters failed to approve this measure, Welch found another opportunity to get a causeway to the beach. Partnering with P.J. McDevitt of Pinellas Park, Welch worked tirelessly to muster support for a 1923 road bond that created Park Boulevard in Pinellas Park and provided financing for a bridge to the beach. Although the Treasure Island Causeway had to wait until 1939 to open, workers dredged the approaches and constructed Welch Causeway in 1925–1926, the first free causeway to the lower Gulf Beaches. (HV.)

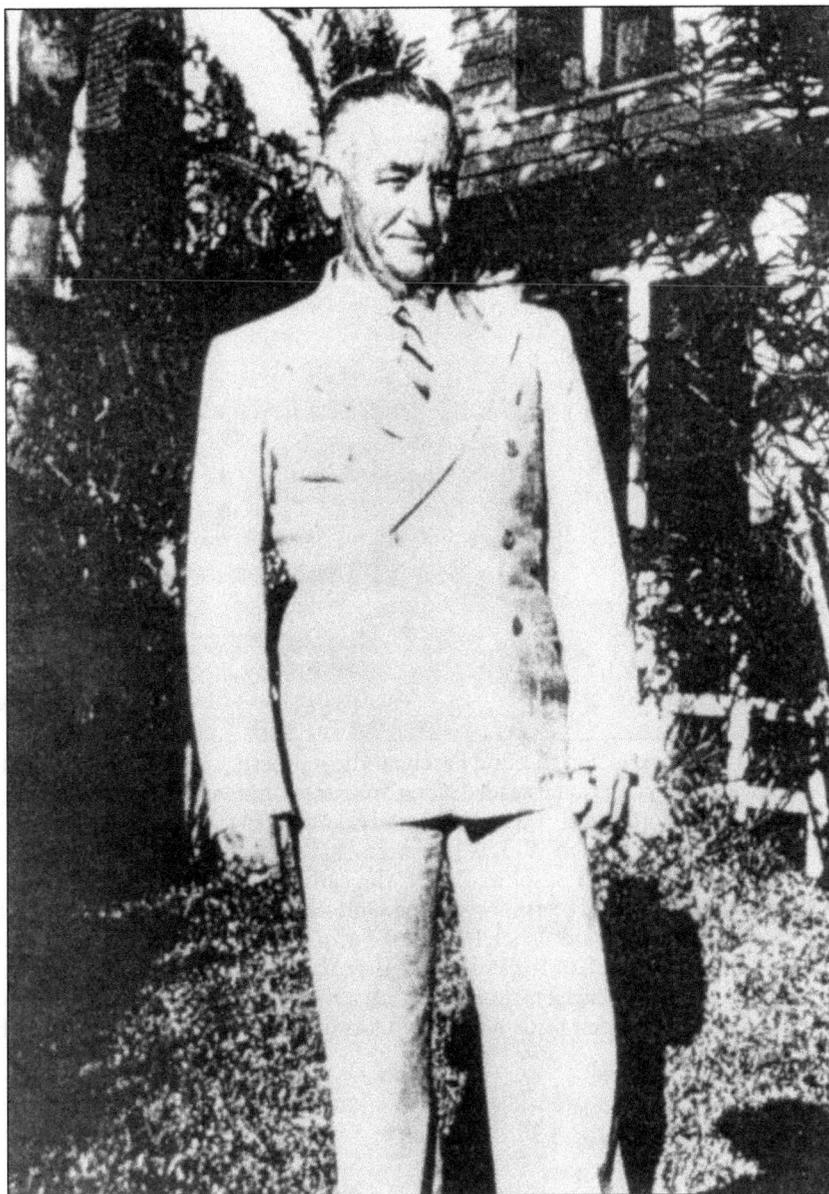

Albert "Bert" Archibald came to St. Petersburg in 1901 as a teenager. The Detroit native had a strong business sense. He operated a produce company near the downtown railroad terminal and later gained an interest in real estate. St. Petersburg developer H. Walter Fuller purchased much of present-day Treasure Island for $800 in 1913. Fuller created a development company and issued 25¢ shares to investors. Archibald purchased one share. By the end of World War I, he had acquired all of the other shares. Along the northern area of Treasure Island, later known as Sunshine Beach, Archibald developed plans for a resort he named Coney Island. As the land boom of the 1920s transformed St. Petersburg, limited transportation (no bridges between the islands of Johns Pass and the mainland), a lack of potable water, and the omnipresent mosquitoes slowed Archibald's plans. He joined Welch in trying to secure a free causeway from Central Avenue to the beaches, but Perry Snell, a notable St. Petersburg developer, used advertisements to discourage voters from approving this measure. (Bob Griffin collection.)

This image shows a 1913 excursion to Blind Pass near the southern part of Treasure Island. By the early 1910s, Thomas H. Sawyer homesteaded along Treasure Island's southern area, Sunset Beach. He and a friend, Whiteford Smith "W.S." Harrell, bought acreage in the area, and Fuller and Archibald also became investors in 1913. While Archibald moved forward with plans to develop the Coney Island area just south of Johns Pass in the early 1920s, the defeat of a bond issue to fund a causeway connecting St. Petersburg and the Gulf Beaches forced him to rethink the scale of this project. By that time, David Welch had started acquiring substantial tracts north of Johns Pass, including parcels up to Indian Rocks Beach. After Welch successfully lobbied for a measure to fund the construction of a bridge across Boca Ciega Bay north of Johns Pass, Archibald also focused his efforts on the Madeira side and moved forward with plans for his Madeira Holding Company. (HV.)

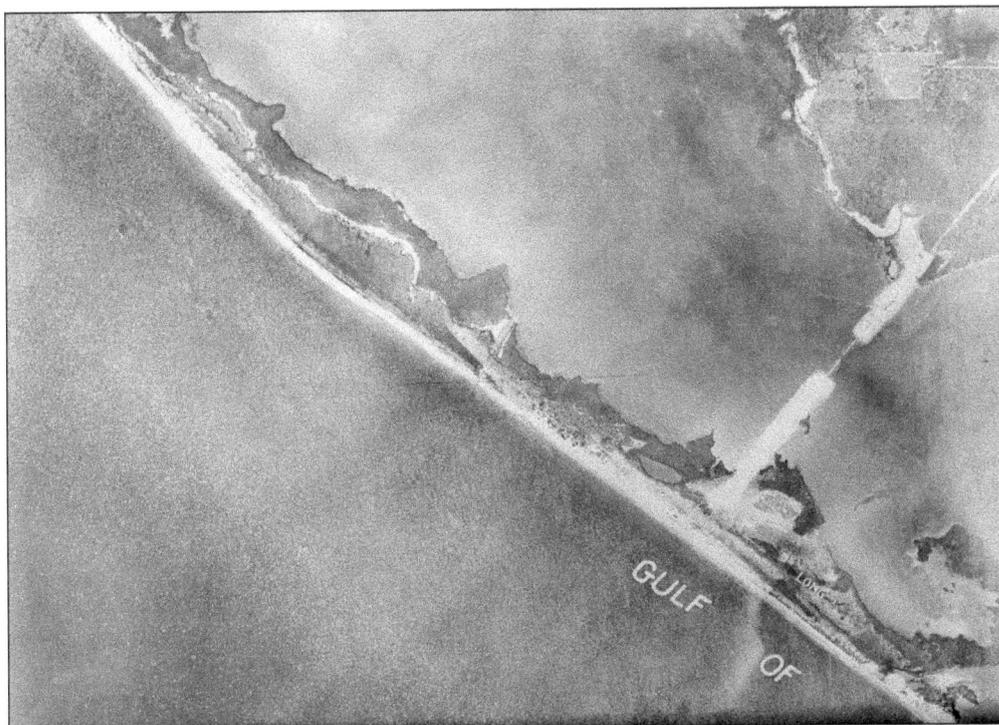

This 1926 aerial view clearly reveals the lack of development on lands acquired by Archibald and Welch. Crews dredged the approach to Welch Causeway along both sides of Boca Ciega Bay. A large lake covered much of the area where Carter Plaza now sits. The sandy, narrow path that later became Gulf Boulevard ended near 155th Avenue. (HV.)

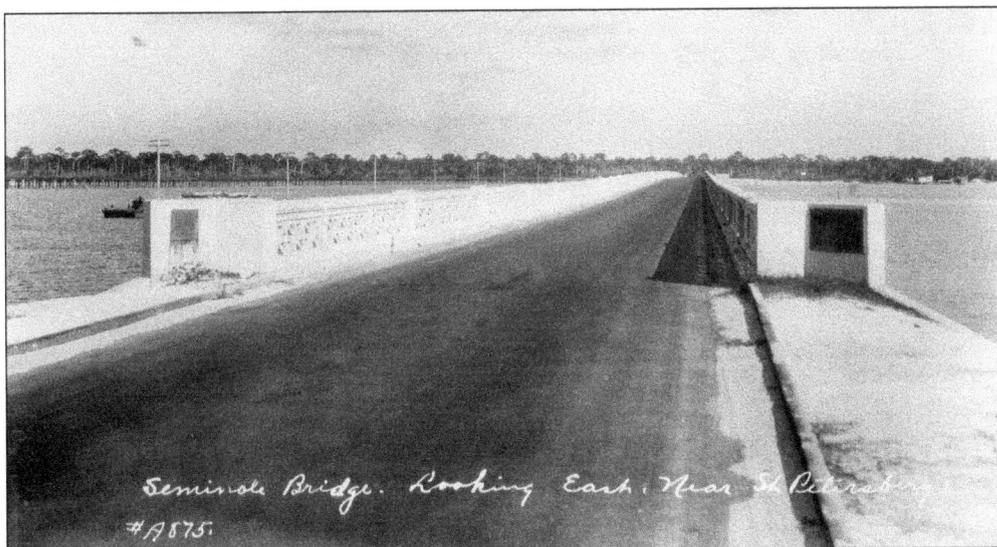

The first bridge to cross Long Bayou between St. Petersburg and Bay Pines lasted only a few months in 1911 before collapsing under the weight of a herd of mules. Its shoddy construction swayed voter support to establish Pinellas County in 1912. A 1914 replacement bridge suffered damage in a 1919 storm before being destroyed in a 1921 hurricane. The third span, opened in 1924, provided access to Seminole. (HV.)

23

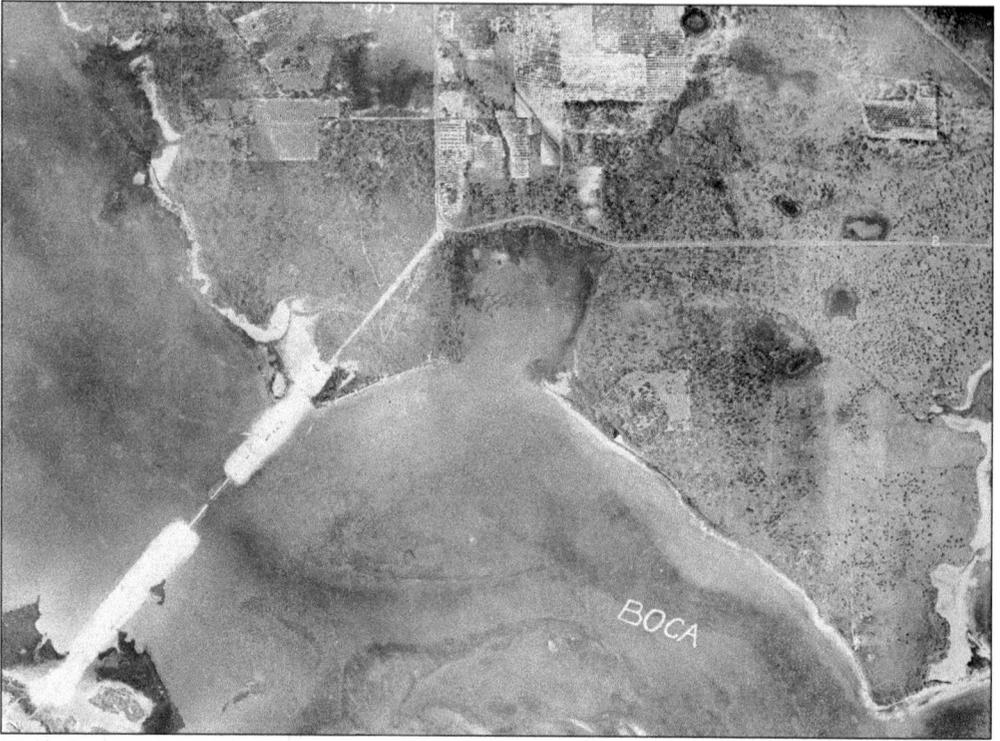

With the new Seminole Bridge opened in 1924, travelers could drive from the right side of this image along the roadway until they passed Hurricane Hole. At that point, they could either continue northward into the groves of the Seminole/Largo area or take a sandy path southwest to the new causeway that would bring them to lands that Archibald and Welch had started to develop. (HV.)

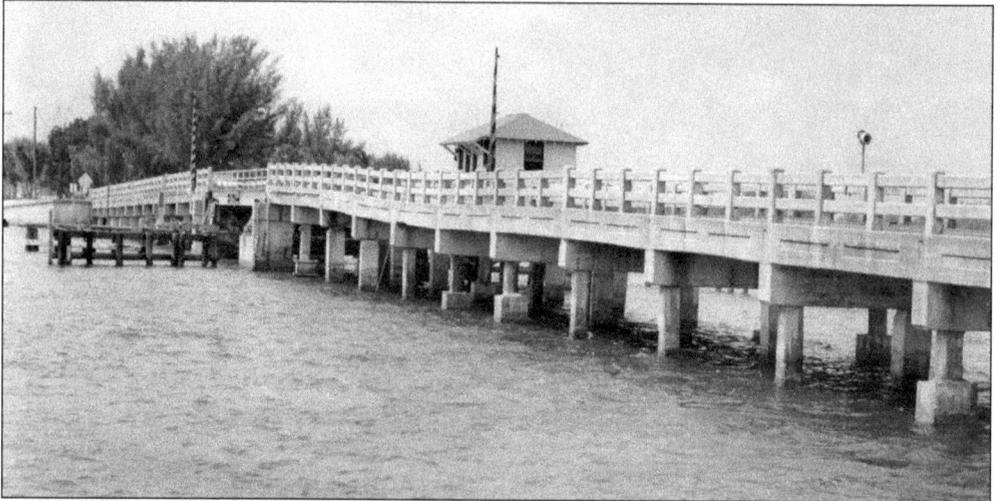

The causeway connecting the island to the mainland opened on July 4, 1926, the sesquicentennial of the nation's Declaration of Independence. With the barricades on the eastern section removed, Archibald took the liberty of driving the first car across. Nearly 2,500 other vehicles crossed the narrow bridge that day along a path called Welch Causeway even though Welch had spent that historic day at his summer home in North Carolina. (GBPL.)

After Welch Causeway opened, Archibald started courting potential residents and developers. He built a wooden bathhouse on the beachside of 150th Avenue and Gulf Boulevard, but a fire soon consumed it. In 1926, Archibald sold land between 150th and Archibald Park to outside investors who planned to develop a resort known as Casa Madeira. When they ran short of money, he reacquired the land and built a recreational casino. (USFSP.)

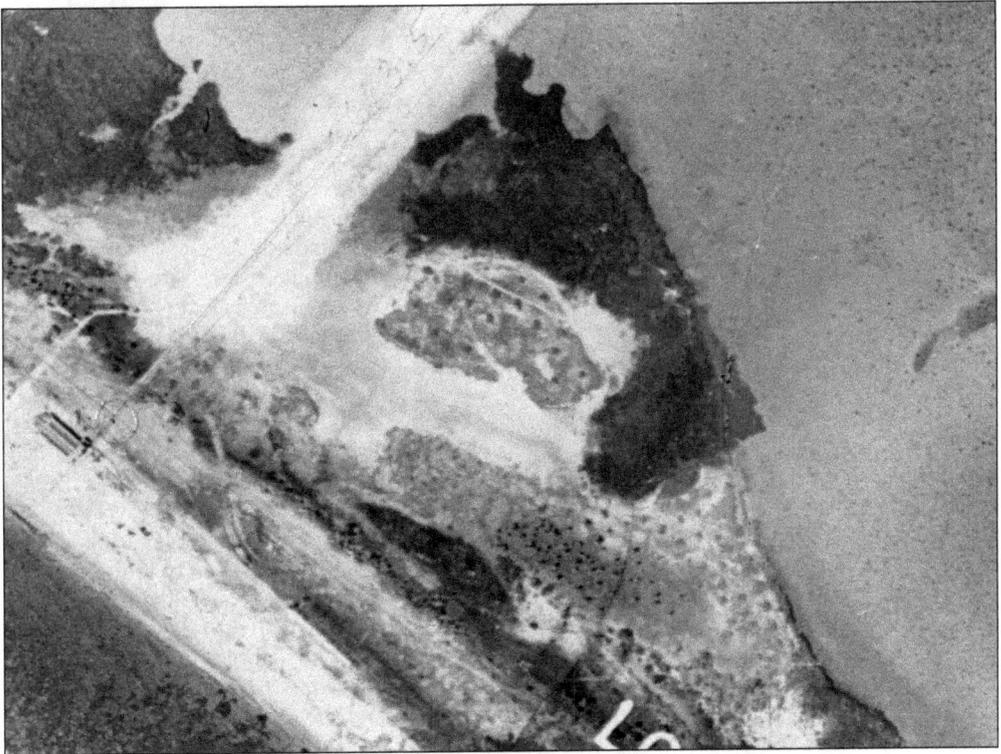

This 1926 view shows part of the development that later became Archibald's Madeira Casino. By 1927, he had constructed a new bathhouse, a small restaurant, and a grocery store. Finding that a generator did not meet his needs, Archibald also secured electrical service from the mainland in 1928 and telephone service a couple of years later. By the late 1920s, he developed plans for a large amusement facility. (HV.)

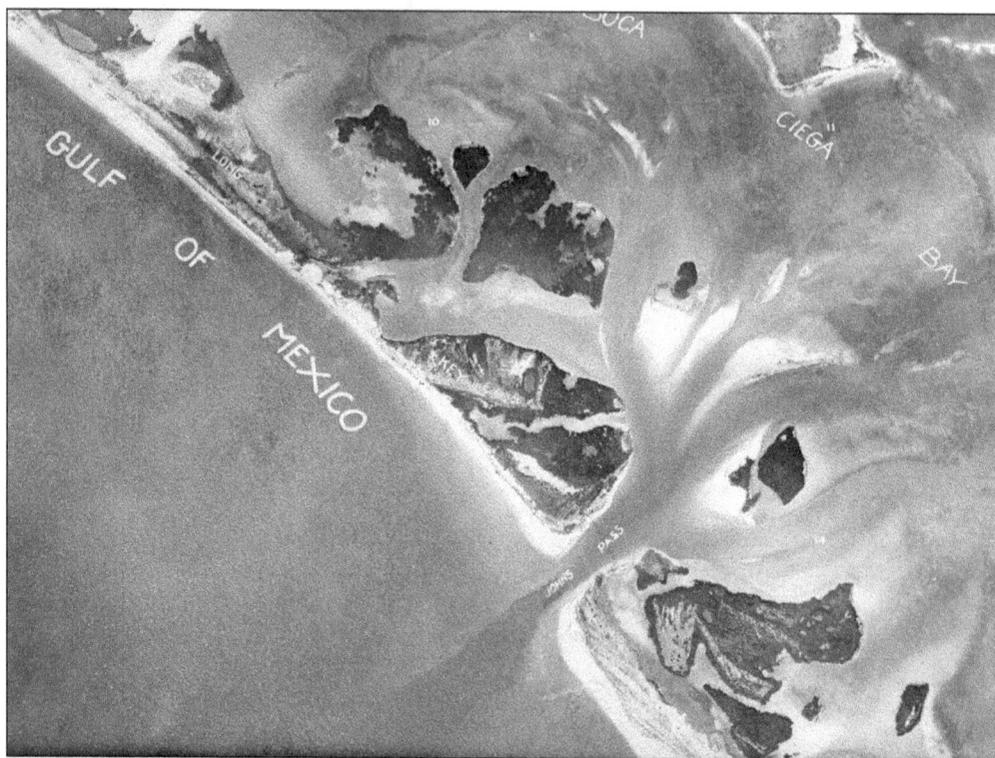

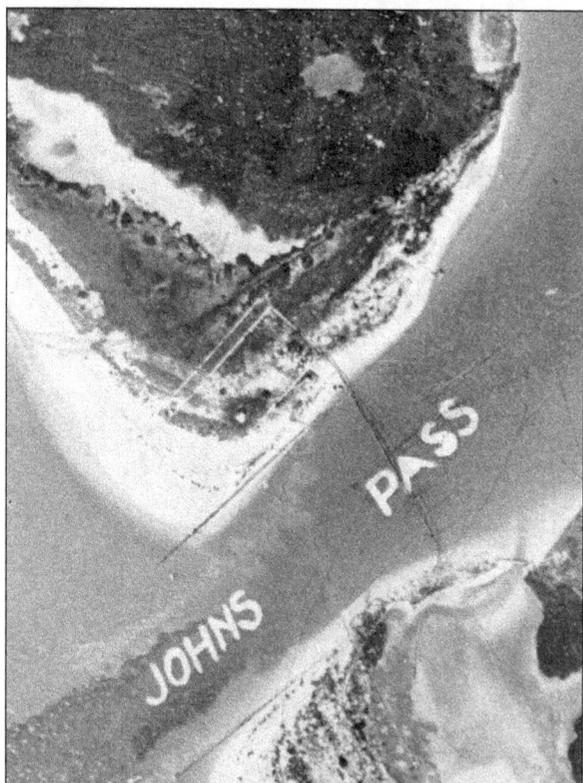

This 1926 view from Archibald's Madeira Casino site towards Johns Pass shows a landscape that differs greatly from present-day Madeira Beach. Aside from dredging operations to create Welch Causeway, no finger islands or other notable developments existed. During this time, Archibald acquired other islands in the bay, including Elnor Island and adjacent "Island A," both visible to the right of Johns Pass. Elnor was his second wife's first name. (HV.)

This 1926 close-up of Johns Pass reveals that little remained—or ever actually materialized—from Noel Mitchell's ambitious plans. A couple of small structures in poor condition and the remnants of sand pathways on the northern side of the pass sit upon an otherwise undeveloped landscape. Soon, Archibald and other investors devised plans to span Johns Pass with a bridge that would connect the islands. (HV.)

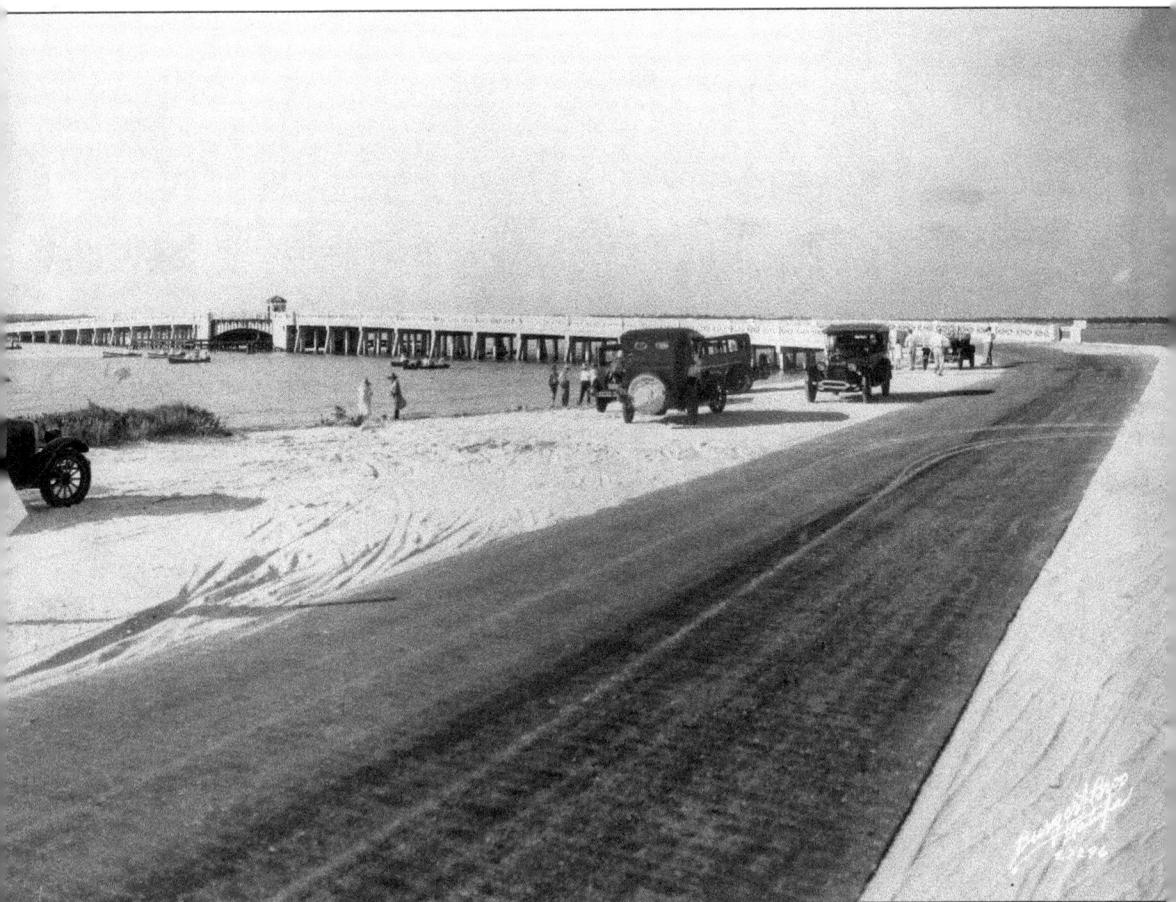

The original Johns Pass Bridge opened in 1927. This view looks northeastward from the Treasure Island side of the bridge in 1928. Note that much of the approach required additional dredging on the Treasure Island side. Archibald's holdings in the Coney Island area of northern Treasure Island could now be reached by cars. Also in 1927, a free bridge between St. Pete Beach and the mainland, Corey Causeway, opened to traffic, replacing the wooden McAdoo Bridge and eliminating tolls. Another bridge connected Treasure Island and St. Pete Beach at Blind Pass. Before 1926, the landholdings of Archibald and Welch seemed remote and inaccessible. By the mid-1930s, after the closing of Indian Pass, motor vehicles could travel without interruption from the Sand Key area north of Indian Rocks Beach to Pass-a-Grille at the southern tip of present-day St. Pete Beach. The Johns Pass Bridge also promoted the development of the commercial fishing industry in both Madeira Beach and Treasure Island in the 1930s and 1940s. (THPL.)

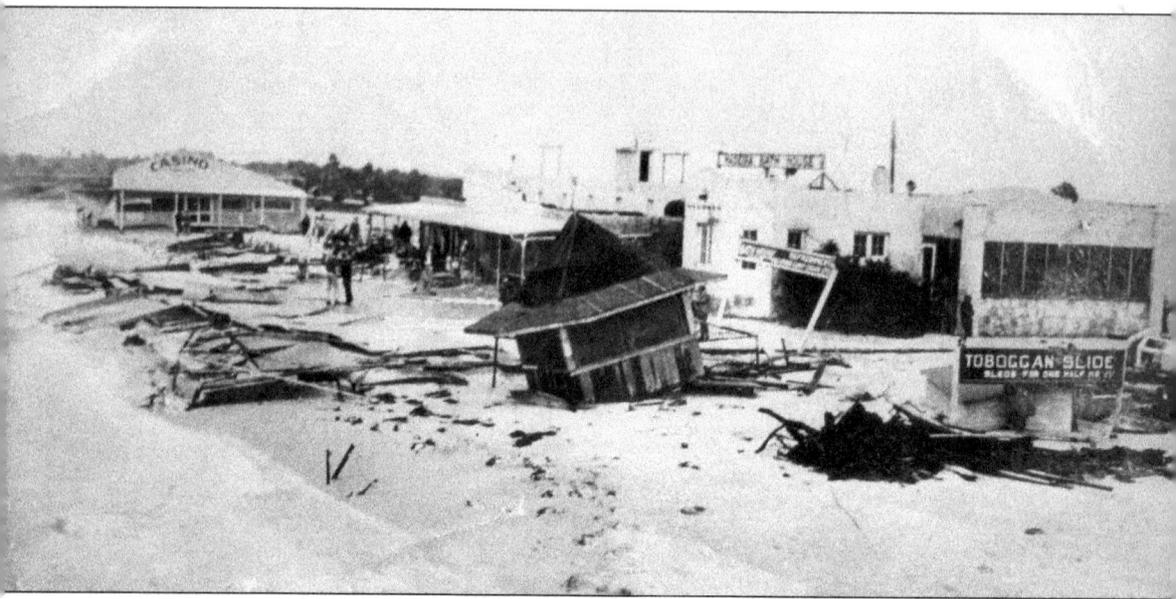

In the late 1920s and early 1930s, Albert Archibald expanded the Madeira Casino south towards 140th Avenue. He created a popular Florida roadside tourist destination along the otherwise vacant beach, complete with a water toboggan slide, a skating rink, picnic tables, and swings. He added a fishing pond, a shooting gallery, pony rides, and even monkey shows and circus performances during the busy winter months. Archibald also acquired a 75-foot yacht from the Coast Guard, placed it in concrete supports on the beach near 150th Avenue, and called it Archie's Ark. A storm in early March 1932 did substantial damage to Archibald's entertainment complex, as seen in this view looking northeastward along the coast, but he rebuilt parts of it and soon renamed it the Madeira Beach Amusement Park. By the mid-1930s, the phrase Madeira Beach became synonymous with developments north of 140th Avenue, while those in Johns Pass still occasionally referred to their settlement as Mitchell's Beach. (Wayne and Nancy Ayers collection.)

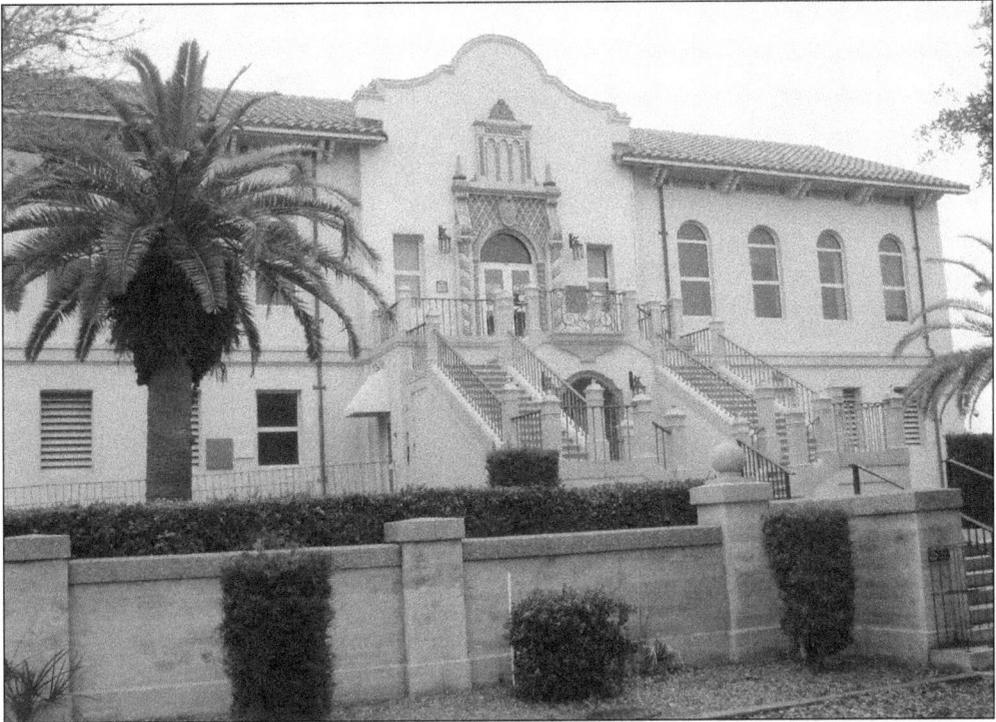

When Archibald and Welch discovered that federal officials planned to construct a soldiers' home somewhere in Florida, they lobbied that the area known as Seminole Point, a peninsula between Boca Ciega Bay and Long Bayou, offered the perfect location. To strengthen their case, Archibald and Welch also agreed to donate a 500-foot tract of land along the Gulf of Mexico as a location exclusively for the use of veterans. The soldiers' home received the name Bay Pines in June 1934. Construction of the pavilion along the beach began a year later. The image above shows one of the original buildings, constructed around 1935, which is still in use at the Bay Pines VA facility. The structure below, one of many that once sat along Welch Causeway near Hurricane Hole, served as a residence. (Above, author; below, Lyn Friedt collection, HV.)

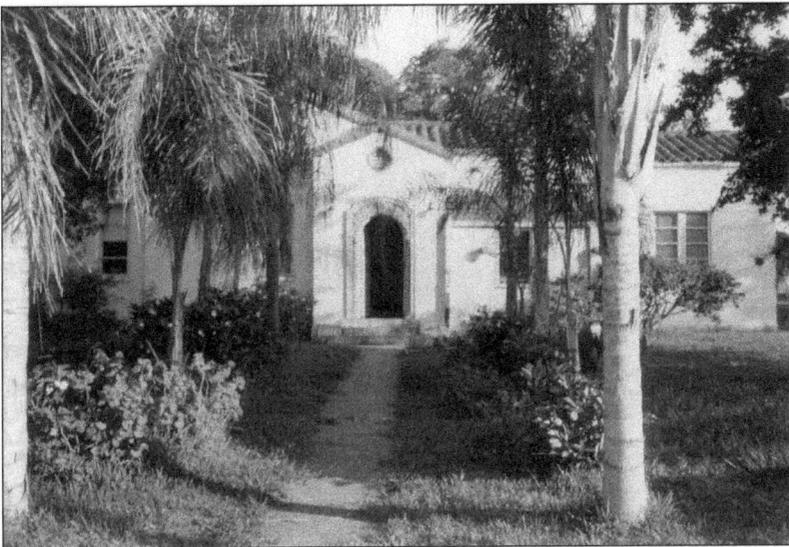

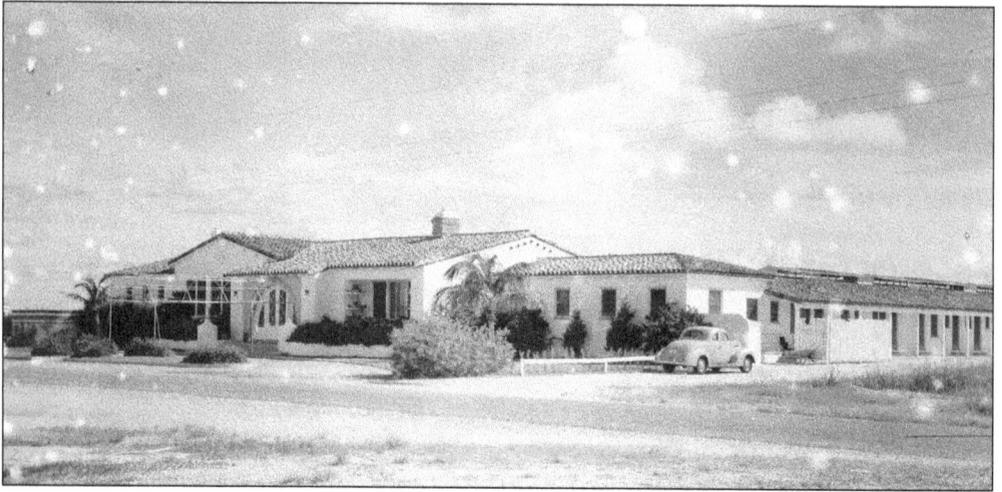

Charles Ezra Redington purchased some of David Welch's holdings north of Madeira Beach and started to develop in the Lone Palm subdivision. A native of Indiana born in 1884, Redington also became involved with projects in St. Petersburg, Pass-a-Grille, Lido Beach, and parts of Treasure Island. His sons Charles Jr. and John joined the family enterprise. Redington built his first home in Lone Palm in 1935. Within a couple of years, he developed a casino that became the Bath Club, (above in August 1939) and the Tides Hotel (below). Redington paved the road from Madeira to this resort. The Tides and the Bath Club grew into popular destinations, and memberships to the Bath Club became quite a commodity as the facility expanded over the next half-century. (Above, THPL; below, HV.)

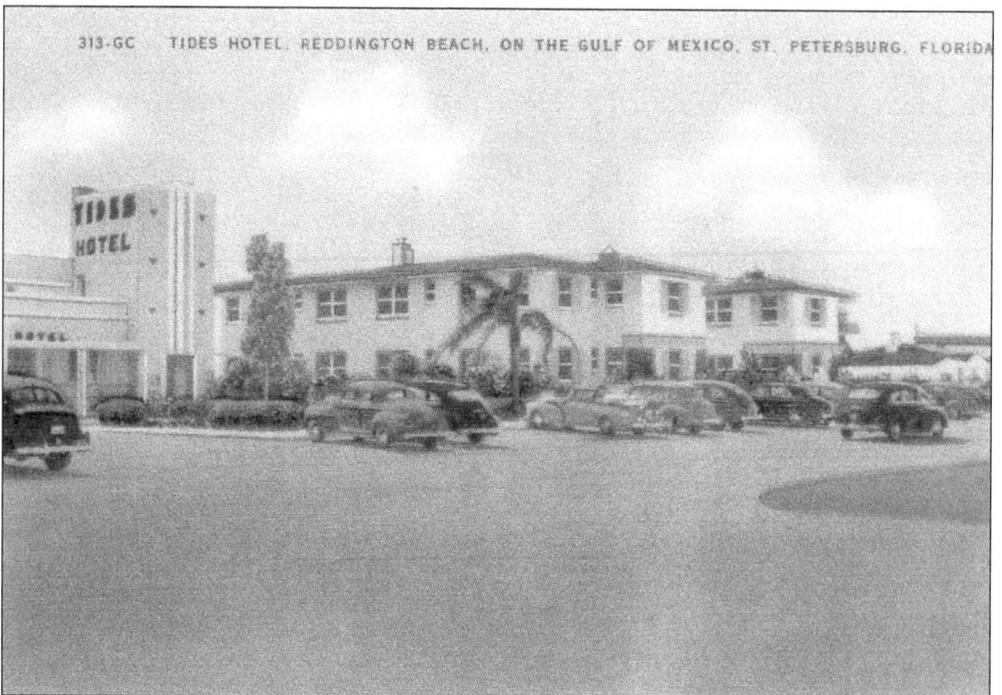

Two

FAMOUS FISHING
AT JOHNS PASS
1946–2013

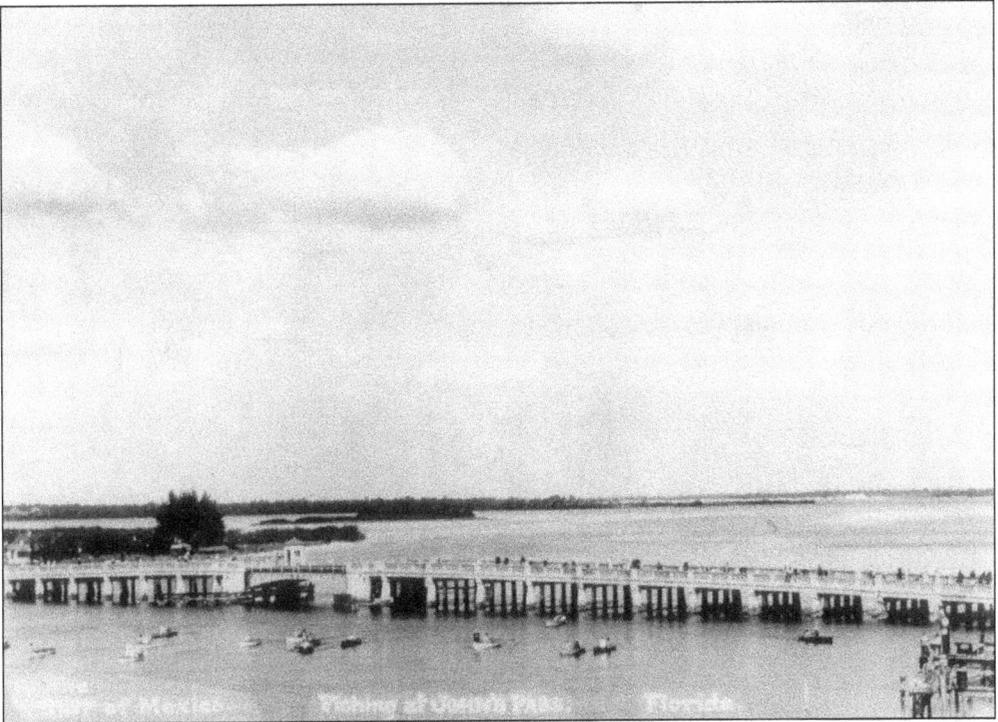

Boats surround the Johns Pass Bridge in the mid-1930s. Turtle Crawl Point, now part of War Veterans' Memorial Park, appears directly behind the bridge. Bay Pines occupies the left portion of the peninsula behind the bridge. The Little House Restaurant opened on the north side of the pass in 1937, offering most sandwiches for 15¢ or less and a double tenderloin steak for 75¢. (HV.)

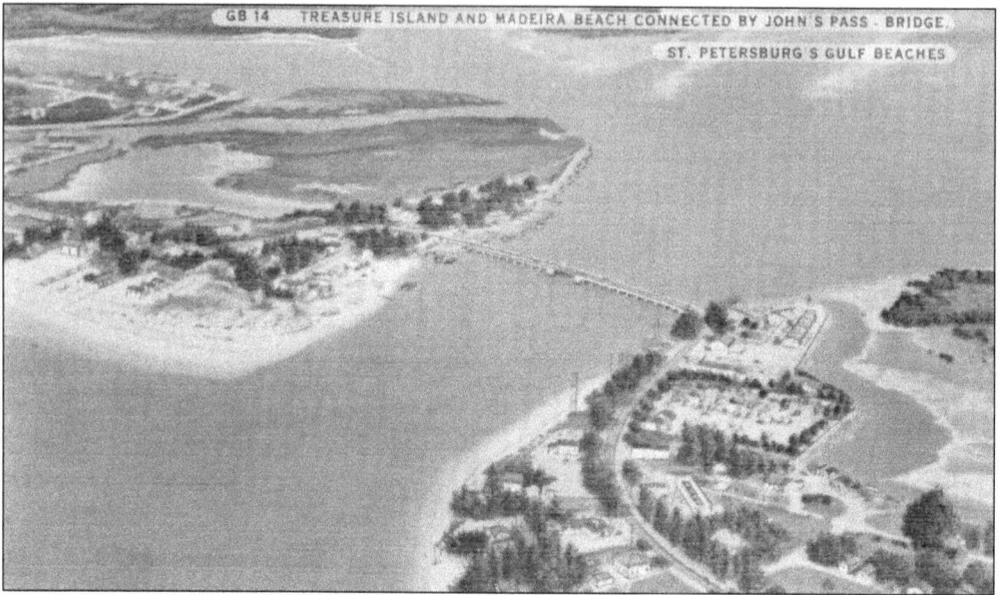

Izzy Schuster moved to the north end of Johns Pass in 1934. With few buildings nearby aside from a barnlike structure for the lonely bridge-tender and a fishing camp, Schuster opened a lunch counter, store, and gas station in Virgil Almand's former real estate office. Schuster later expanded his holdings, establishing the first post office between Pass-a-Grille and Indian Rocks Beach in January 1947. (HV.)

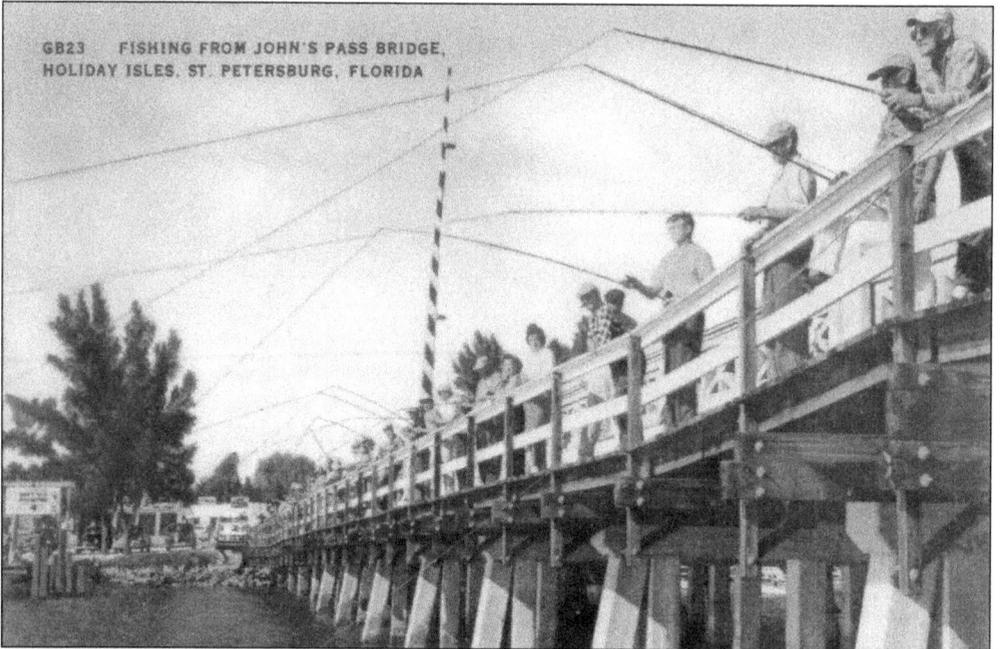

In the years following World War II, views such as this of the Johns Pass Bridge facing Madeira Beach became an effective way of promoting recreational opportunities along the Holiday Isles. As Florida's population soared, postcards frequently referred to Johns Pass and Madeira Beach as if they fell within the municipal limits of St. Petersburg, the Sunshine City, even though that was never the case. (HV.)

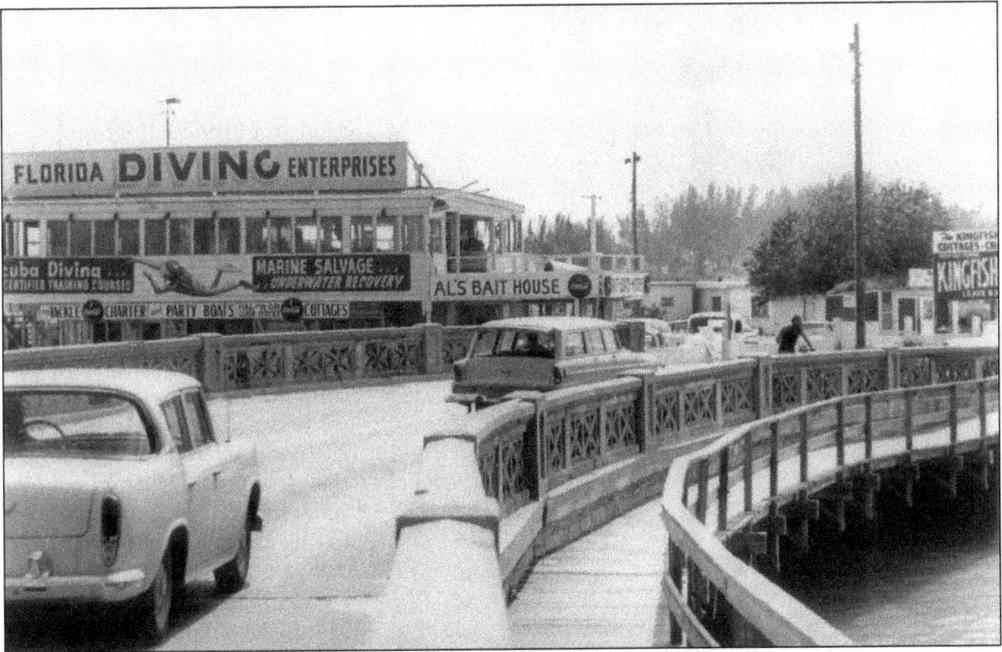

Cars making the curve onto the Treasure Island side of Johns Pass in the 1950s and 1960s found a variety of businesses, including bait shops, curio shops, and restaurants. Charter boat excursions ran from both sides of the pass, cottages sprouted along the bayside of northern Treasure Island, and larger hotels occupied the sandy beaches farther south along Gulf Boulevard. (HV.)

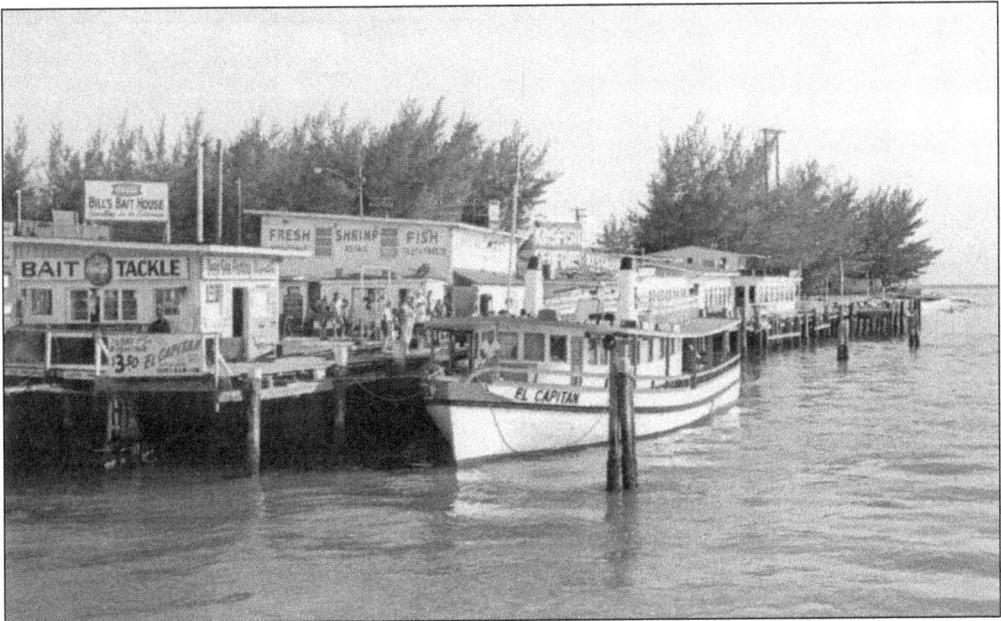

Bill's Bait House and the Kingfish Restaurant sat dockside on the Treasure Island side, seen here along the western catwalks of the original bridge. The large pine trees and the telephone pole in the background occupy the footprint of the approach to the current Johns Pass Bridge. Many of the tall pines along the barrier islands perished in the freezes of the early 1960s; few remain today. (HV.)

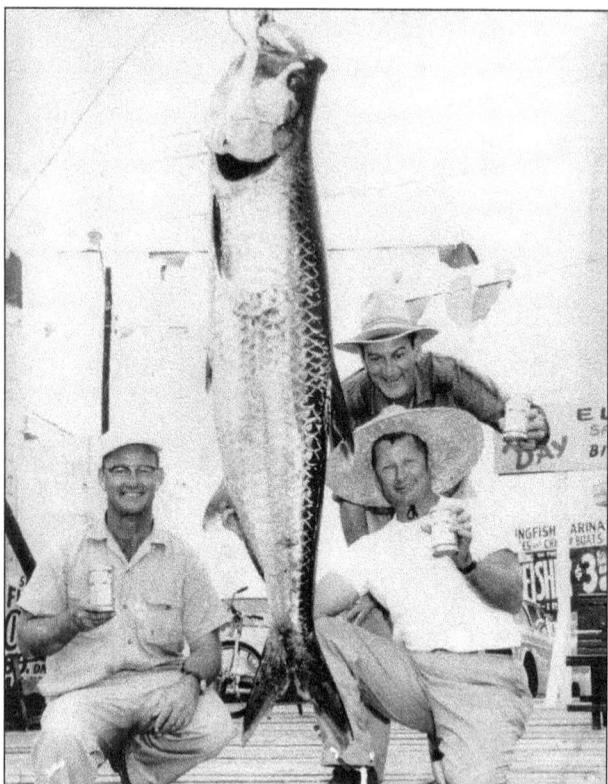

Members of the Redington family stayed in the area after the communities they developed north of Madeira Beach took shape. At left, Jack Redington (left) and Charles Redington Jr. (lower right) are joined by a friend as they celebrate a tarpon catch at Bill's Bait House on the Treasure Island side of the pass. Below, Jack Redington poses in front of a 122-pound catch at Bill's, with the original bridge in the background. Redington Beach, the section of Long Key north of 155th Avenue, was incorporated by vote of its residents in November 1944, two and a half years before Madeira became a town. North Redington Beach incorporated in 1953, followed by neighboring Redington Shores in 1955. (Both, Redington collection, HV.)

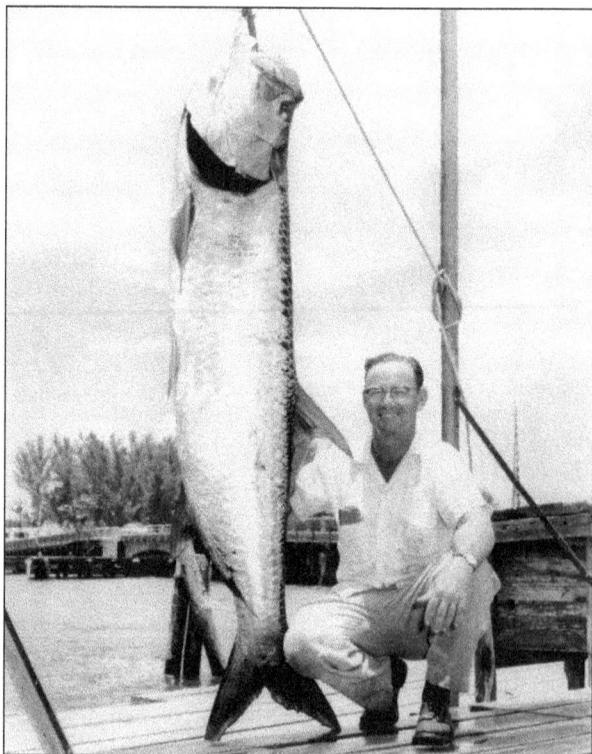

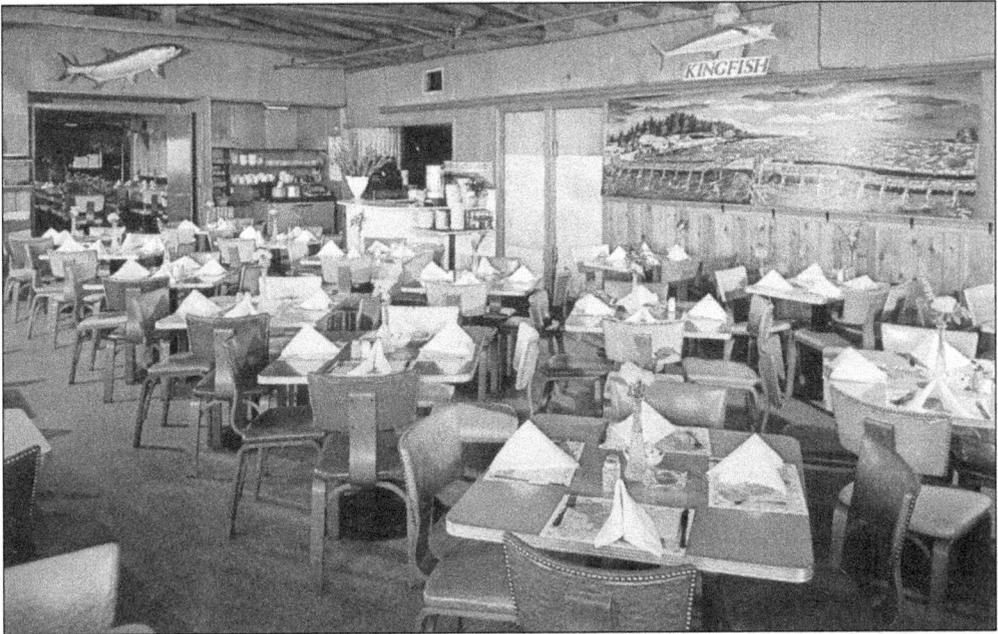

Charlie and Agnes Rice established landmark businesses along Johns Pass. A native of Poland who was raised in Oklahoma, Charles came to the area to catch kingfish. As a child, Agnes had watched her family operate a fish camp at Rocky Point in Tampa before the construction of the Courtney Campbell Causeway. In the mid-1940s, they opened the Kingfish Restaurant along the waterfront on the Treasure Island side. The Kingfish dining room is seen above in the 1960s, with the painting of the bridge on the wall. The Rices became involved in other enterprises as well, including the Johns Pass Seafood Company. The Kingfish moved and closed a couple of times, and members of the Rice family later opened Gators at this site, as seen below in 2013. (Above, Daun Fletcher; below, author.)

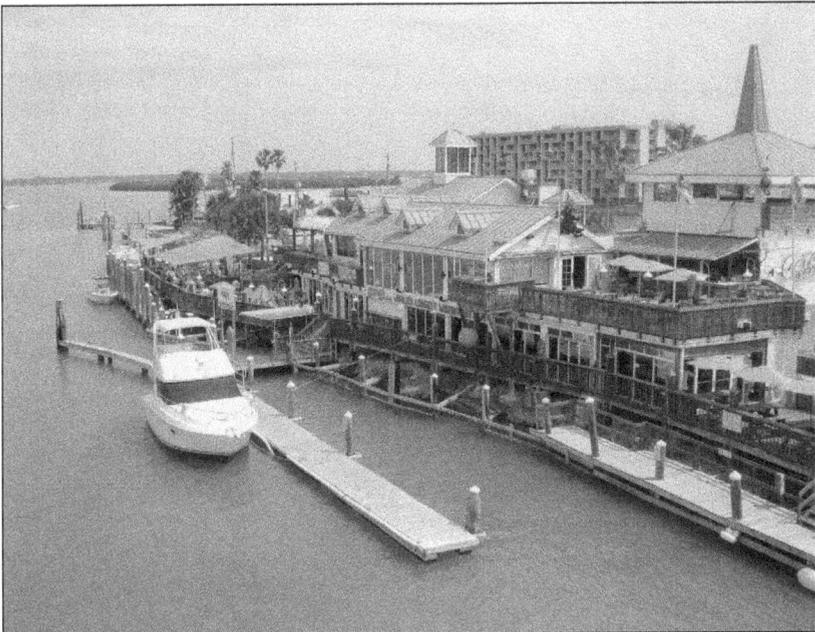

Above, a family prepares for a cruise from the Treasure Island docks along Johns Pass in August 1957. As they walked along the boardwalk at the time, they would have noticed that commercial boats still moored along the waterfront even as the number of restaurants and shops geared towards tourists grew in number. By the 1950s, many fishing boats docked along other areas north of Johns Pass within Boca Ciega Bay. The commercial fleet remained an important part of the economic livelihood of Johns Pass well into the 1970s; however, escalating property values, net bans, and other regulations reduced the fleet as the 20th century came to and end. (Both, HV.)

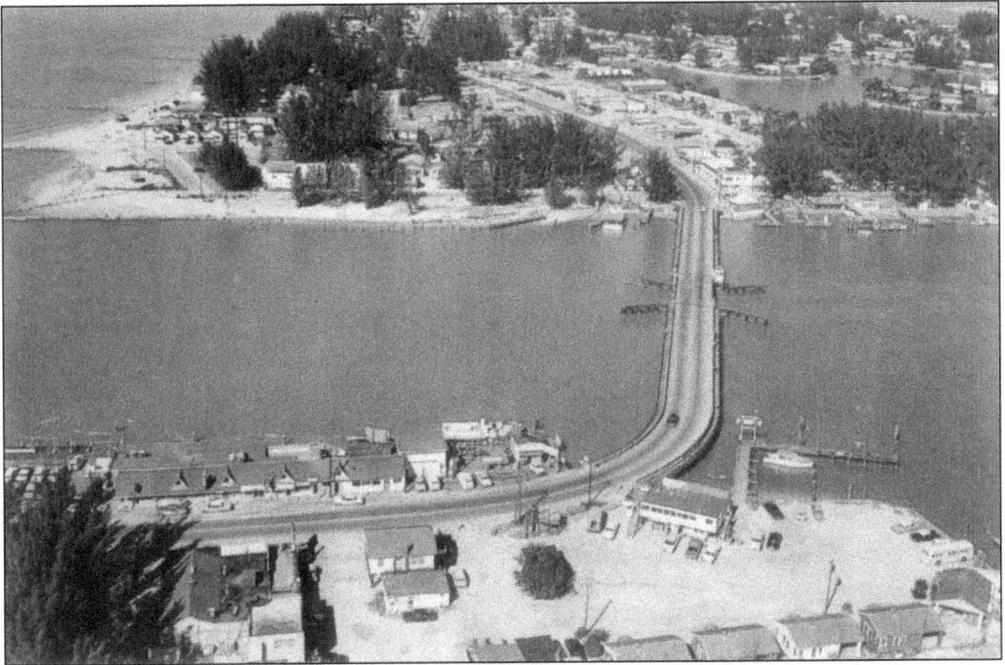

The aerial view above offers a great view of the landscape along both sides of Johns Pass in the late 1950s. While the Kingfish and other Treasure Island enterprises sat along the docks, most of the businesses on the Madeira Beach side occupied space farther away from the waterfront and continued northward along Gulf Boulevard towards 133rd Avenue. As the popularity of Johns Pass grew, the frequent opening and closing of the drawbridge—a necessity due to the strong currents between Boca Ciega Bay and the Gulf—led to long lines of traffic on both sides of the bridge. Although the postcard below paints a tranquil image of leisure on Johns Pass, traffic jams became commonplace by the 1960s. (Both, HV.)

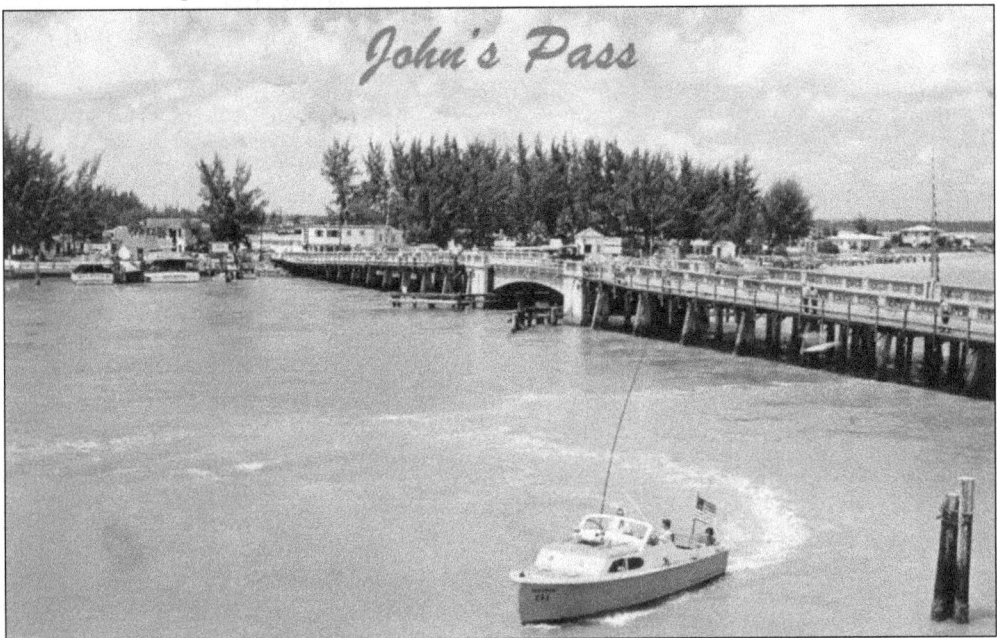

John's Pass

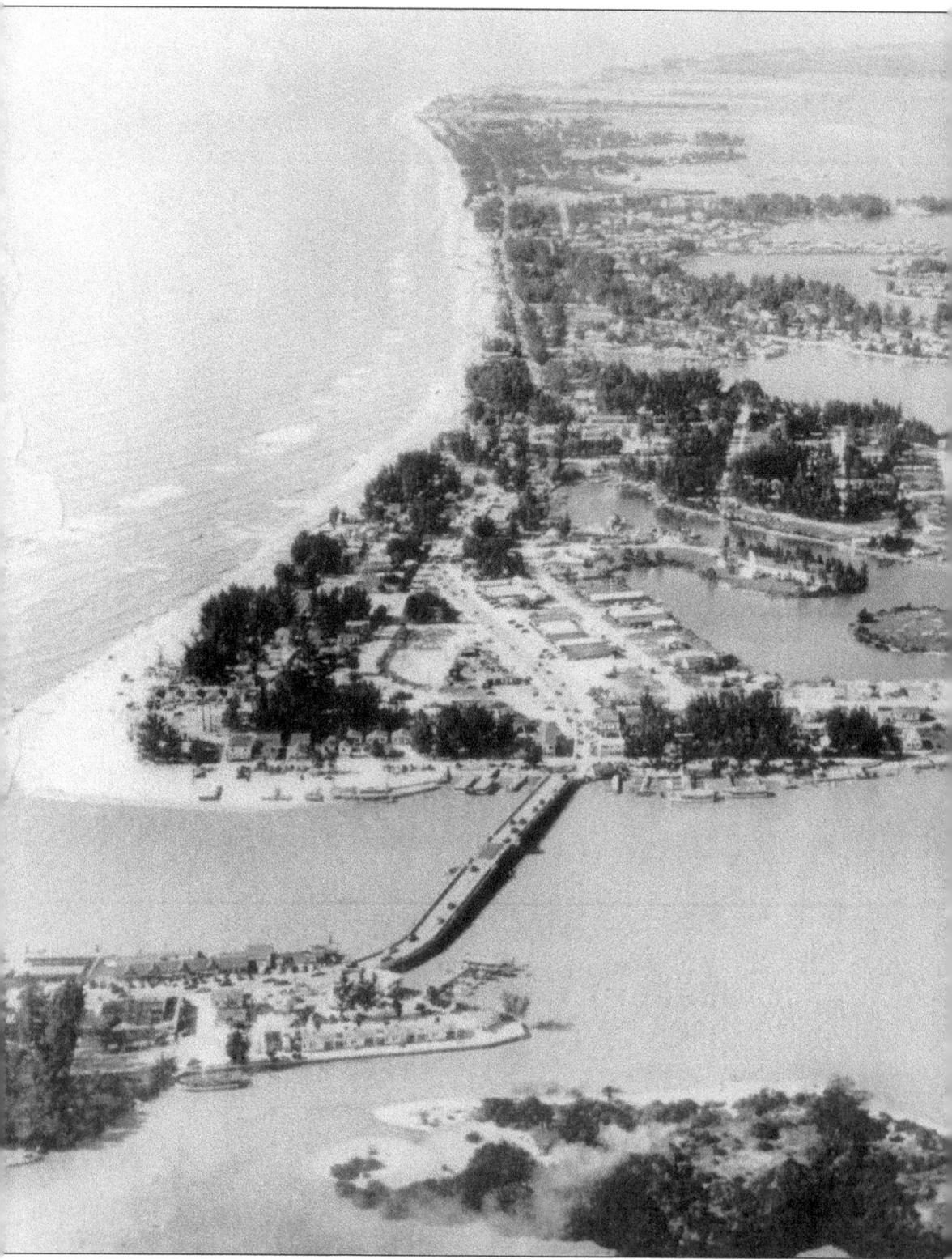

This aerial view from the mid-1950s illustrates the growth along Johns Pass, as well as some of the subdivisions dredged out of Boca Ciega Bay on either side of the pass. The large island in the center right would soon become the Crystal Island subdivision of Madeira Beach, a series of finger islands that includes Crystal Drive, Flamingo Drive, Lillian Drive, and Johns Pass Avenue. Just beyond Crystal Island, the recently dredged area of Bay Point Drive stretches out from Pruitt Drive. On the mainland in the distance, the site of the present-day campus of Madeira Fundamental School is still under water, while the Madeira Shopping Center has just taken shape. The island at the bottom of the image would soon become part of the Isle of Capri development in Treasure Island. (HV.)

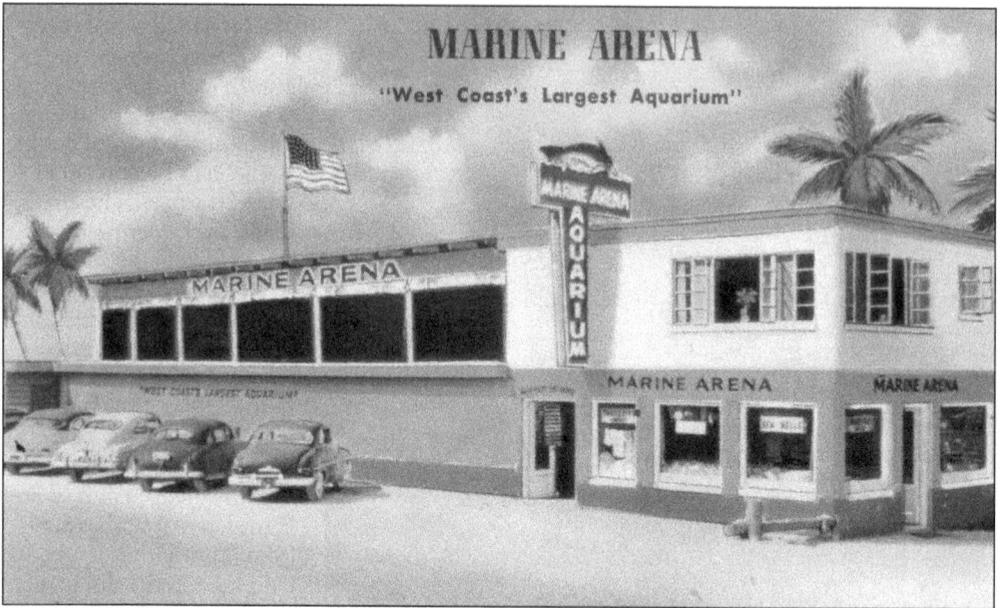

Jack Hurlbut opened his small Marine Arena (above) on the Madeira side of Johns Pass in 1953, with a large aquarium for porpoise shows and smaller aquariums for viewing. Paddy the Porpoise brought in the crowds. Originally caught by Capt. Wilson Hubbard near Tierra Verde, Paddy first performed at Hubbard's Shell Island Sea Ranch before coming to the aquarium at Johns Pass. The attraction closed in 1965 shortly after the larger Aquatarium opened a few miles to the south in St. Pete Beach. The Johns Pass Aquarium (below), as Marine Arena was also known, did reopen for a short period after the Aquatarium closed in the late 1970s. (Both, HV.)

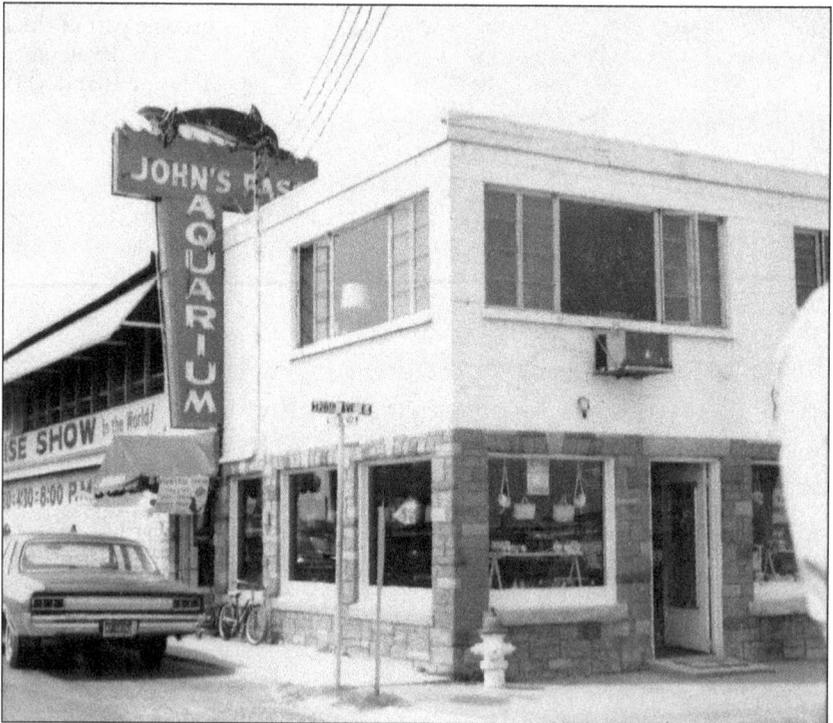

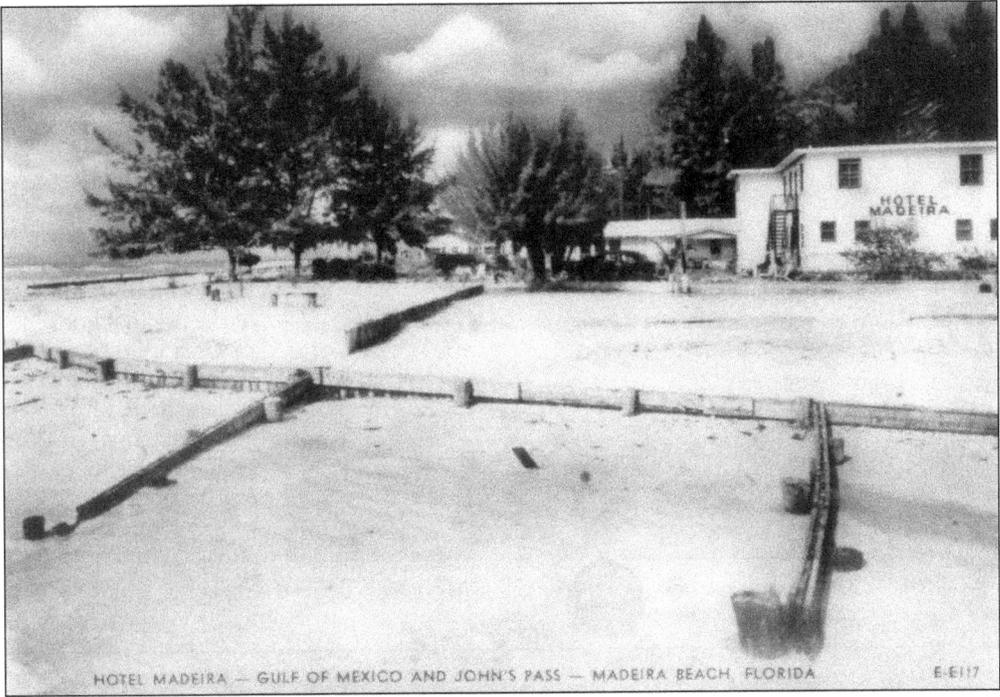

HOTEL MADEIRA — GULF OF MEXICO AND JOHN'S PASS — MADEIRA BEACH, FLORIDA E-E117

Between the 1950s and the 1970s, developers acquired and later demolished most of the small cottages and other quaint accommodations along the beaches near Johns Pass. Businesses such as the Hotel Madeira (above) that thrived during the postwar years faced new pressures by the early 1970s. The year 1971 served as an important benchmark, as the April dedication of the new airside and landside terminals at Tampa International Airport allowed for the expansion of tourism. Later that year, the October 1 opening of Walt Disney World in the Orlando area forever redefined the nature of vacations in Florida. Closer to home, the twin spans of the new Johns Pass Bridge, located closer to the mouth of the pass along the Gulf of Mexico, allowed for improved traffic flow. Before the end of the 1970s, new condominiums like the ones below appeared. (Both, HV.)

The opening of the 1971 twin-span across Johns Pass allowed businesses on the Madeira Beach side to expand the boardwalk across the former roadway. The former section of Gulf Boulevard from the site of the original bridge towards 130th Avenue, seen here, became Village Boulevard, and merchants promoted the shops and attractions as part of Johns Pass Village. (Author.)

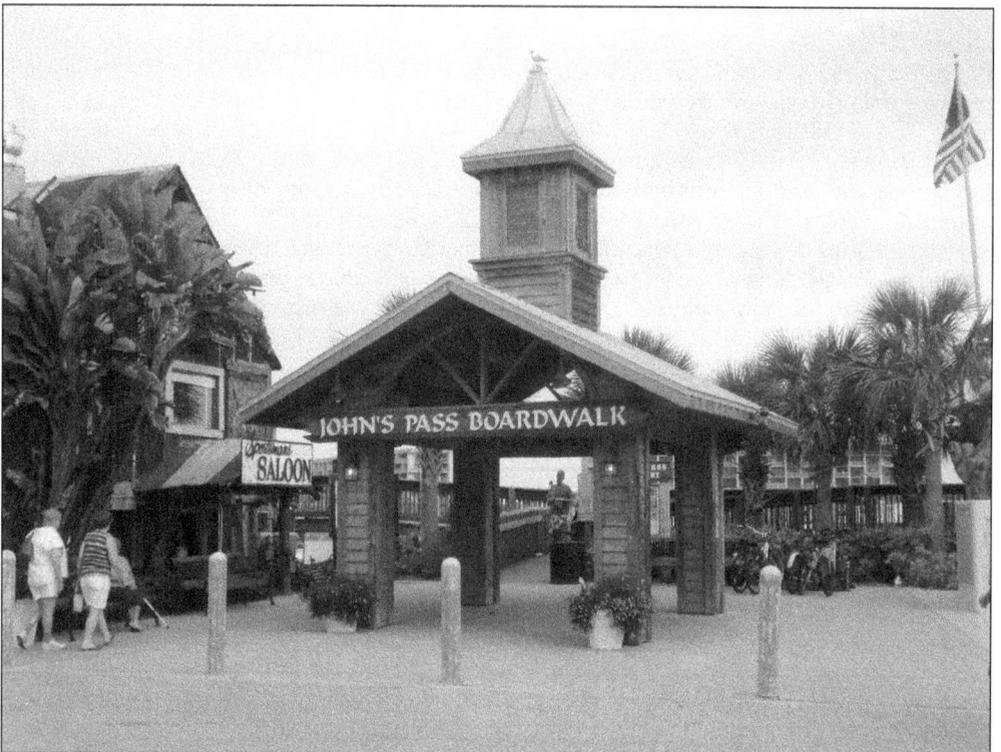

This March 2013 view of the former bridge approach shows the substantial transformation of the old roadway into a successful commercial enterprise. For more than three decades, crowds have enjoyed the annual Johns Pass Seafood Festival, which takes place each October at the Johns Pass Village and boardwalk area. To accommodate the large amount of attendees, the city and merchants operate shuttles from other areas of Madeira Beach. (Author.)

This transformation has taken place in waves. In the 1980s, many of the former cottages across from the boardwalk along 128th Avenue were remodeled or removed. Escalating property values also forced some longtime property owners to sell their smaller dwellings to developers. The structures seen here sat along the 200 block of 128th Avenue in April 1986. (Lyn Friedt collection, HV.)

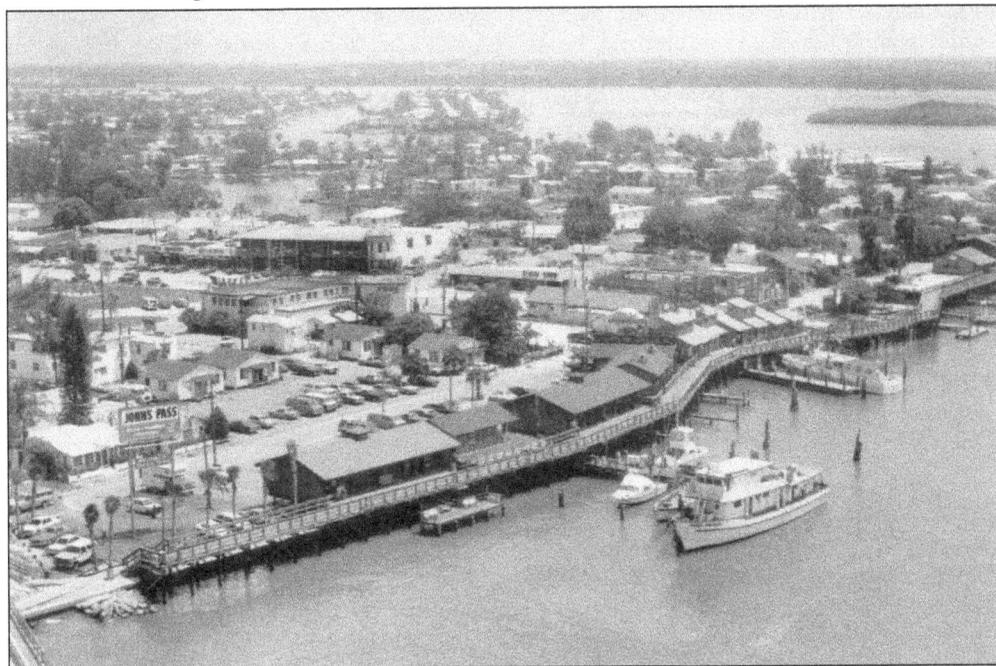

By the mid-1980s, the boardwalk spanned continuously along the southern tip of Madeira Beach, from the footprint of the 1971 Johns Pass Bridge to the point where 128th Avenue curves into East End Lane. Recreational boats replaced most of the fishing fleet during this decade, and new shops and restaurants opened. (HV.)

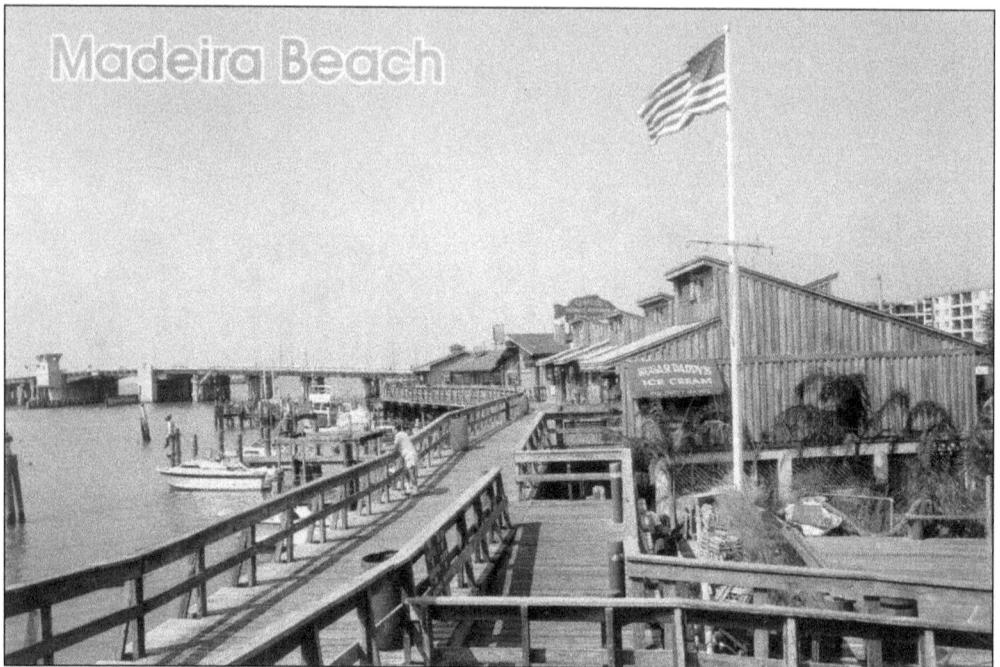

Madeira Beach

A variety of nautically themed shops sat along the boardwalk in the 1980s, as seen above from the spot where the original bridge once crossed the pass, looking southwest towards the 1971 bridge. Although the four lanes on the 1971 bridge eased traffic jams within Johns Pass Village, strong tides scoured sand under the bridge. State transportation officials noted severe scour and sand depletion just five years after the bridge opened. Occasionally, maintenance divers even discovered that the pilings on the bridge were fully exposed, such as in 1984 when three pilings set more than 20 feet into the limestone bed under the sand became exposed. Remediation kept the bridge in place for approximately 40 years before it was replaced by the current structure. The boardwalk is seen from a similar view in March 2013. (Above, HV; below, author.)

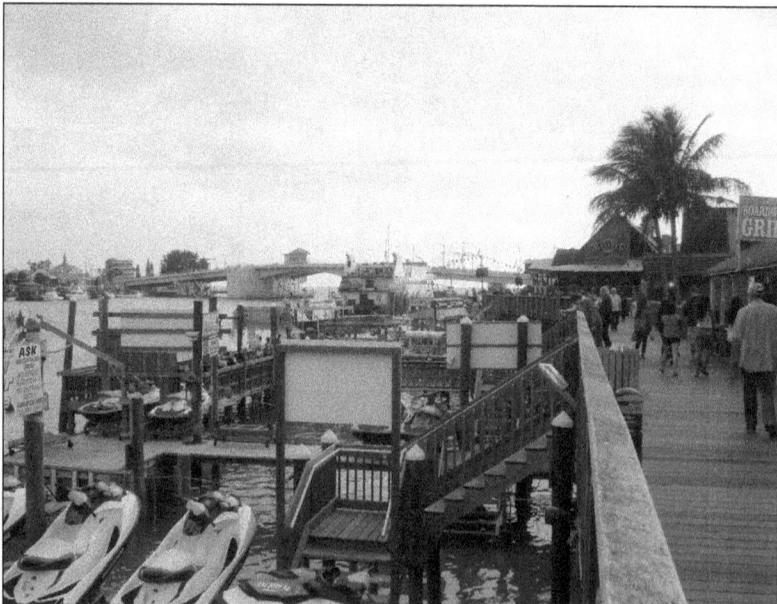

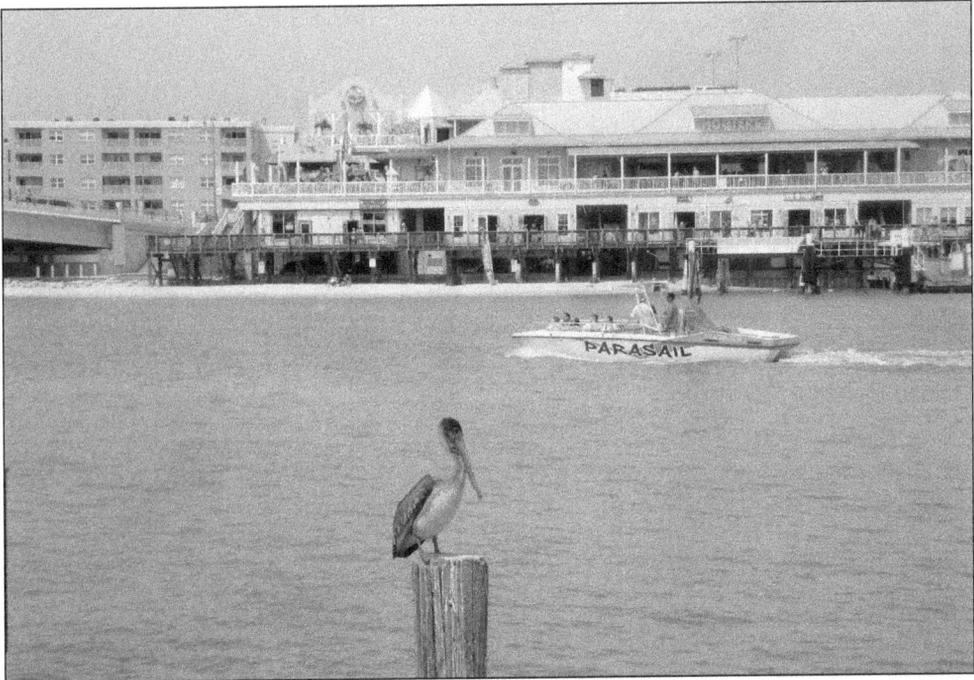

New construction in the early 2000s brought additional stores and a covered parking garage to the Madeira Beach side, as new businesses occupy multistory structures that include patios with excellent views of Johns Pass. Boating and recreational opportunities abound as Johns Pass begins its second century as a highly touted destination. (Author.)

The former stretch of Gulf Boulevard along the Treasure Island side, now known as Johns Pass Drive or Kingfish Drive, has fewer businesses than it did in its heyday in the 1950s and 1960s. Plans to redevelop some of the property with new enterprises and perhaps a hotel have started to move forward though. (Author.)

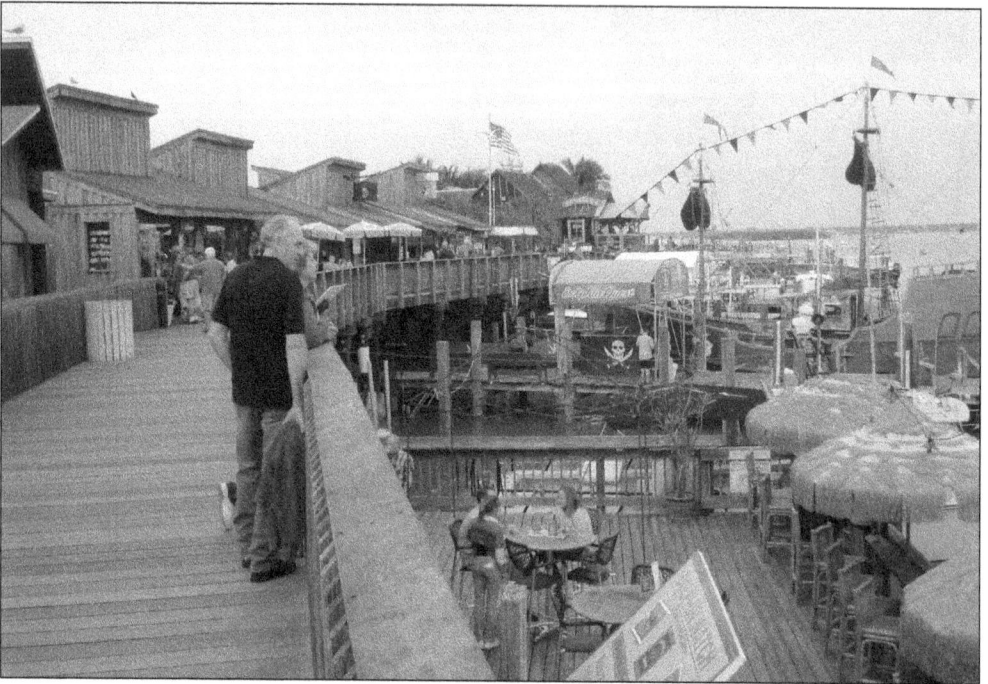

Charter boats, personal watercraft, "cruises to nowhere," and dockside dining can all be found along the boardwalk at Johns Pass. Just 75 years ago, a small restaurant and little else greeted those who drove along the poorly paved and narrow roads to reach Johns Pass. Since then, each succeeding generation has enjoyed a new array of amenities. (Author.)

This view looks northwestward from the mouth of Johns Pass towards Redington Beach, revealing miles of appealing beaches. Although the structures along the beach have changed dramatically since the end of World War II, the shoreline remains a popular destination throughout the year. Tourism officials continue to tout Madeira Beach and other neighboring beach communities in promotional literature. (Author.)

Three

BUILDING A TOWN AND A SENSE OF COMMUNITY

1946–1960

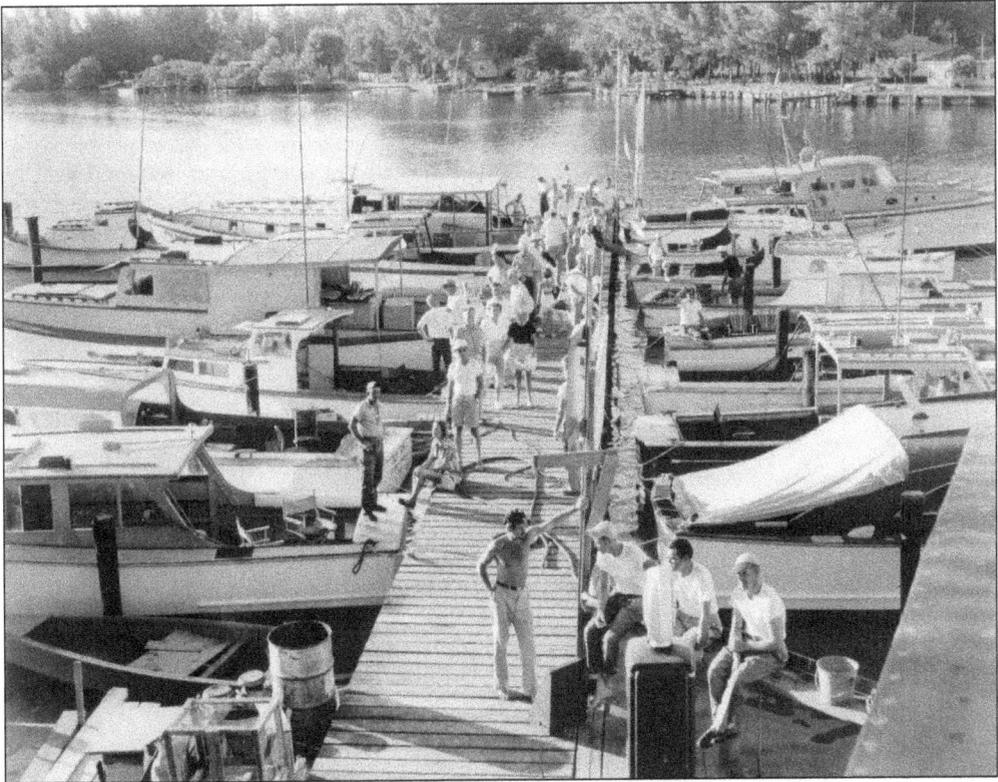

Boaters gather on the bayside docks near the Church by the Sea in 1953. Fishing enterprises thrived during the years after Madeira Beach incorporated. Jack Brawner, a regional director for the National Marine Fisheries Service of the National Oceanic and Atmospheric Administration (NOAA), attended meetings in Madeira Beach from 1956 to 1961 before moving to the city in 1963. On many days, after returning from work, he jumped in his boat and caught Spanish mackerel. (Redington collection, HV.)

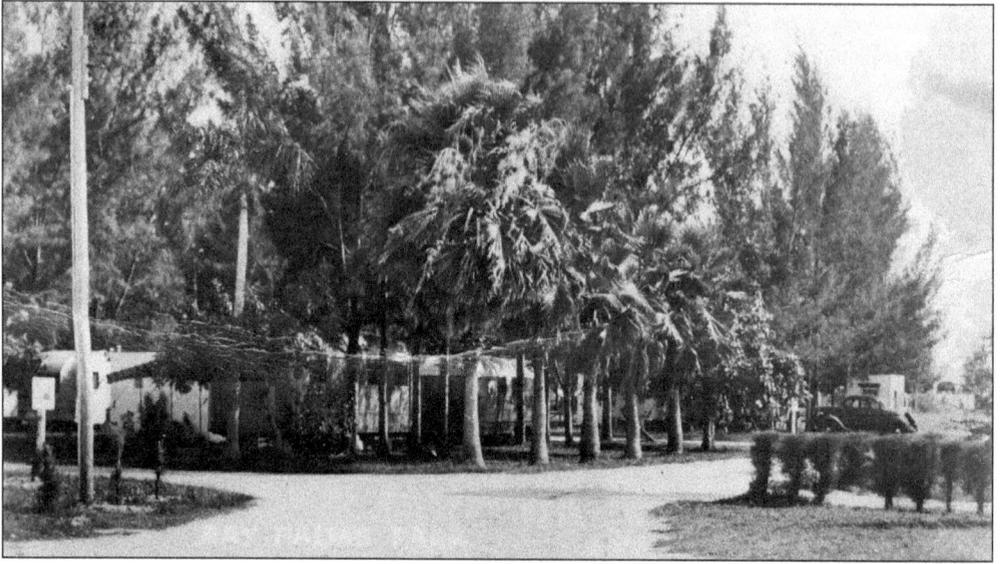

Bay Palms Trailer Park (above), once located along the south end of 150th Avenue, became the meeting place for those who wished to establish Madeira Beach as a municipality. In April 1947, a group of 37 residents and property owners between 140th and 155th Avenues gathered there to consider incorporation. Harold J. Regan was elected temporary chair. On May 5, 1947, a total of 69 of the 101 eligible voters living between 140th and 155th Avenues along Madeira visited the park's two-story recreation hall (below) and approved the measure. Only seven people voted against incorporation. With Regan the unanimous choice as mayor, the town council held its first meeting on May 14, 1947, at a real estate office at 141st Avenue and Gulf Boulevard. (Both, Sandy Holloway collection.)

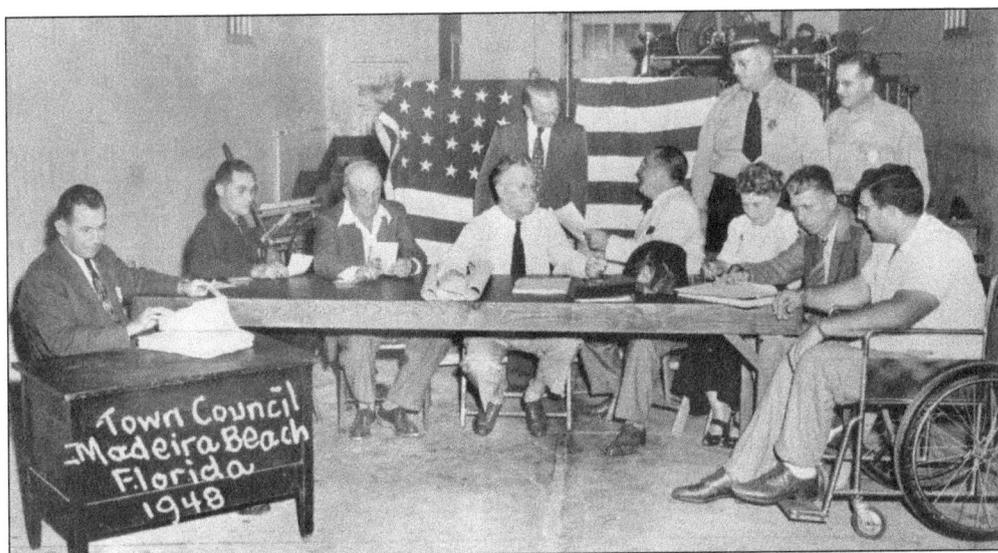

This 1948 town council meeting, led by Madeira Beach mayor Joseph W. Klingel, illustrates the simple settings of the time. Early councils debated a variety of rules, such as Ordinance No. 5, a measure passed in 1947 that regulated the burning of trash and refuse materials so that people could no longer start fires in the open except under supervision. The 1953 city charter added a city manager as an administrator. (HV.)

An important event took place in 1935, when the county announced plans to extend water utilities to the central Gulf Beaches. Before workers installed pipelines in the late 1930s, wells often suffered from saltwater intrusion, and people had to truck water from the mainland. The original system brought water from the Lake Walsingham Reservoir. A water tower rose above 150th Avenue near Madeira Way in the late 1940s. (HV.)

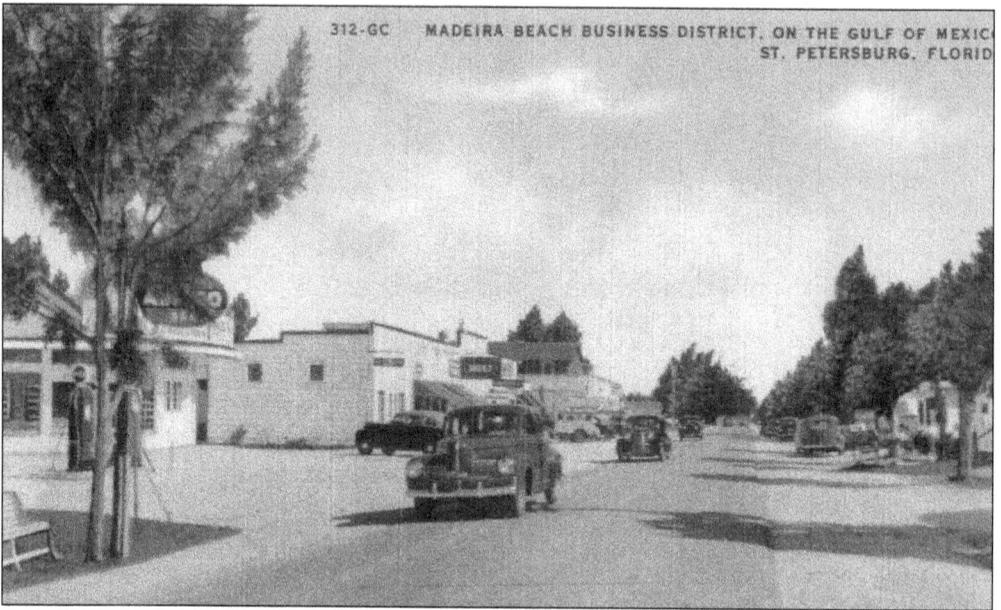

312-GC MADEIRA BEACH BUSINESS DISTRICT, ON THE GULF OF MEXICO
ST. PETERSBURG, FLORID

This 1940s-era postcard shows vehicles coming across Welch Causeway past businesses (left) and Bay Palms Trailer Park (right). Plans to build Madeira Way as a four-lane cutoff road between the causeway and Gulf Boulevard took shape in January 1949. Rex Cole, a local realtor, planned to develop commercial establishments along Madeira Way, a road that began at the bench and tree in the left corner. (HV.)

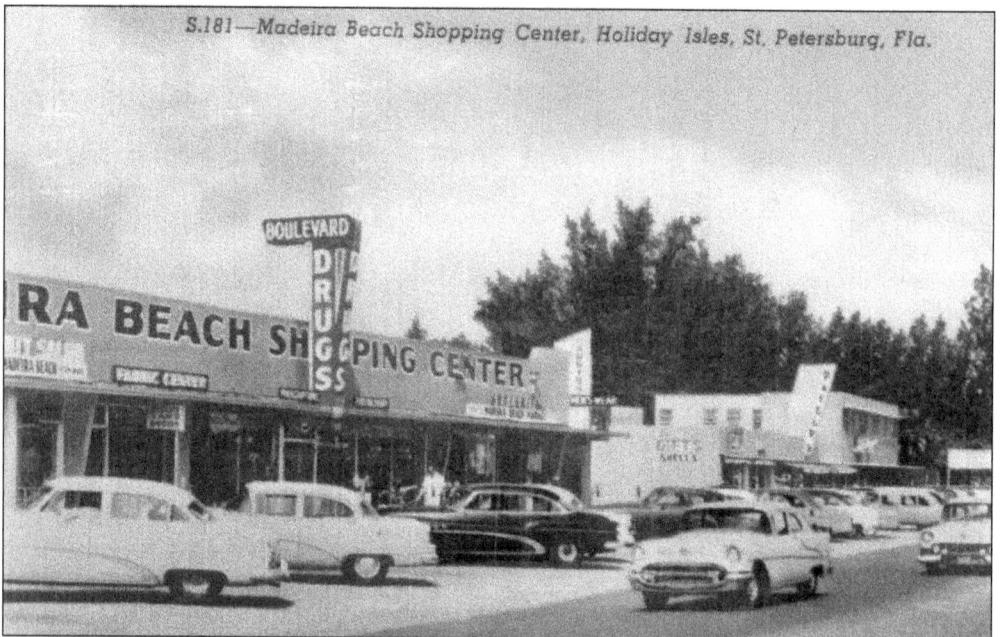

S.181—Madeira Beach Shopping Center, Holiday Isles, St. Petersburg, Fla.

In September 1945, Ralph Dewberry and other investors acquired a 99-year lease on Albert Archibald's 1926 Madeira Beach Casino, located on the beach side of Gulf Boulevard from north of 150th Avenue to the present site of Archibald Park. After remodeling part of the former casino, the structure reopened as the Madeira Beach Shopping Center. This view looks north towards the stores, with the veterans' beach in the background. (HV.)

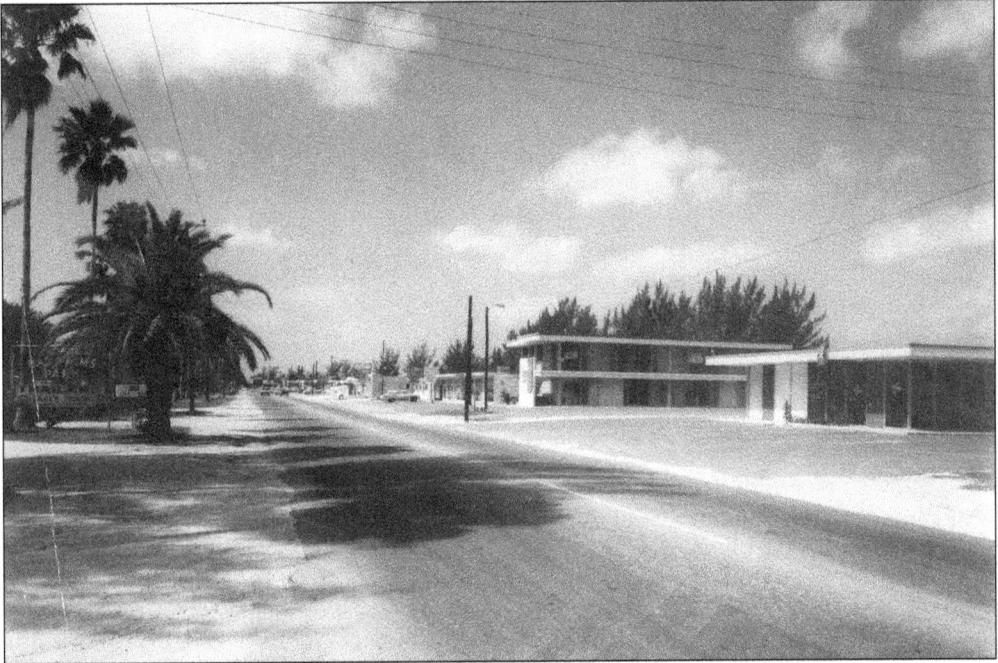

The c. 1960 view above looks towards the Madeira Beach business district and shows 150th Avenue when it existed as a narrow, two-lane roadway. The entrance to Bay Palms Trailer Park sat on the southwest (left) side of the causeway. Service stations, the Al Williams Real Estate office, the Ali Baba Supper Club, the "410" Professional Building, and a stand-alone building that became the home of Peninsula Cablevision in the 1970s were on the right side of the road. Below is the 2013 view from the same spot, with the 410 on the right. (Above, GBPL; below, author.)

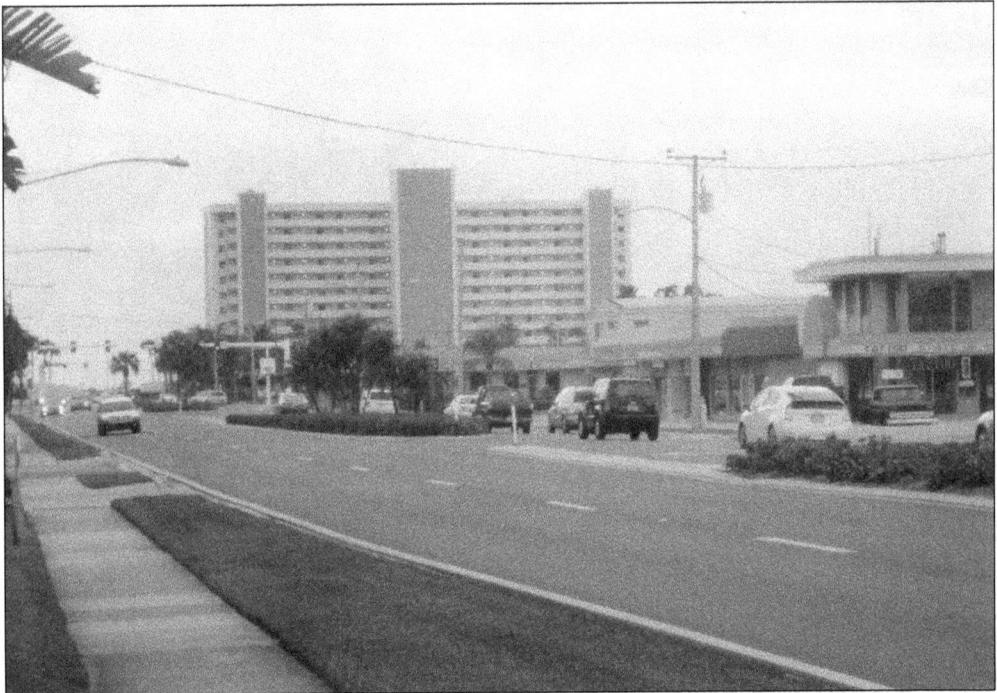

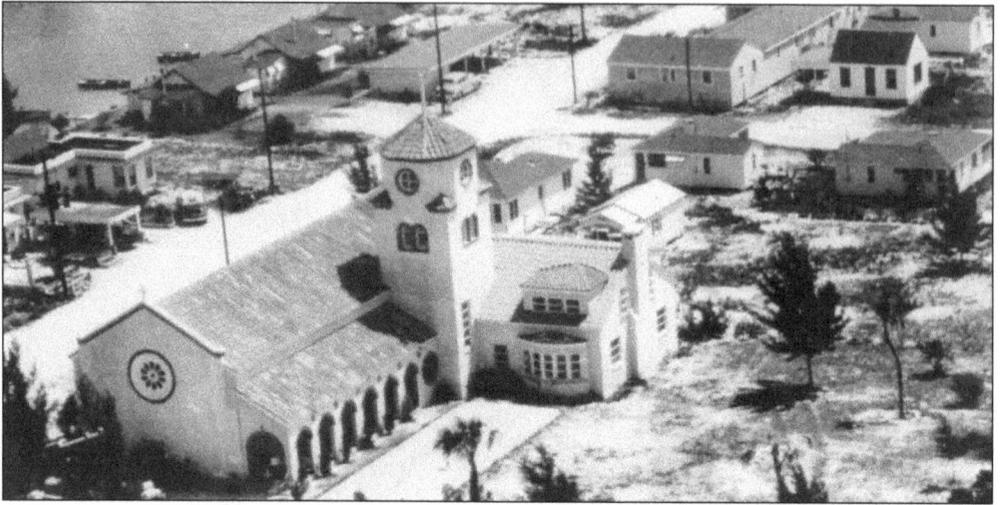

The Church by the Sea has served the community for seven decades. Rev. Philip Ralph, a retired minister, held early services in 1944 in the Fishermen's Union Hall, south of Johns Pass; fundraising efforts ensued. Soon, land was acquired in the heart of the 137th Avenue Circle. Officially organized in June 1944, the church started to take shape when construction began in July 1945. A labor of faith and love, parts of the sanctuary remained under construction even as services took place. The 1948 aerial view above looks south at the church before a paved parking lot existed. For many years, the Church by the Sea's profile served as a beacon for fishing fleets, with a light atop a mast that remained on until the last boats returned home. The lighted cross below later replaced the mast. (Above, Bob Griffin collection; below, GBPL.)

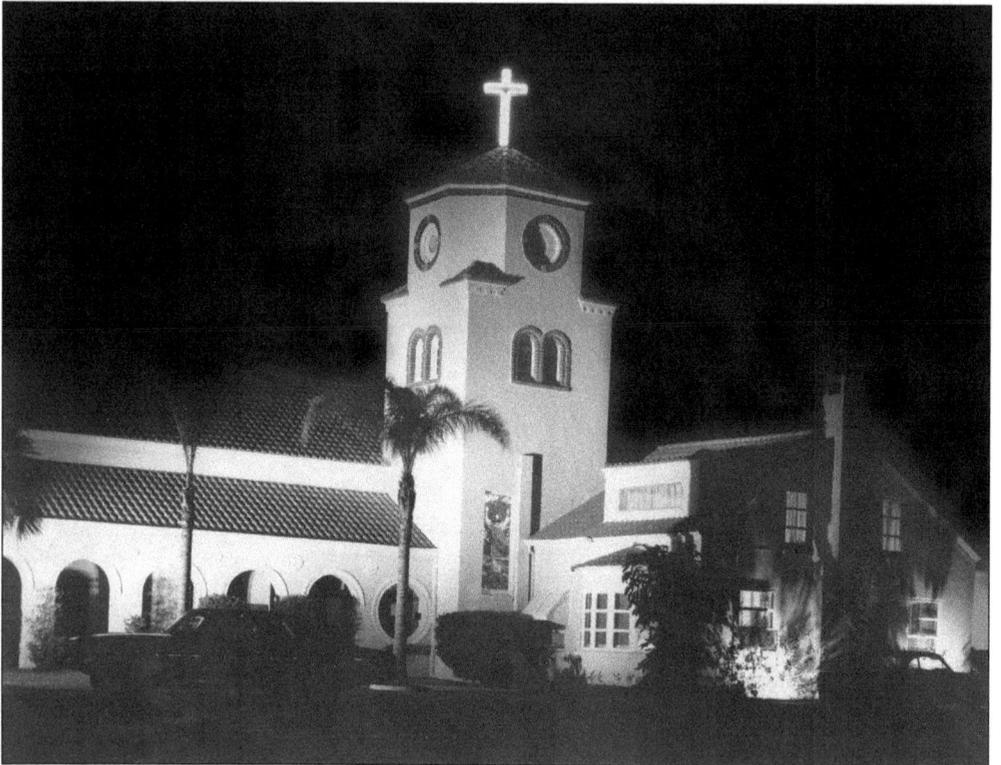

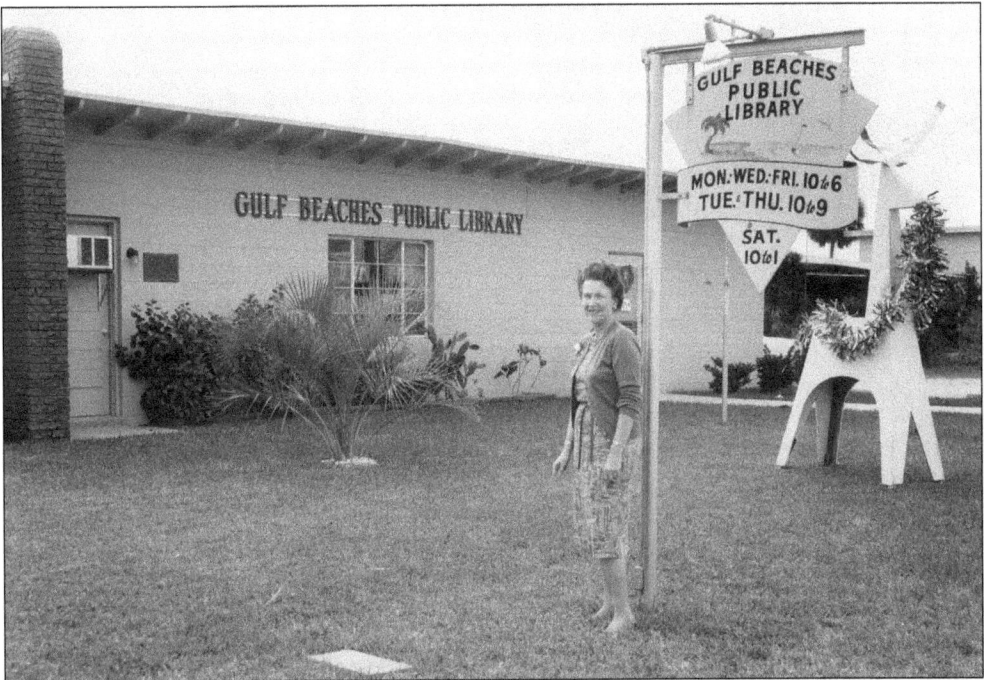

Polly Van Dyke and other members of the Gulf Beach Woman's Club talked about the need for a library along the central beaches at their September 1949 meeting. Soon, six women from the organization, led by Edyth Mariani, began to collect books. The original library for their collections opened in 1952 in the one-room building, seen above, on 140th Avenue. The club remained involved in the library during the 1950s and 1960s, sponsoring a variety of activities for youth and young adults. Mariani, seen above in front of the library and below (third from left) with others in the library in the 1960s, served as head librarian until December 31, 1979. By that time, the library had moved to its home along Municipal Drive. (Both, GBPL.)

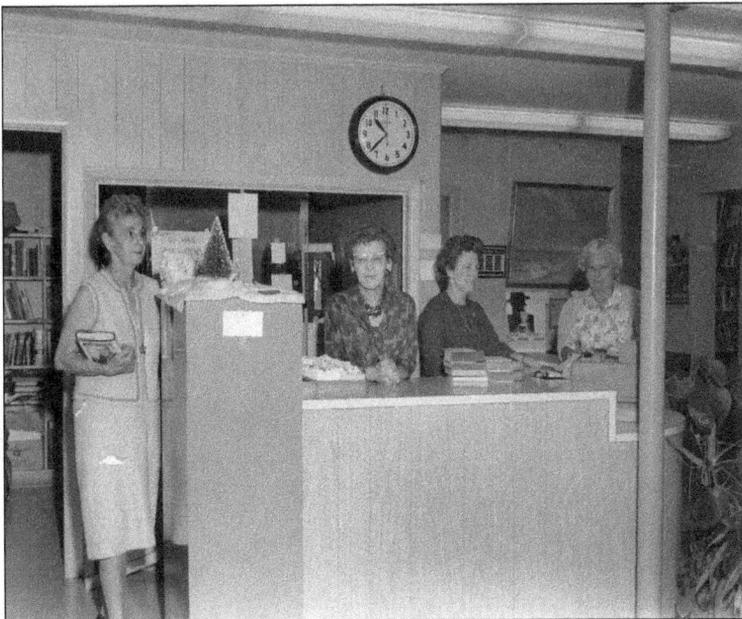

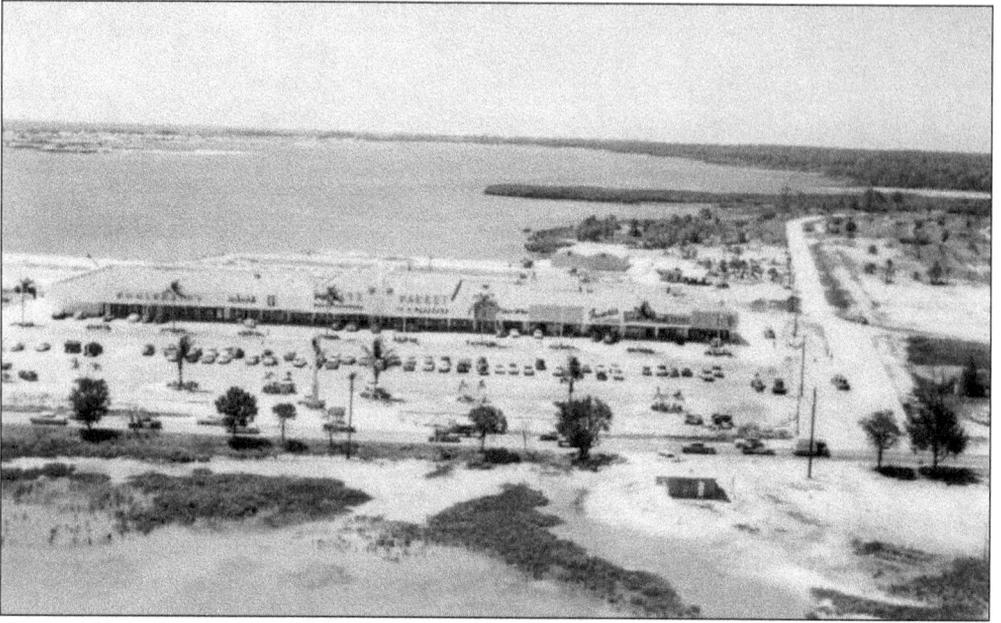

The Madeira Shopping Center officially opened in August 1957 on the mainland side of the Welch Causeway. With a Publix anchoring the plaza, the 85,000-square-foot complex originally had 11 stores, all of them air-conditioned. Older shopping establishments often did not invest in retrofitting their venues with air-conditioning at that time due to the cost, making for a sweltering shopping experience during the warm summer months. The aerial view above shows the original shopping center on August 14, 1957, shortly before the dedication ceremony. Duhme Road curves into the distance on the right side of the photograph, while the future location of Madeira Beach Junior High School (lower left and center) was still under water at the time. The shopping center is seen below in the early 1960s. (Above, Graber collection, USF; below, GBPL.)

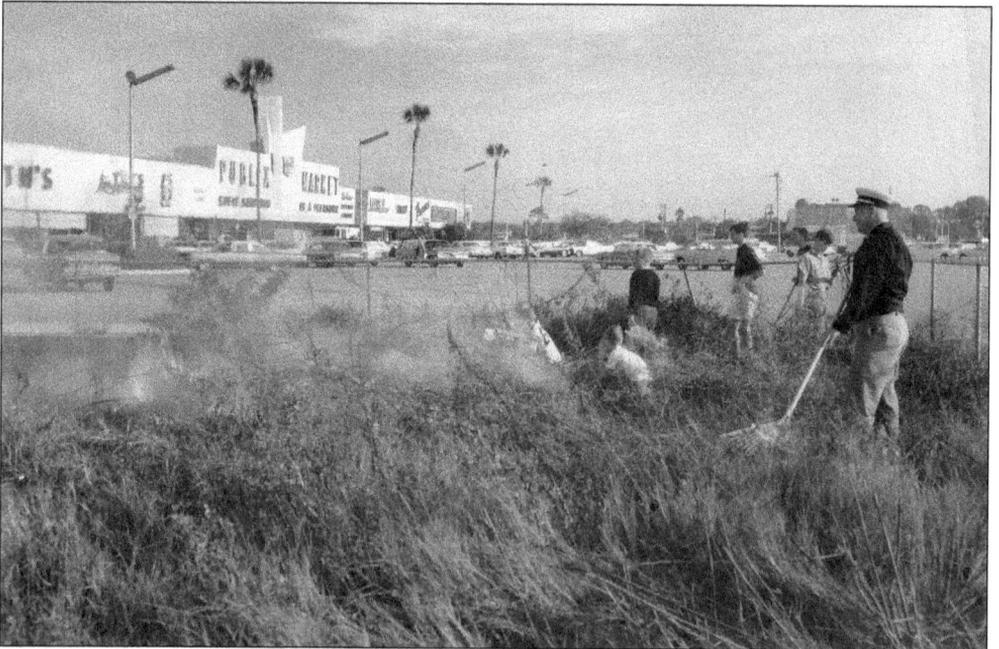

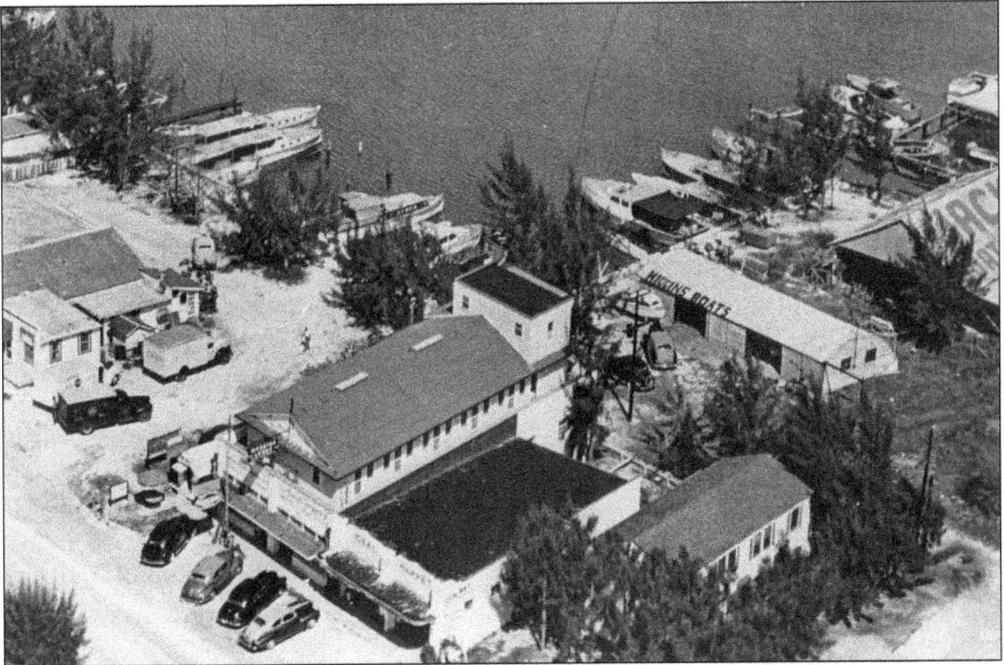

The Ideal Market opened in 1946 at 13105 Gulf Boulevard. S. Quintanilla and Manuel Lorenzo, the proprietors, featured imported goods in their store. In April 1951, four months before the merger between Madeira Beach and South Madeira Beach, the Ideal Market and the adjacent Madeira Lodge briefly doubled as the town hall facilities for the municipality of South Madeira Beach. Later, the lodge, by then a one-story structure, became the Mad Beach Surf Shop. (HV.)

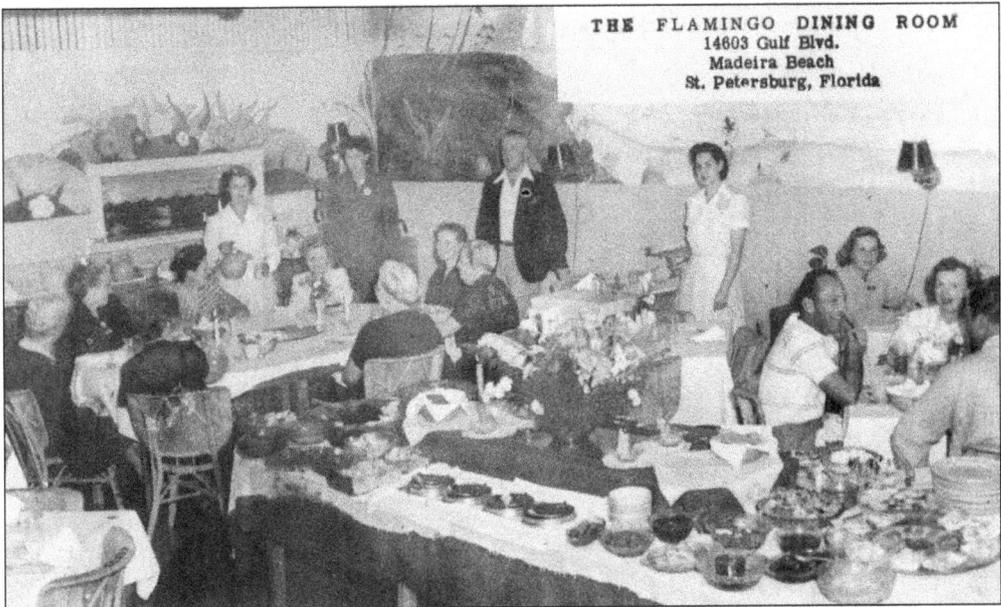

THE FLAMINGO DINING ROOM
14603 Gulf Blvd.
Madeira Beach
St. Petersburg, Florida

The Flamingo Dining Room offered smorgasbord meals with a Scandinavian flair, usually featuring 50 or more menu items. Located at 14603 Gulf Boulevard, the restaurant operated in a building constructed in 1948 as part of the initial land boom after Madeira Beach incorporated. The restaurant later became the Old Denmark. (Sandy Holloway collection.)

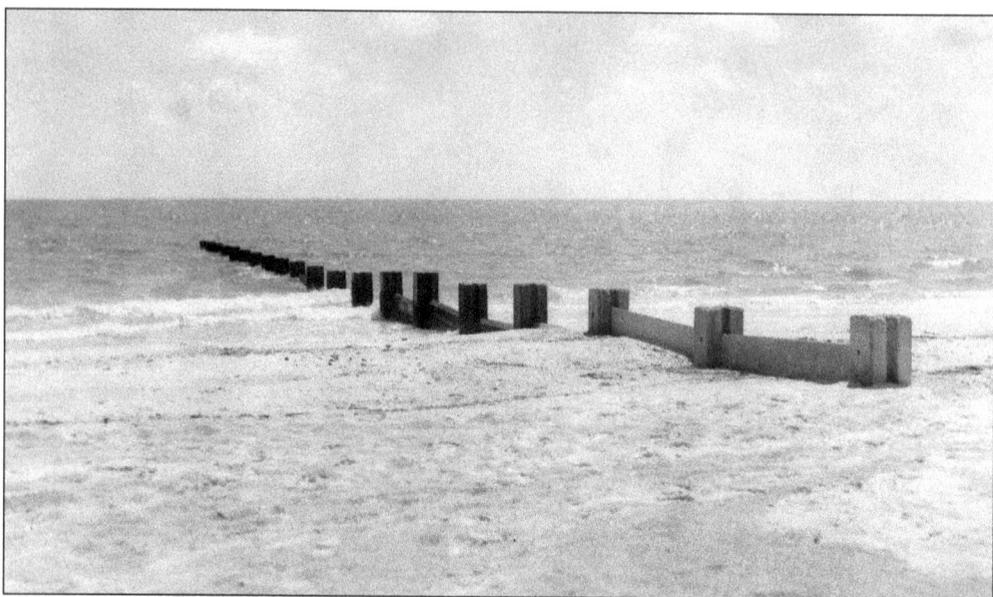

Erosion-control efforts along Madeira Beach began in the 1930s before the municipality existed. Early wooden and concrete groins placed along the sand helped somewhat, but they had a short lifespan. Property owners supported a $300,000 bond measure in January 1956 to construct a series of 37 groins, each 200 feet long, along Madeira Beach from the city limits with Redington Beach towards Johns Pass. Dubbed Operation Comeback, this project sought to curb the southward movement of sands from Madeira into the longer beach at Treasure Island. Workers began installing the groins in the fall of 1956. The image above shows a groin near Archibald Park in 1958. Below, city workers inspect a different groin in the early 1960s. These groins continue to shore up the shoreline today, nearly a half-century later. (Both, GBPL.)

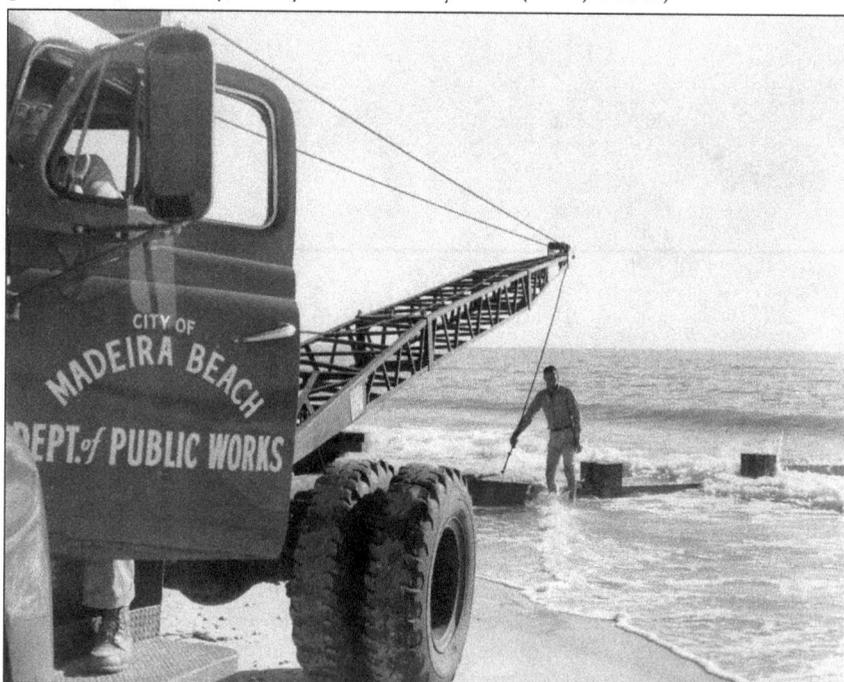

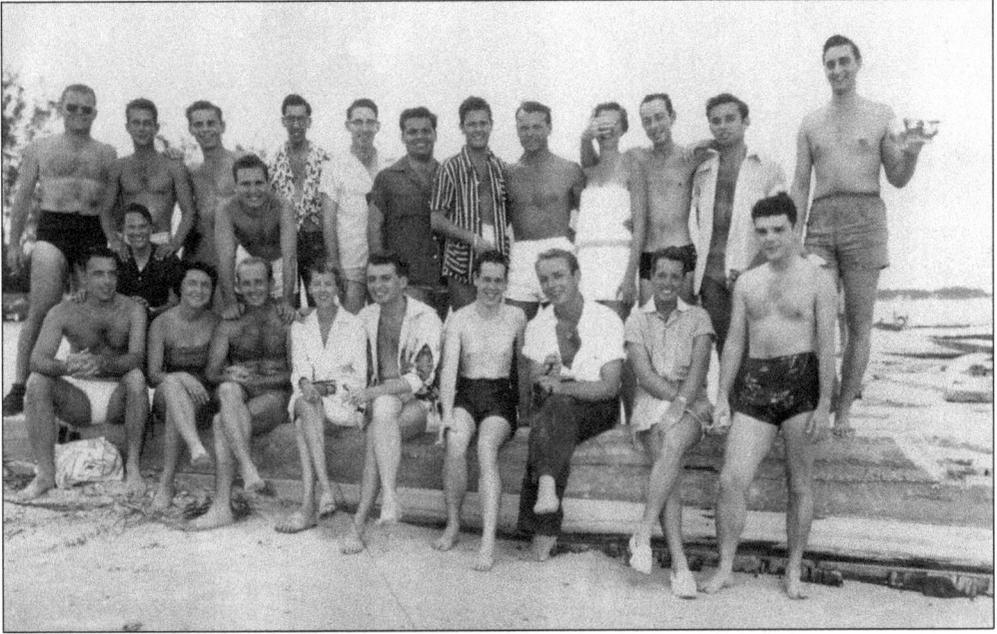

While crowds flock to the beach today, the relatively remote nature of the beaches north of Johns Pass in the 1950s provided a safe place for some to gather. At the time, throughout the United States, few establishments catered to gays and lesbians who were open about their sexuality; however, one bar in Johns Pass did. This image captures memories of a gathering in the early 1950s. (Donald Bentz collection, USF.)

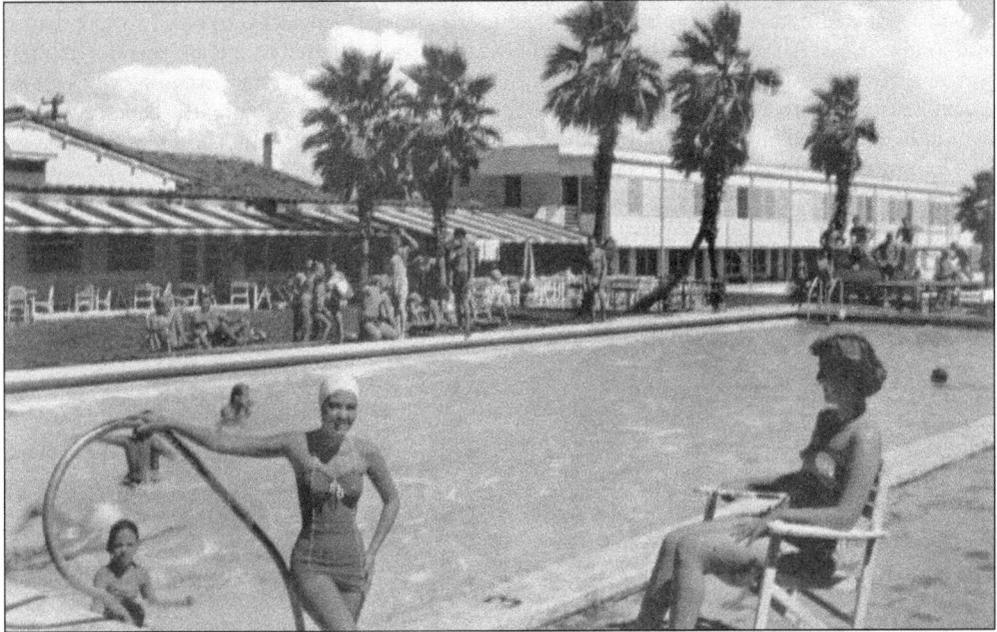

Swimmers and sunbathers enjoyed the pool at the Tides Hotel and Bath Club in the 1950s. Although located in North Redington Beach, the connections between this resort destination and Madeira Beach remained strong for nearly 60 years. The Aquabelles, a swimming ensemble from St. Petersburg, occasionally offered synchronized performances in the pool. (HV.)

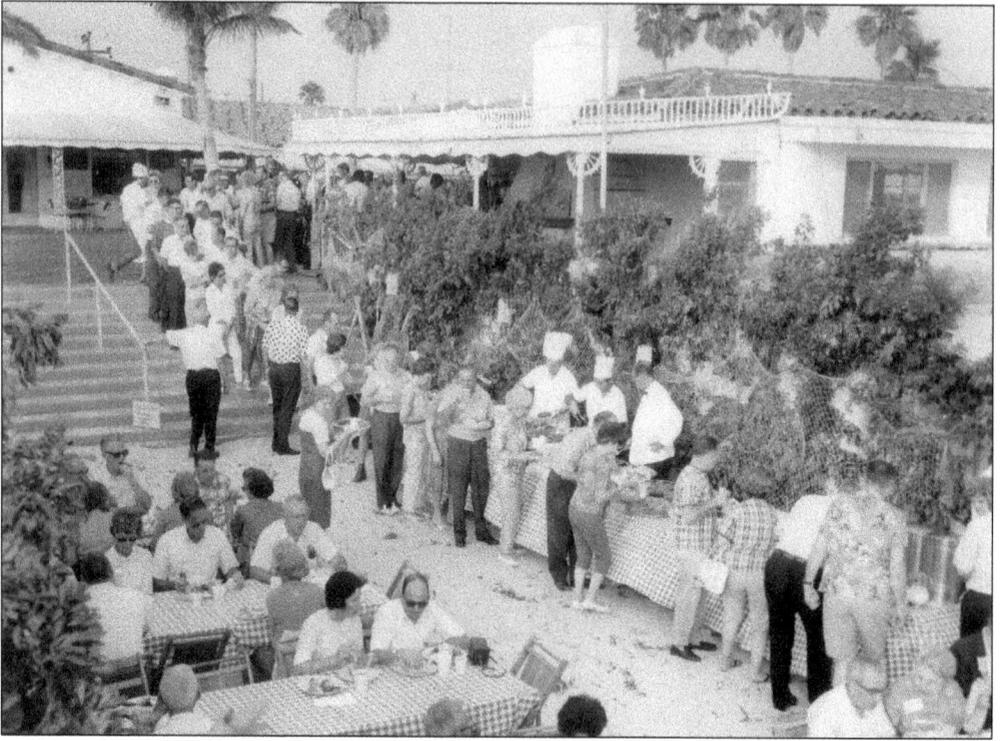

The Tides and Bath Club had become an important community gathering place by the 1950s, and it retained that role for much of the next 40 years. Some residents of Madeira Beach and the adjacent Redingtons maintained memberships that gave them access to beachfront cabanas and lounge areas. Above, diners in a line beginning by the pool area wait their turn for a buffet in the early 1950s. Memories of another gathering in the 1950s are captured below, as those assembled for an early evening dinner also enjoy a musical performance along the beach. Workers demolished the Tides and Bath Club in the mid-1990s, and developers built the Tides Beach Club condominium on the site. (Both, HV.)

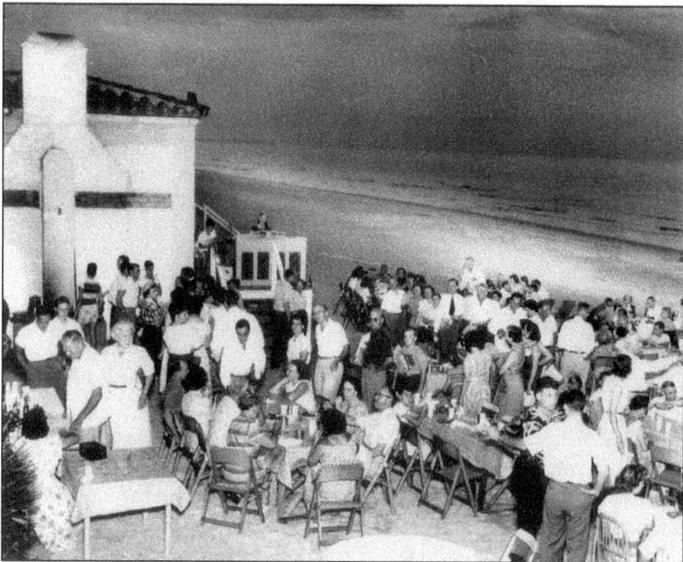

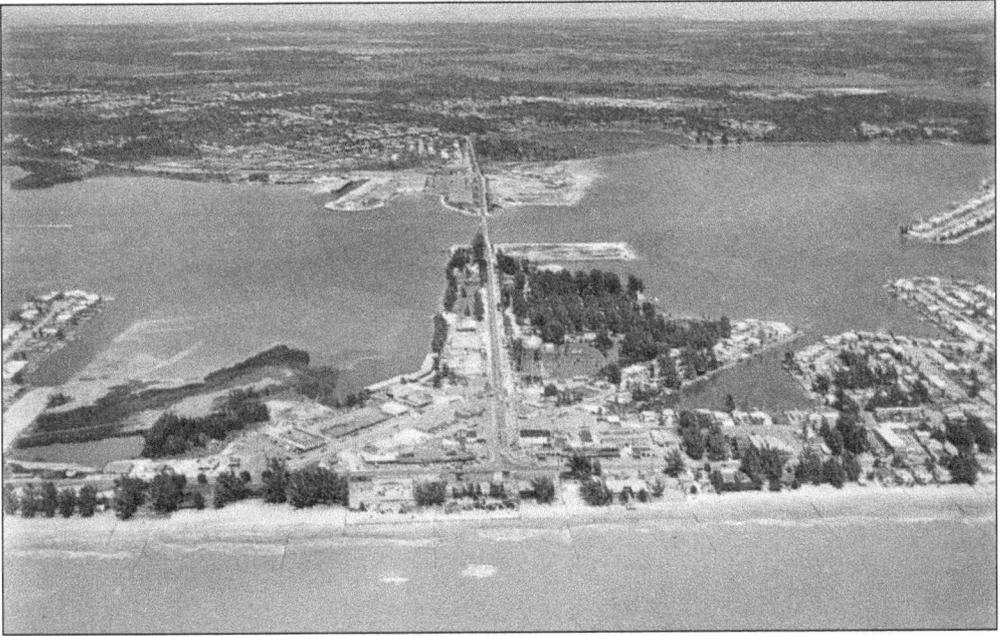

By the end of the 1950s, the site of the original Madeira Casino beachside (bottom center) had evolved into one of the busiest shopping areas along the Gulf Beaches. New stores appeared along Madeira Way, and plans moved forward to dredge the site of the municipal complex. The beach along Archibald Park remained under the control of the VA and was fenced and closed to the general public. (HV.)

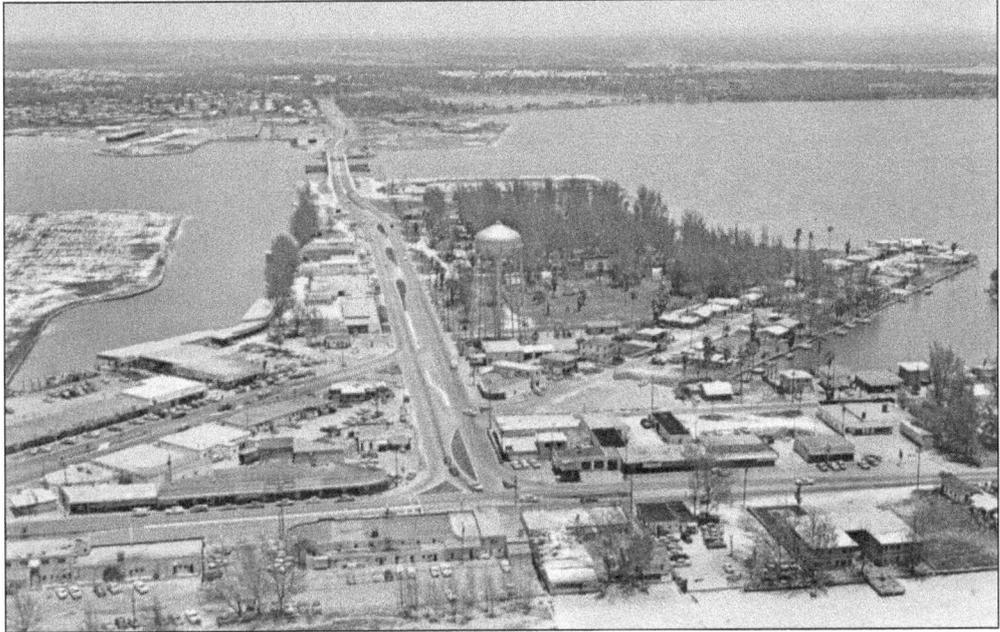

This c. 1962 aerial view is similar to the view at the top of this page, showing the shops along Gulf Boulevard and Madeira Way as well as the recently dredged areas north of Welch Causeway (center left). The opening of the 1962 bridge slightly curved the roadway. Bay Palms Trailer Park, the site of the original town meetings and the vote for incorporation, is behind the water tower. (HV.)

Dredging operations transformed the Gulf Beaches in the 1950s. This 1951 aerial view runs from Boca Ciega Avenue in Madeira Beach (lower right) to 175th Avenue (upper left), which is now within Redington Shores. Work crews had recently completed the filling of sand along Harbor Drive, Bay Point Drive, and much of Pruitt Drive and Sunset Cove within present-day city limits. The future sites of the city hall and recreation area, and on the mainland the Madeira Shopping Center and the Madeira schools, were still submerged. In Redington Beach, the future causeway and Fourth through Sixth Streets remained under the bay. The Bay Pines Triangle (center right) allowed travelers from St. Petersburg to turn towards the Welch Causeway and Madeira Beach or continue northward along Seminole Boulevard, with its few homes and many groves, at a time when that stretch of roadway was still Highway 19. Duhme Road, still mostly dirt and sand at the time, ended at Fifty-fourth Avenue North. (HV.)

This aerial view was taken in March 1957 and shows the same area as the image on the opposite page, revealing substantial development over the previous six years. Within Madeira Beach, homes now occupied both sides of Harbor Drive, Bay Point Drive, Pruitt Drive, and Sunset Cove. Madeira Beach Elementary School and the Madeira Shopping Center prepared for openings later in 1957. Redington Causeway had reached Fifth Street, while Dolphin Drive in North Redington had a street full of homes built over the past couple of years. A new subdivision appeared between Duhme Road, Seminole Boulevard, and Fifty-fourth Avenue North. Although the Seminole area, north of Fifty-fourth Avenue towards Oakhurst Road, remained either in citrus groves or undeveloped in 1957, over the next 15 years Charles K. Cheezem and other developers turned much of that area into a desired location for home buyers. Seminole Mall opened in 1965, and the city of Seminole officially incorporated in 1970. (HV.)

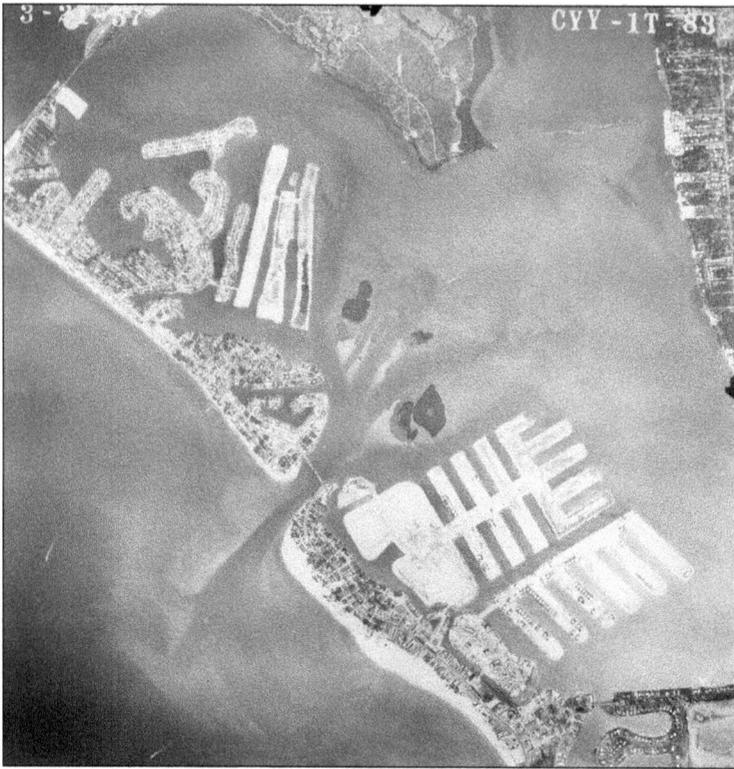

This view of Madeira Beach between the Welch Causeway (upper left) and Johns Pass shows the dredging of the three long, linear islands that became the Crystal Islands subdivision. South of Johns Pass and between Elnor Island and the Treasure Island Causeway, similar dredge-and-fill operations carved out the finger islands that later became the Isle of Capri and the Isle of Palms in Treasure Island (lower right). (HV.)

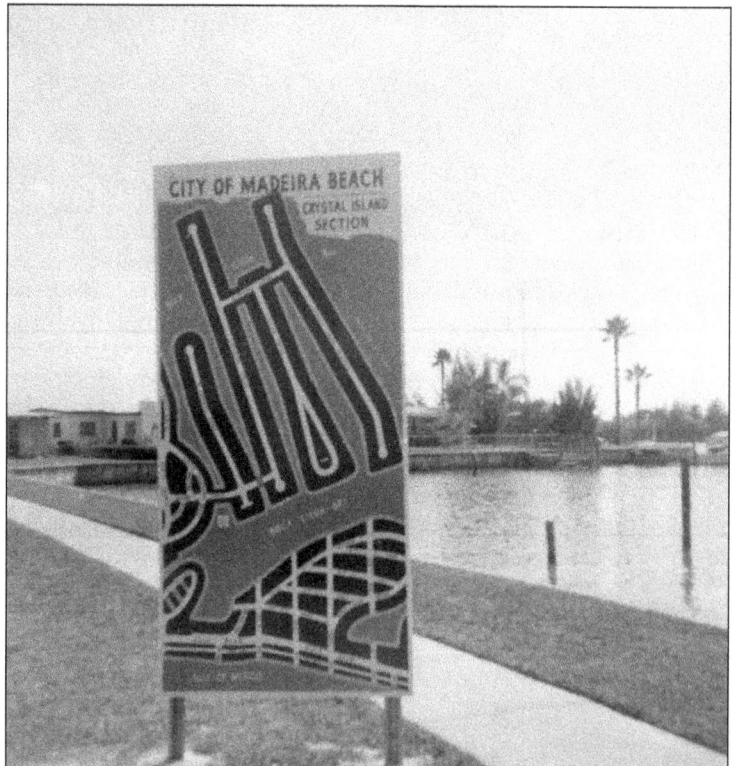

The Crystal Island subdivision occupied a large area of Boca Ciega Bay between the original barrier island and Turtle Crawl Point. By the 1960s, when the Madeira Area Community Service organization installed this sign along Island Drive, homes occupied nearly all the available lots. The large, teardrop-shaped park at the southern end of Lillian Drive continues to offer recreational space to those who live on Crystal Island. (GBPL.)

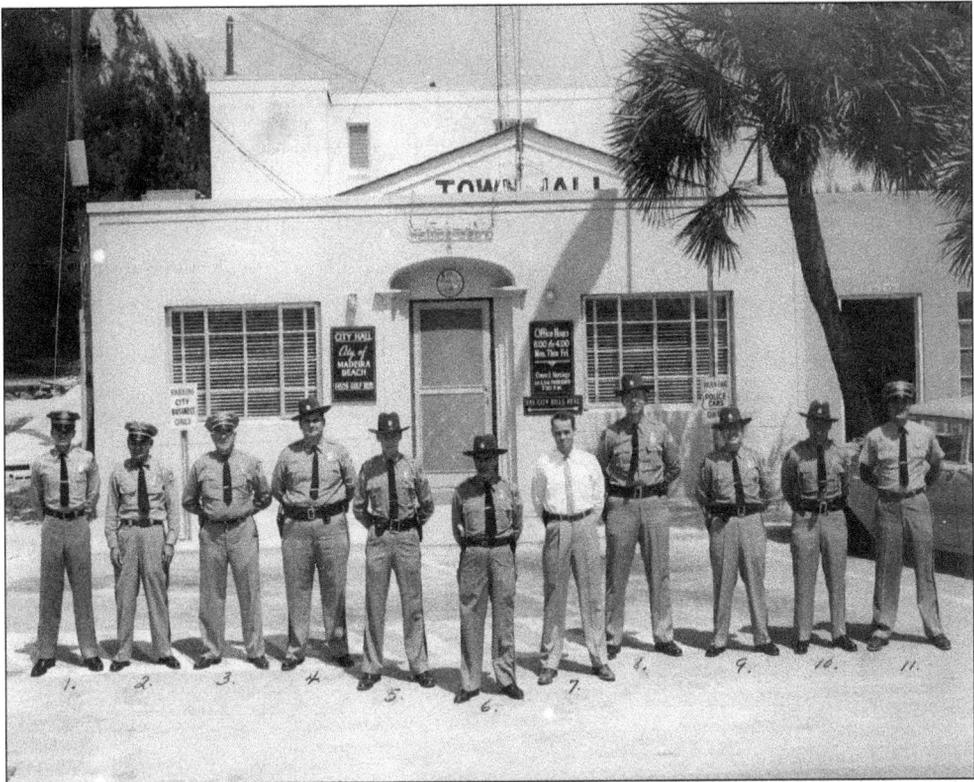

Officers of the Madeira Beach Police Department are lined up in front of city hall, then located at 14509 Gulf Boulevard, for this photograph in 1958. From left to right, Dave Roberts, Barney Golinski, Tom Johnston, Jack Sheehan, Charles Gallagher, police chief Charles Sullivan, Ed Kelly, Tom Faulkner, Carl Pelamati, Frank Vento, and Dan Meyerson worked together to protect the island community. Gallagher later served as chief for many years. (GBPL.)

Capt. Charles Gallagher (left) and police chief Charles Sullivan stand next to two new 1959 Studebaker Larks acquired by the Madeira Beach Police Department. They are posing along the recently dredged lands that later became Carter Plaza and the municipal complex. The dirt roadway behind them represented the outline of Municipal Drive. The Madeira Shopping Center is the white building in the far distance across Boca Ciega Bay. (GBPL.)

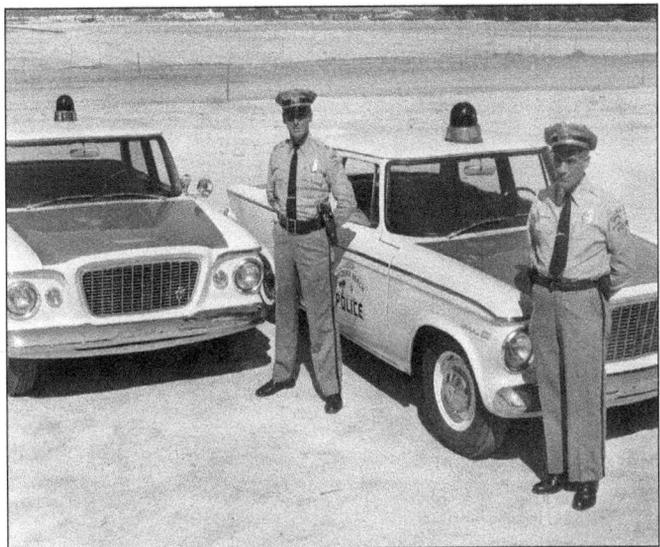

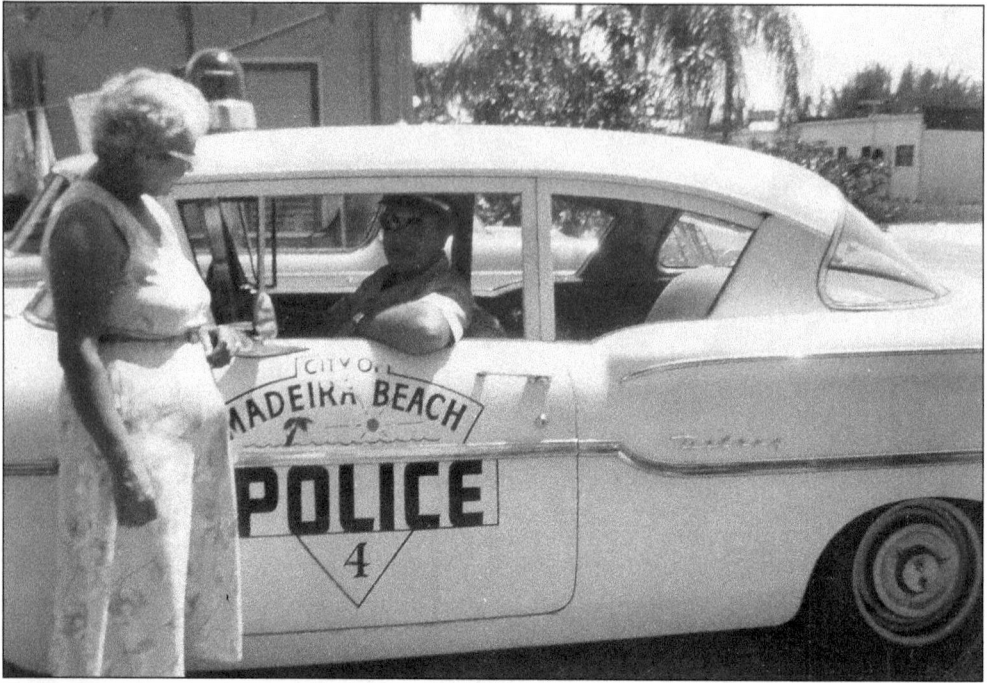

Officer Carl Pelamati, a longtime member of the police department, joined the force in 1958. A Korean War veteran, he traded his Army uniform for that of a patrol officer and sergeant. During his 25-year career, he watched the town grow into a city. Pelamati (above and at left on the left) also enjoyed fishing excursions along the local waterways. Pelamati retired in 1983 and spent his retirement years fishing along Madeira Beach's waterways before passing away in 2006. City officials voted to abolish the police department in September 1995, and the Pinellas County Sheriff's Office now provides police services on a contractual basis. (Both, Pelamati family collection.)

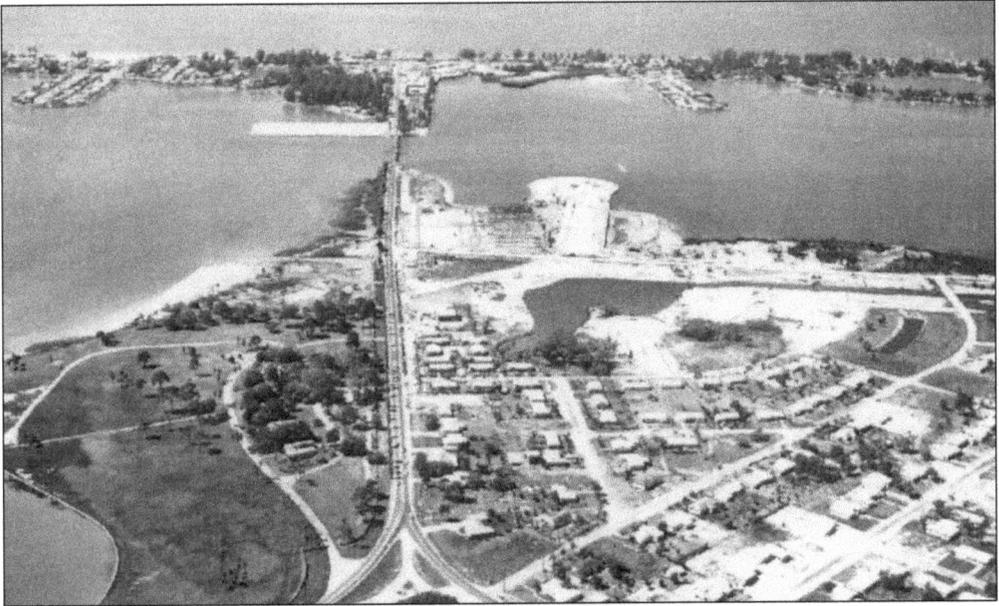

This southwest-facing aerial view from early 1957 shows the Bay Pines Triangle (bottom center), an intersection that became notorious by the 1970s. Dredge-and-fill operations created land for the newly opened campus of Madeira Beach Elementary School (left of causeway), the Madeira Shopping Center (right of causeway), and the area near the municipal marina (left of causeway, on the island). The future sites of the recreation fields and municipal complex were still submerged at this time. (Graber collection, USF.)

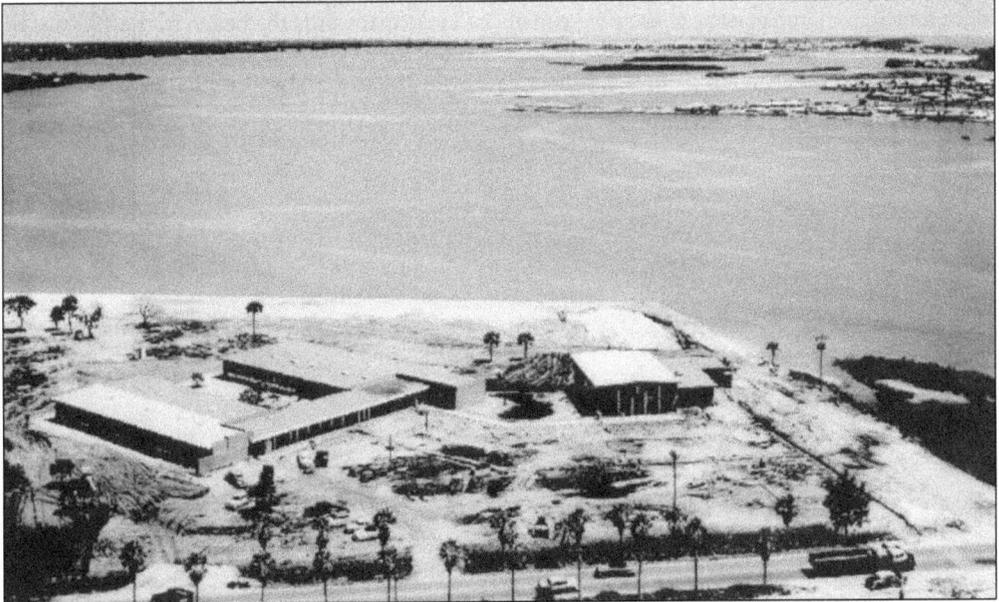

Crews finished construction of Madeira Beach Elementary School in 1957. Built on 10 acres at a cost of $255,424, the school opened later that year with 12 classrooms, 13 teachers, and 361 students. Robert L. Moore served as the first principal. The cafeteria's location also allowed it to serve food to students at Madeira Beach Junior High School, which opened later on land that was not fully dredged until 1959. (Graber collection, USF.)

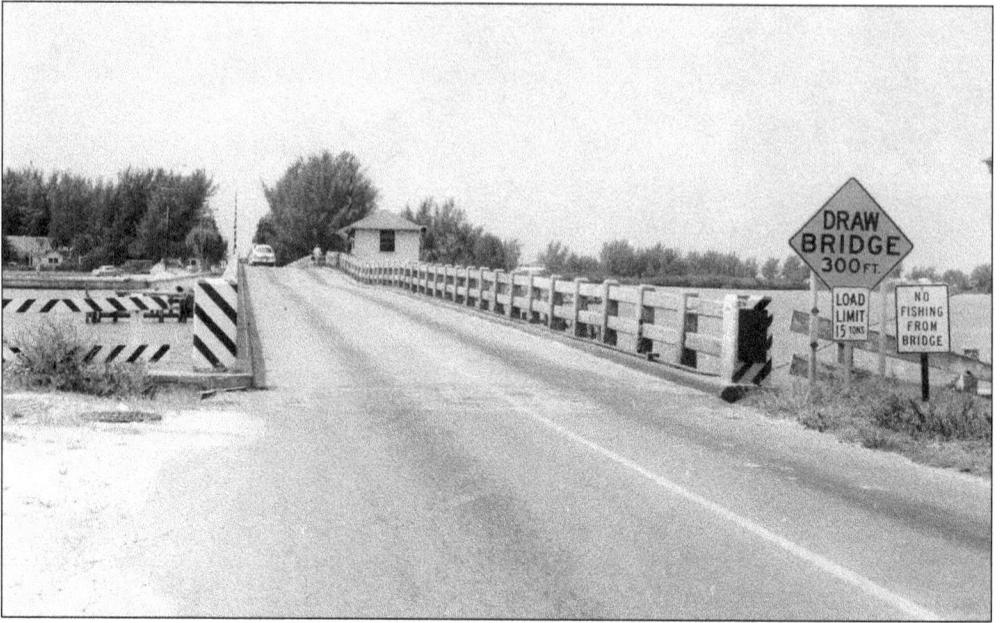

The opening of Madeira Beach Elementary School prompted new concerns about the narrowness of Welch Causeway. When the causeway opened in the summer of 1926, the bridge across Boca Ciega Bay could handle the traffic. By the postwar era, though, as new developments opened along the Gulf Beaches, automobiles often had to wait on one end of the bridge as larger vehicles tried to cross. At one point, mothers even stopped traffic on the bridge to allow school buses to cross the narrow structure without incident. On June 8, 1961, ground-breaking ceremonies took place for a span to replace the causeway, seen above looking towards the beach in the 1950s. The community celebrated the new four-lane bridge and widened causeway at a July 14, 1962, ribbon cutting. A March 2013 view from the same area is seen below. (Above, GBPL; below, author.)

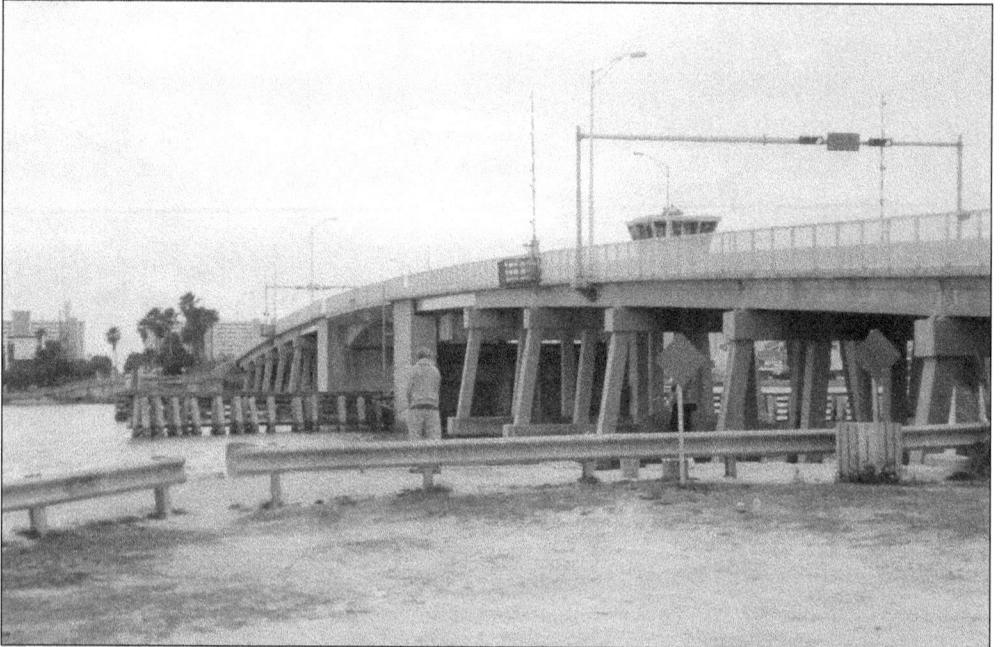

Four

A DREDGED DREAMSCAPE
1961–1980

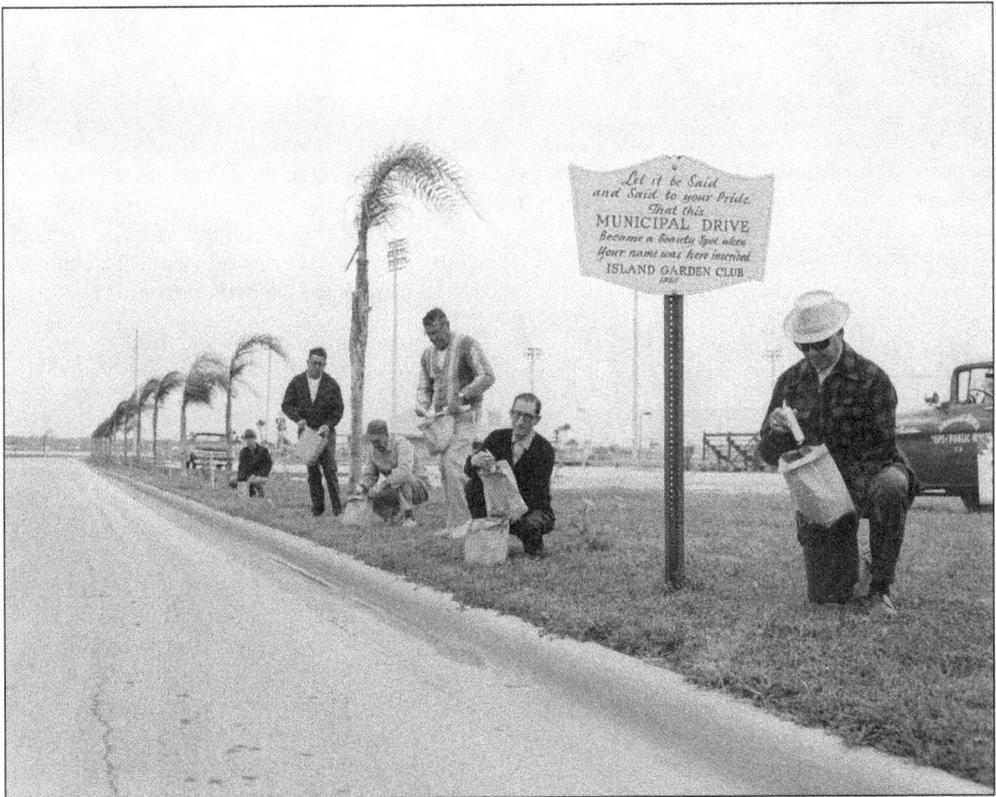

Members of the Island Garden Club and city workers decorate 153rd Avenue in the mid-1960s. In the 1960s and 1970s, civic organizations such as the Beach Boosters and the Island Garden Club supported a variety of beautification efforts. The recently opened city hall and fire department are in the background. Kirk Field, the baseball diamond behind them, became the Carter Plaza shopping center in the mid-1970s. (GBPL.)

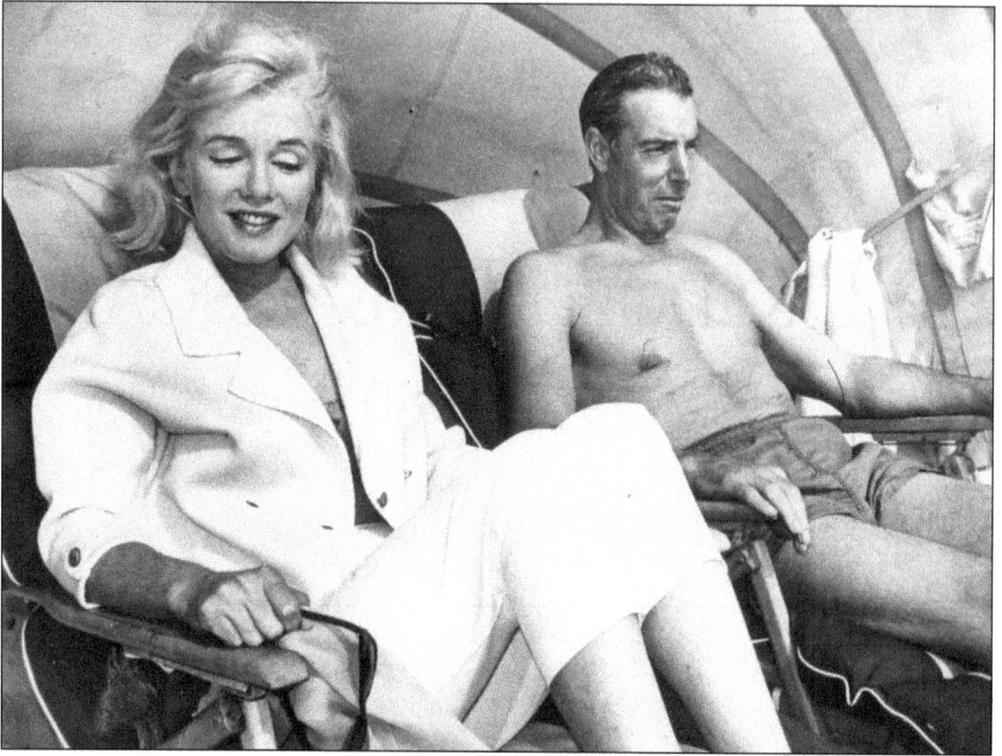

Reporters and photographers swarmed along the Gulf Beaches when Joe DiMaggio and Marilyn Monroe stayed at the Tides and Bath Club in March 1961. DiMaggio, a Hall of Fame baseball player with the New York Yankees from 1936 to 1951, was working as a Yankees batting coach during spring training at Al Lang Field in St. Petersburg. During a whirlwind visit, with members of the media everywhere, DiMaggio and Monroe frequently visited Madeira Beach. (HV.)

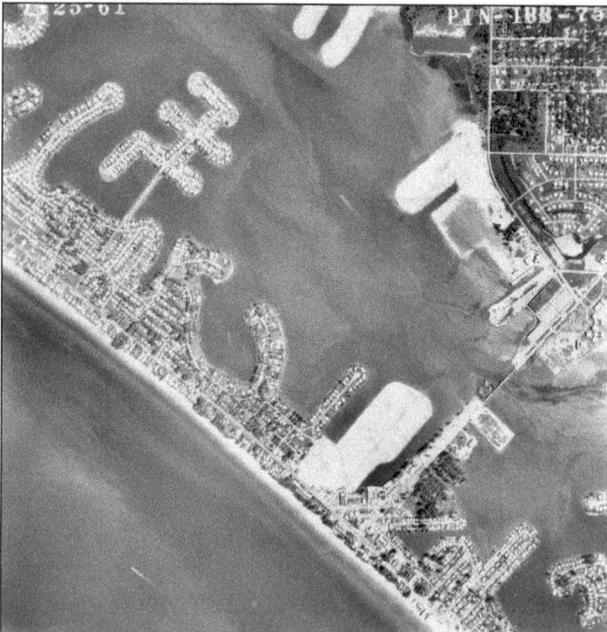

This July 1961 aerial view shows the dramatic reshaping of Boca Ciega Bay that had occurred during the previous decade. The areas surrounding Municipal Drive, Rex Place, 153rd Avenue, and American Legion Drive became the last major portions of Madeira Beach to rise out of Boca Ciega Bay. Along Duhme Road, just beyond the city limits, developers had received permission to dredge the future site of the Sea Towers condominiums. (GBPL.)

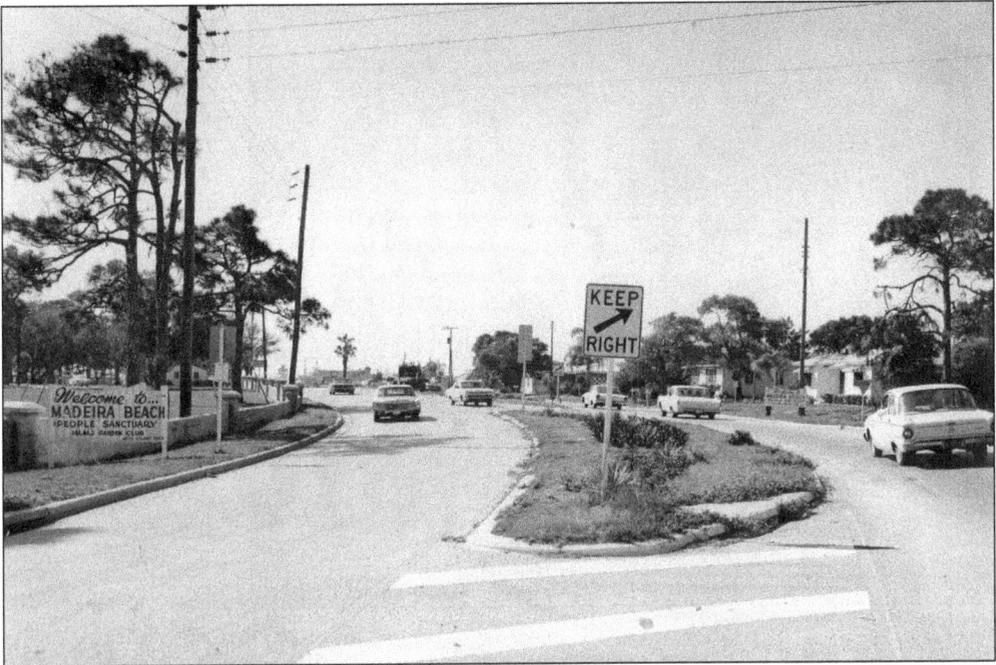

Those coming to Madeira Beach in the mid-1960s would have noticed signs like the one on the left, installed by the Island Garden Club, which welcomed them to a "people sanctuary." Kitty Stuart, the president of the Island Garden Club, led beautification efforts throughout the city for years. The ornamental walls along the left side of the image date from the years when the VA owned the property on the southern side of the roadway. (GBPL.)

Looking towards the intersection of Navajo Drive and the causeway, those traveling along this road would soon pass the Imperial House Restaurant, which was near the current location of the pedestrian overpass near Madeira Beach Fundamental School. After the construction of highway overpasses at the Bay Pines Triangle, a separate frontage road provided access to buildings on the north side of the road. (GBPL.)

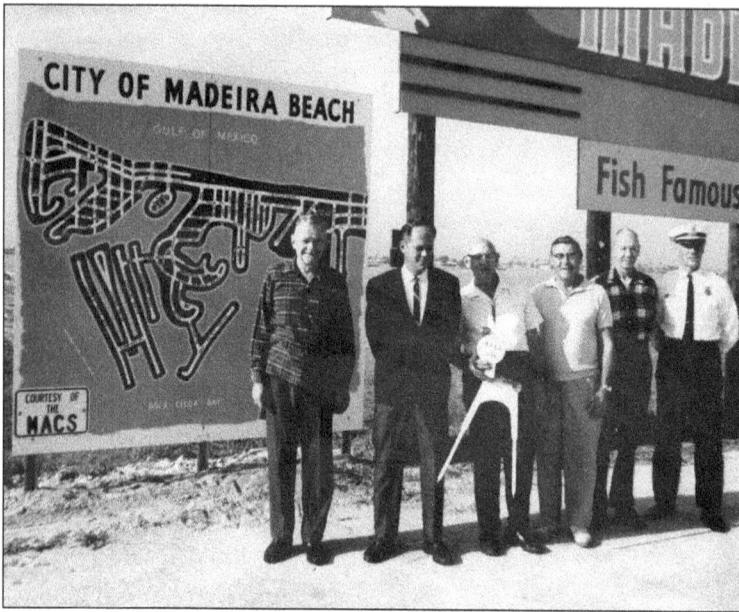

Members of the Madeira Area Community Services organization stand in front of one of the signs they installed displaying maps of the city. The map behind them shows the entire municipality, while other signs placed in various subdivisions (such as the sign at Crystal Island on page 62) assisted visitors in those areas. (GBPL.)

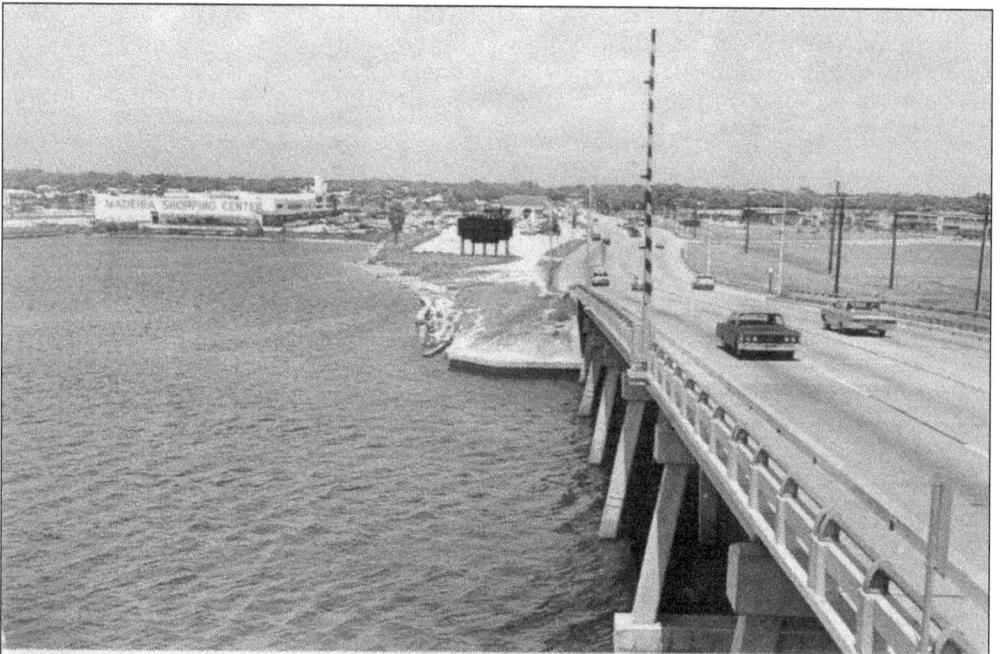

This postcard view looks from the bridge-tender's perch on the 1962 span of the Welch Causeway towards the Madeira Shopping Center (left) and the aqua blue–colored pod buildings of Madeira Beach Junior High School (right). Note the small curb between the walkway and the roadway on the bridge. Fatal accidents led to the installation of an improved barrier in the 1980s to protect bikers and pedestrians. (HV.)

This 1960s view of the Madeira Beach Elementary School campus along 150th Avenue shows a portion of the original fence that followed the road along the side of the VA Hospital. Robert Moore, a popular principal of the school in its early years, also served as the principal of the adjacent Madeira Beach Junior High School in the 1970s. Parents and teachers held popular spaghetti dinners as fundraisers. (GBPL.)

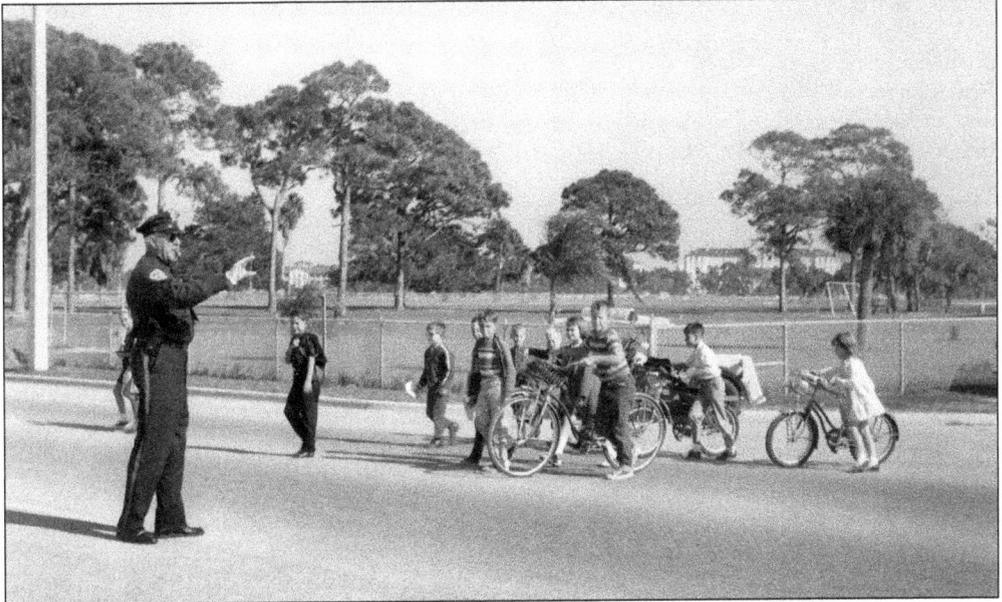

A Madeira Beach police officer stops traffic so students can cross Welch Causeway from the elementary school back to their homes. Parental concerns led state officials to replace the narrow 1926 span of the bridge to the island. Parents and officers had also directed traffic so school buses could safely cross the old bridge. The new bridge opened in June 1962 and is still used today. The Bay Pines VA Hospital is seen in the background. (GBPL.)

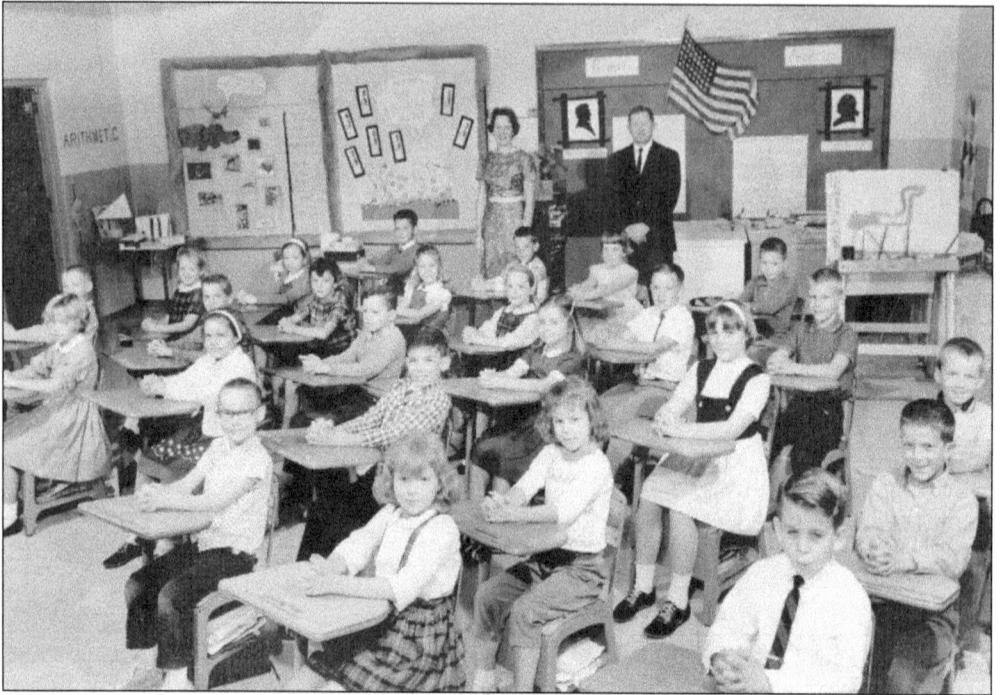

Above, students in Susan Williams's 1963–1964 second-grade class pose with principal Robert Moore. Below, a couple of years later, another crowded class enjoys its open-air classroom. By 1968–1969, overcrowding had required teachers to move the library book collections from one of the classrooms onto the stage in the school cafeteria until a media center shared with the middle school opened in the spring of 1970. Although the media center had air-conditioning in the early 1970s, most other rooms relied upon fans or gulf breezes until the 1980s. Madeira Beach Elementary did not become fully air-conditioned until the 1982–1983 school year. Racial integration of the school took place under the 1971 federal court order that resulted from the *Bradley v. Board of Public Instruction* decision, a Pinellas County case that challenged segregated school facilities. (Both, HV.)

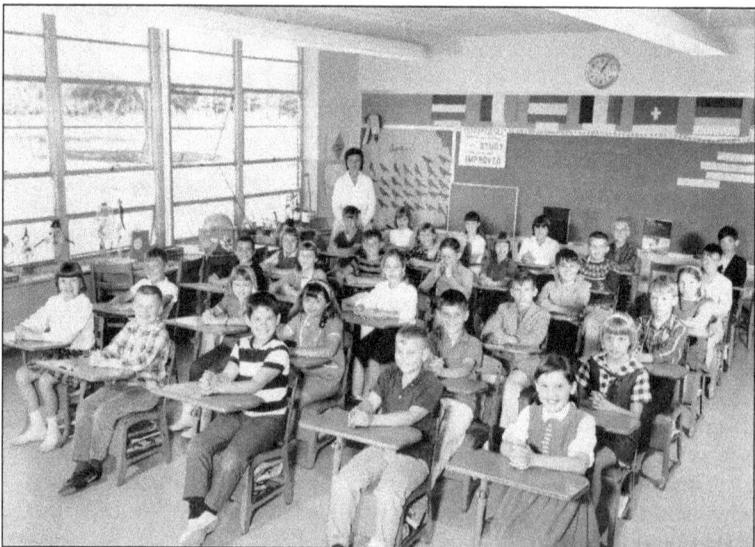

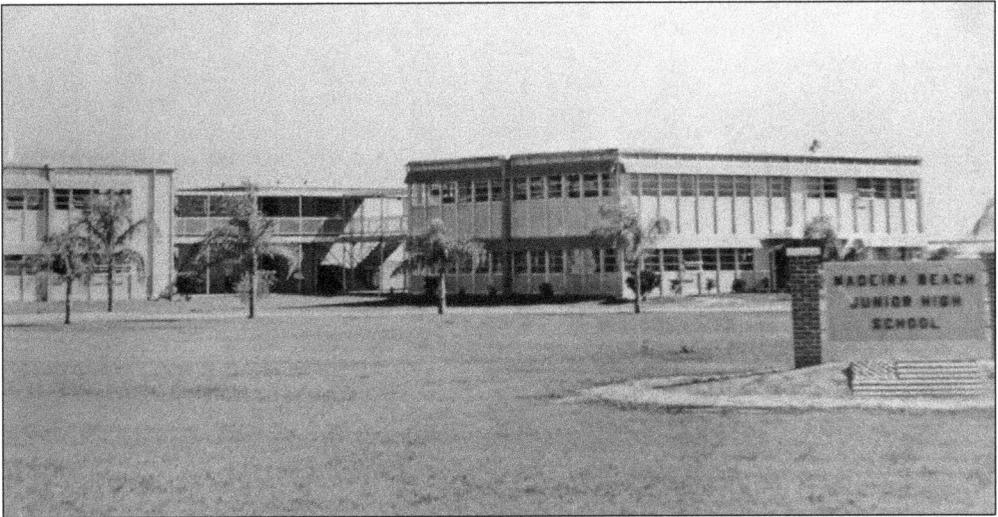

Workers constructed Madeira Beach Junior High School on a 14-acre site adjacent to the elementary school. The cost of the original buildings was just under $630,000. During most of the 1958–1959 school year, students attended double sessions at Tyrone Middle School as crews finished the new school. The 514 students and 26 teachers finally moved into their facility, with its 16 initial classrooms, on May 4, 1959. Originally, Madeira Beach Junior High School received students from five different elementary schools. By 1962, just three years later, 49 teachers taught 1,131 students in 32 classrooms. These two photographs show the school's campus in the late 1960s before school desegregation increased the number of feeder schools to more than 20 as a way of integrating the campus and promoting diversity. (Both, Madeira Fundamental School.)

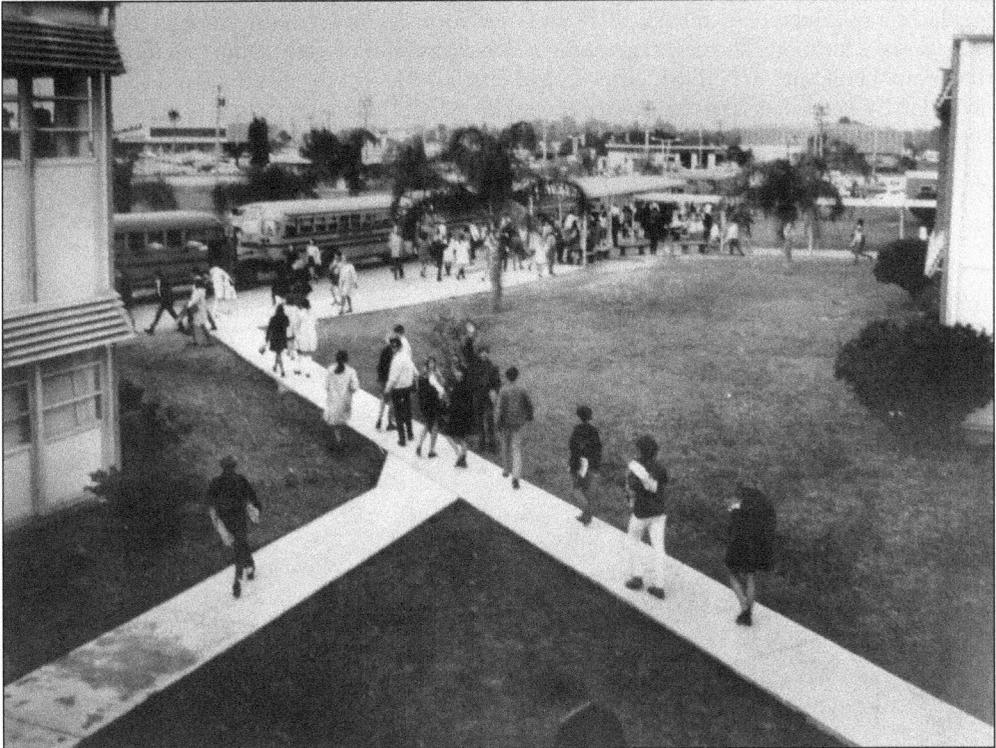

For 50 years, the elementary and junior high schools shared resources. With the transition from junior high schools to middle schools taking place in Pinellas County in 1974, the elementary school gave its sixth-grade class to Madeira Beach Middle School, and ninth-graders moved into their zoned high schools. Innovative teaching activities took place in a large pod known as the "questrum," a place where sixth-graders learned in a setting without traditional walls. The middle school campus expanded in 1977 with new facilities for art, music, foreign language, and exceptional education. The new classrooms were air-conditioned, something that did not come to the original buildings until 1983. After school officials decided to close Southside Fundamental School in St. Petersburg, the elementary and middle school campuses merged into Madeira Beach Fundamental School during the 2009–2010 school year. (Both, author.)

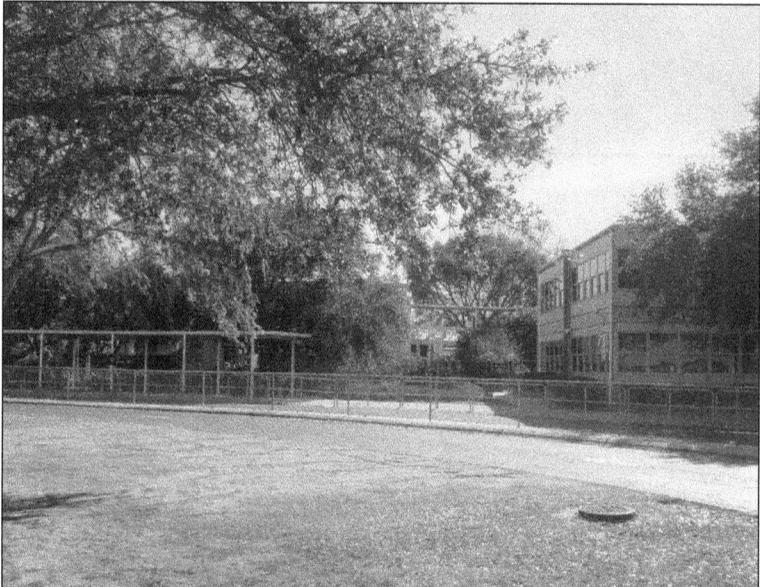

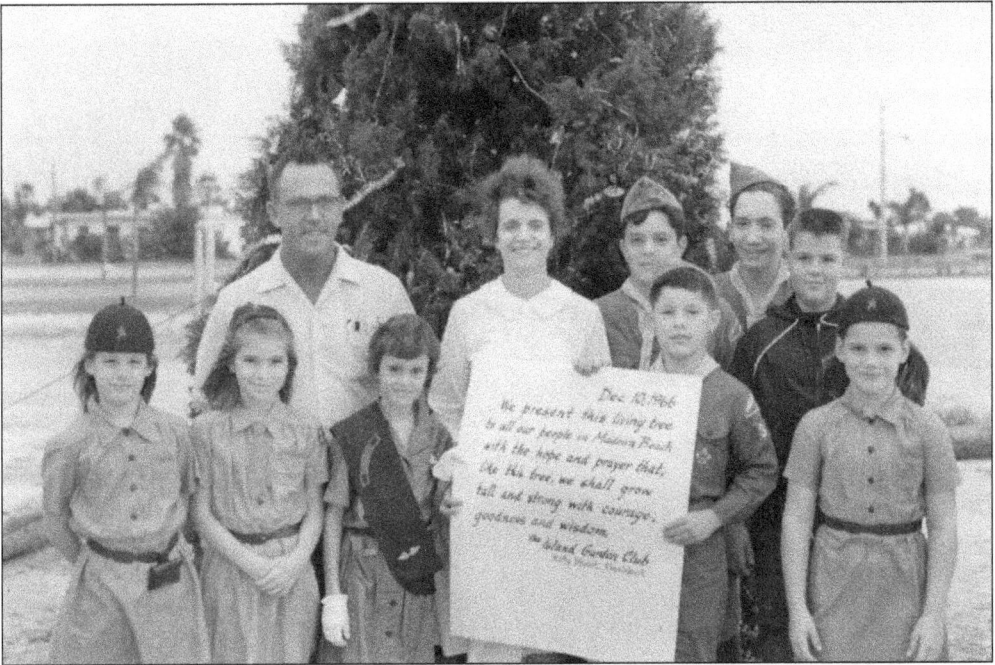

Above, Scouts gather in front of a decorated tree near city hall in December 1966 to celebrate the Christmas season and winter holidays. They often joined members of the Island Garden Club, who worked under the leadership of Tom and Kitty Stuart. Originally from Mississippi, the Stuarts came to Madeira in 1931, more than 15 years before the city existed. They hoped to construct a motel but ran into a few obstacles, such as a lack of running water. The Stuarts then built the Sunglow Cottages (below) at the Madeira/Redington town line. While the children below are seen enjoying an Easter egg hunt at the cottages in the mid-1960s, city leaders praised Kitty Stuart for her beautification efforts. Largely through her labors and those of the Island Garden Club, Madeira Beach won a Distinguished Achievement Award in the 1965 National Cleanest Town contest. (Both, GBPL.)

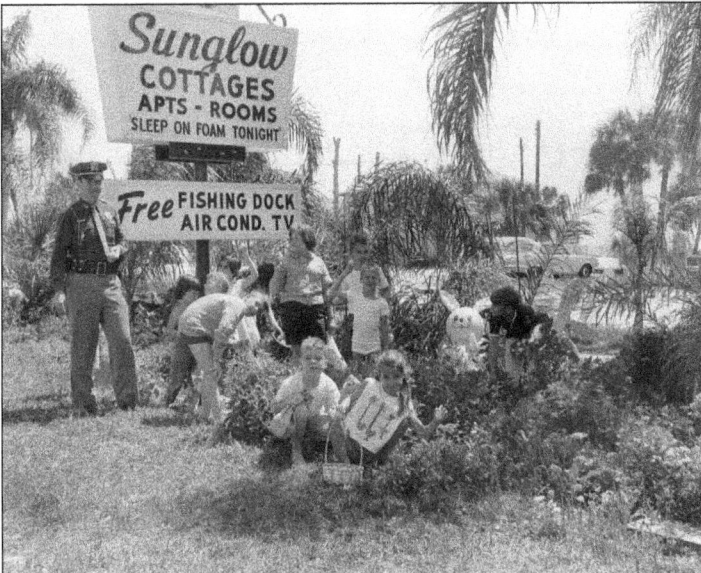

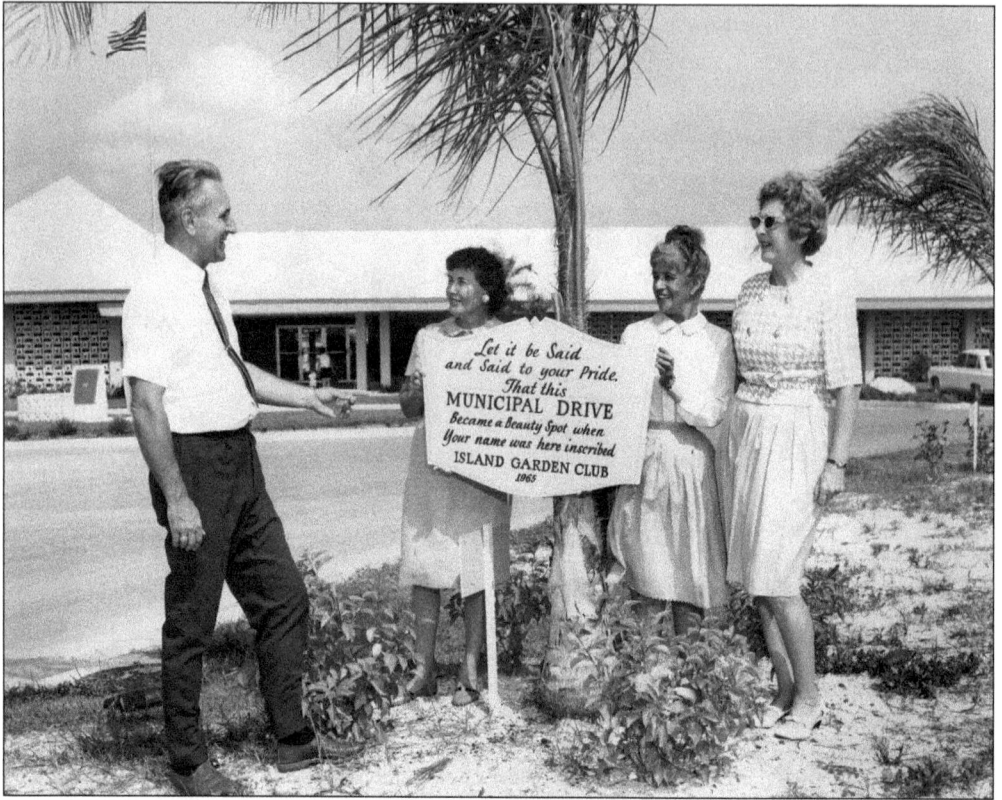

Although leaders often recognized Kitty Stuart and others in the Island Garden Club, Tom Stuart also won accolades, as seen here. He was named the 1970 Man of the Year for the Gulf Beaches. His greatest honor, however, came the year after he passed away in April 1972, when the 1973 Florida Legislature renamed Welch Causeway as Tom Stuart Causeway in a measure sponsored by the Island Garden Club and the local chamber of commerce. (GBPL.)

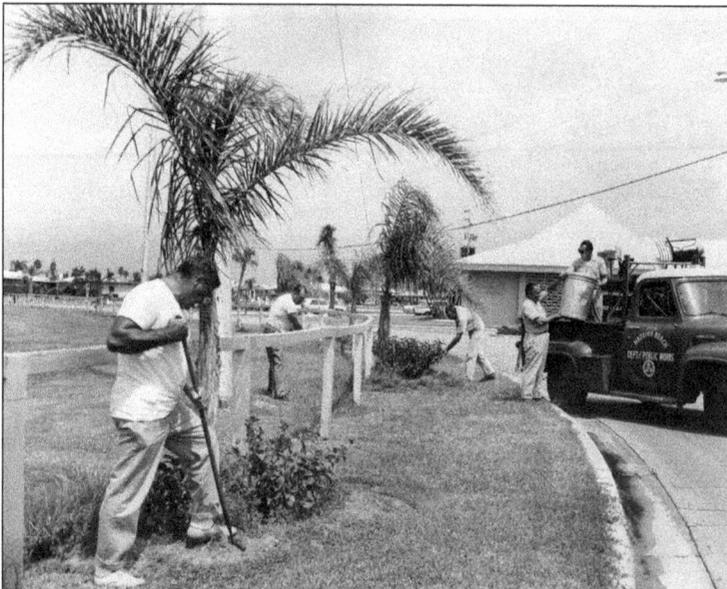

City workers and volunteers from the Island Garden Club spruce up Municipal Drive, a loop road in Madeira Beach that became the home of city hall and police and fire services in 1965 as well as the Gulf Beaches Public Library a couple of years later. All of the land seen here, now forming the heart of the city, was created from dredging operations that started in the 1950s. (GBPL.)

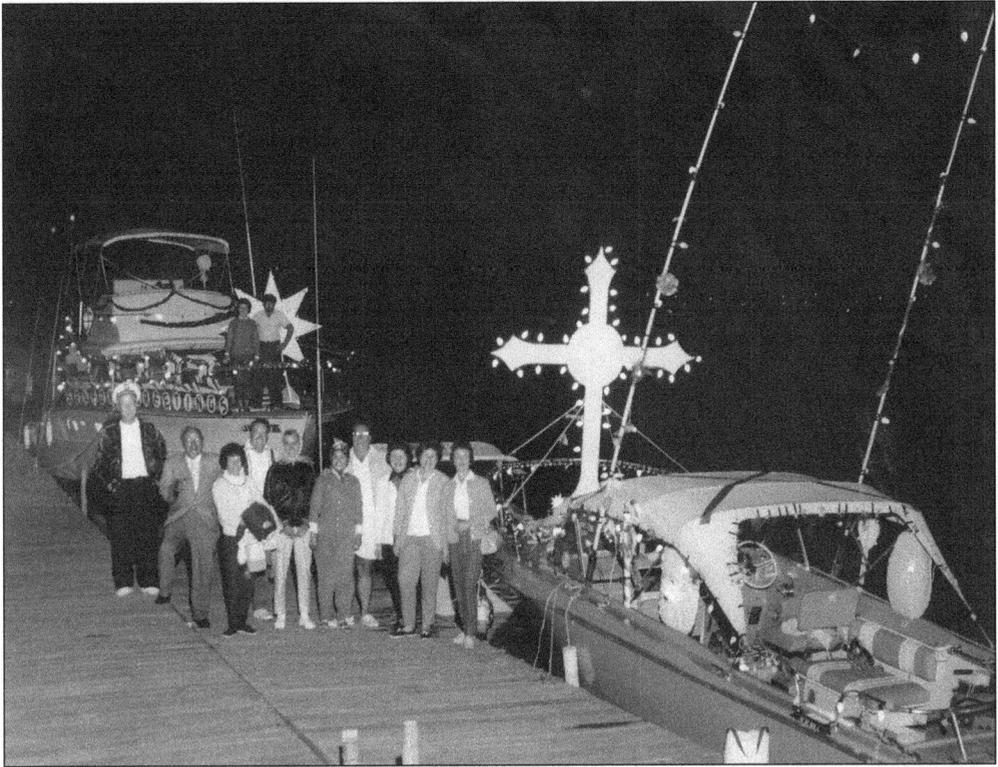

The annual lighted boat parade has been a tradition in Madeira Beach since the late 1960s. Every December, finely decorated boats have assembled in the Intracoastal Waterway for a voyage through and around the finger islands of Boca Ciega Bay, from the causeway to Johns Pass. Although the routes taken and the gathering places have changed over the years, the event remains a popular time to meet with friends and neighbors on the eve of the holiday season. These photographs from the late 1960s capture one of the first boat parades. Below, spectators wait for boats to pass near Gene's Lobster House on the island side of the Welch Causeway. (Both, GBPL.)

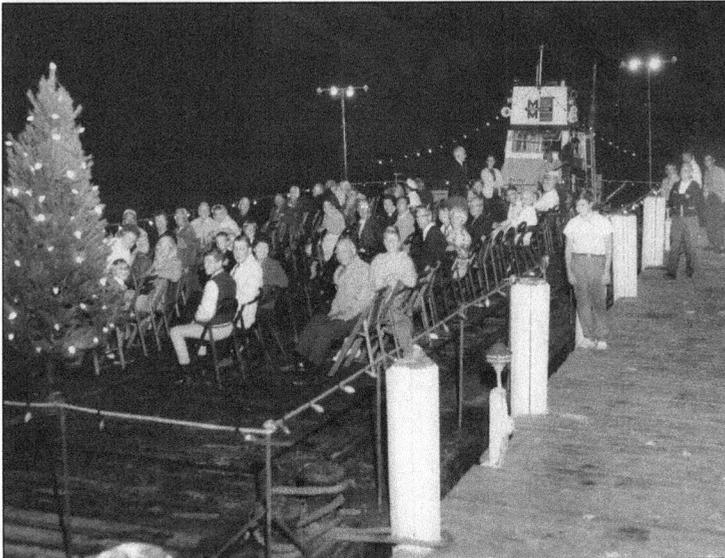

Seen here in early 1965, the municipal building is nearing completion for its April dedication. As police, fire, and administrative services moved from the cramped quarters in the old city hall at 145th Avenue and Gulf Boulevard, officials planned to convert part of their former headquarters into a recreation center to accommodate the growing number of families with children. The new police and fire department facilities are seen below. Although modern for its day, the municipal complex, which approaches its 50th anniversary in 2015, has reached the end of its serviceable life and poses a public-safety hazard due to its low elevation, deferred maintenance, and close proximity to the bay. (Both, GBPL.)

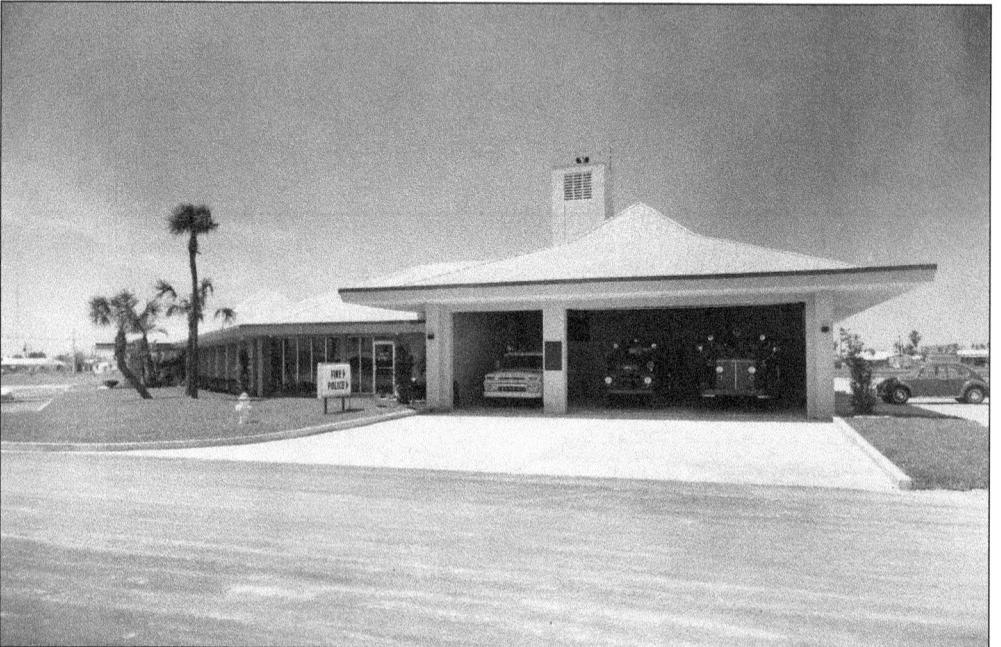

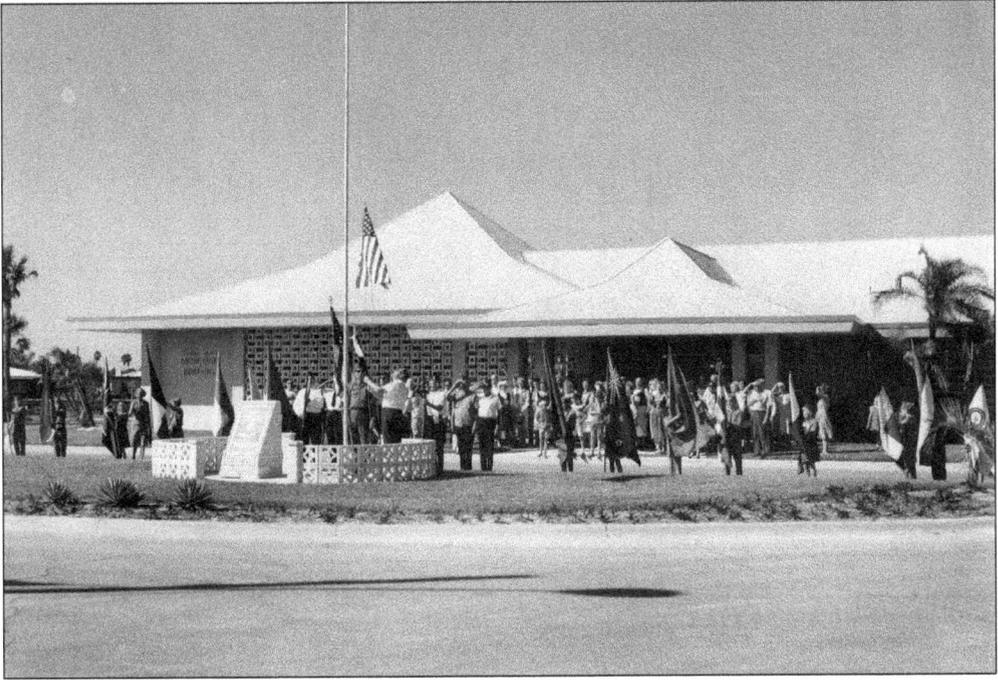

Above, residents of Madeira Beach celebrate the completion of their municipal complex at the dedication ceremonies in April 1965. The photograph below, taken from near the entrance to the new building, had a nearly unobstructed view towards the Gulf of Mexico. The area on the other side of Municipal Drive was rededicated in April 1965 as Richard T. Kirk Memorial Field in honor of a local optometrist who drowned in the summer of 1964. Some of the Sans Souci Cottages appear between these workers and across Gulf Boulevard. Five years later, in the spring of 1970, crews demolished the cottages in one of the first major transformations along northern Madeira Beach. Soon, a large Holiday Inn dominated the skyline. Construction began on that hotel in January 1971. (Both, GBPL.)

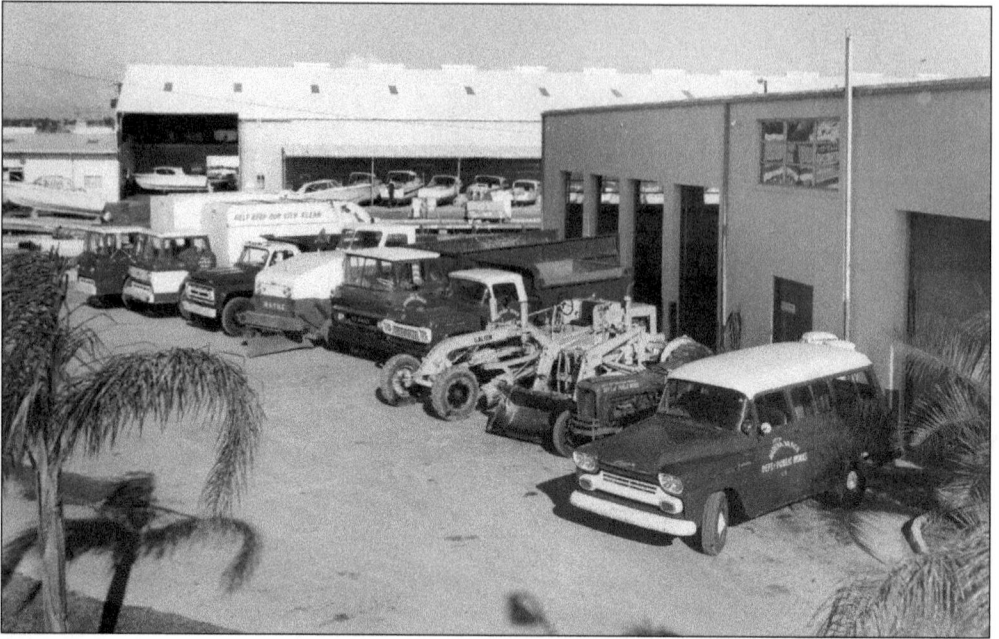

As Madeira Beach grew, an expanded public works staff handled the increased demands for water, sewer, and other infrastructure services. A water treatment plant (below) along the southern end of the Welch Causeway, near the present-day municipal marina, played an important role between the time of septic sewer tanks and the later connection to a consolidated countywide utility system. This facility, first constructed in 1951, helped end unsightly and unsanitary earlier practices such as dumping raw sewage and burning trash. Well into the late 1940s, some establishments dumped raw sewerage into Boca Ciega Bay. For example, in the summer of 1948, the Gulf Beaches Sanitary District filed injunctions against hotels with septic systems, including the Tides Hotel and the Tides Apartments, in present-day North Redington Beach as a way of advocating for a sewer connection to treat waste effluent. (Both, GBPL.)

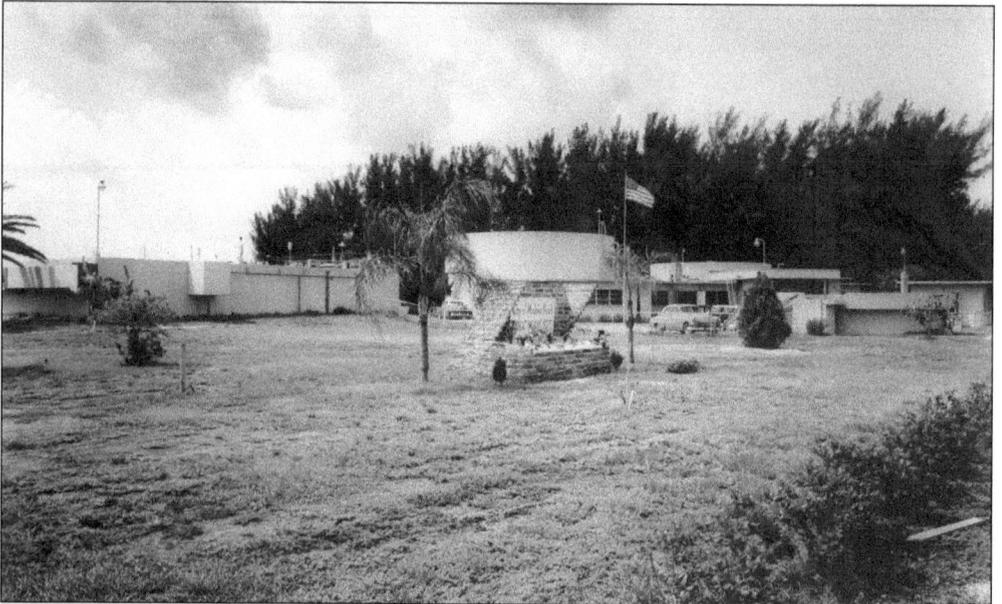

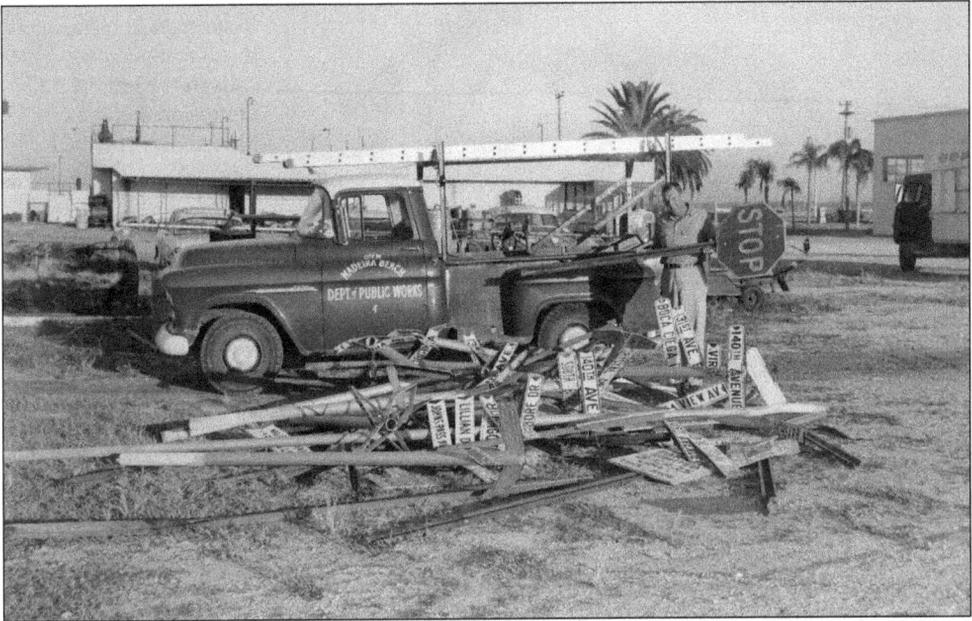

With the new municipal complex completed, work crews focused on a variety of projects to improve neighborhoods throughout the beach community. They replaced older street signs, such as the ones seen above at the public works headquarters. Madeira Beach also ran a fancy street sweeper from one end of the town to the other. Seen below near the Welch Causeway and Gene's Lobster House, the sweeper logged over 600 hours of service annually in the mid-1960s. Just 30 years earlier, sand roads had dominated the landscape, but as the city moved forward in 1965, it boasted to taxpayers that the public-works services of the municipality cost less than $30 per citizen per year. (Both, GBPL.)

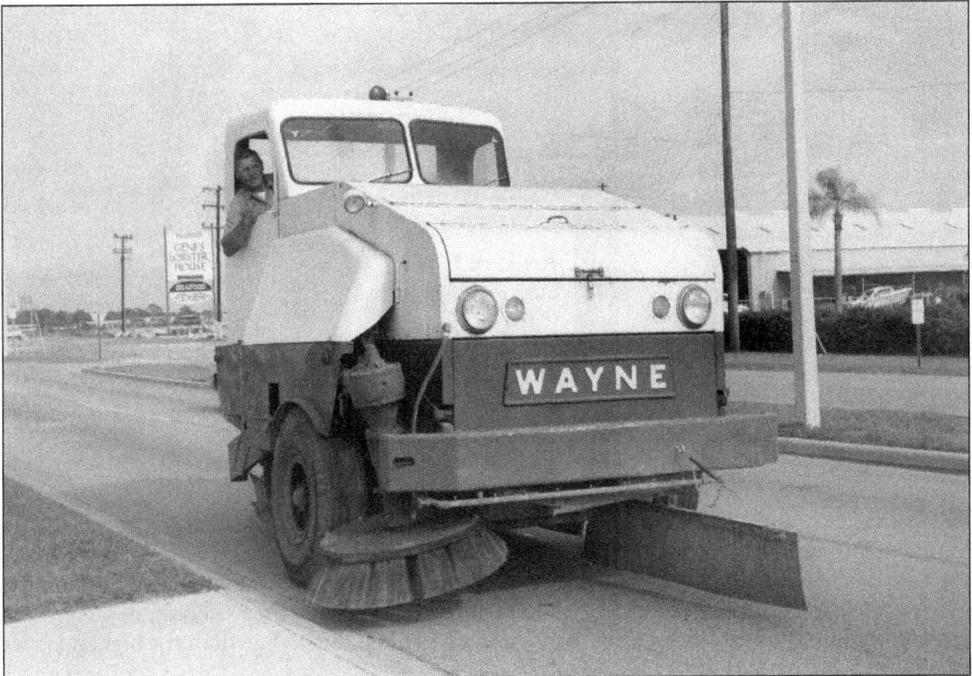

Volunteers continued to cover emergency calls in the era before professional crews or paramedics operated in Pinellas County. Dr. John E. Pickens Jr. (right) served as a volunteer firefighter and chaplain who also performed healing and nurturing for the parishioners at the Church by the Sea during his long tenure as senior pastor. Dr. Pickens and his wife, Alpha, were loved and respected in the community. (GBPL.)

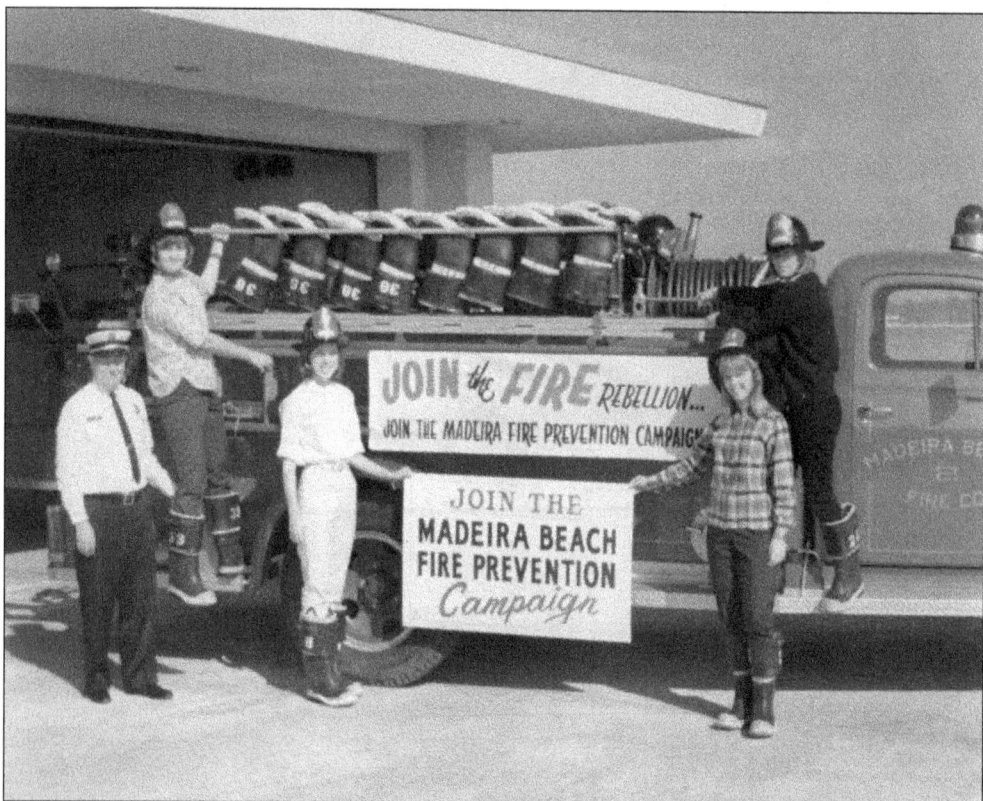

Children are seen here participating in a fire prevention program at the municipal complex in the late 1960s. While improved building codes and regular trash collection reduced the number of fires caused by human error in the years when residents burned their rubbish, new concerns arose in the late 1970s as condominiums rose much higher on the skyline than the highest ladder on the city's fire truck fleet. (GBPL.)

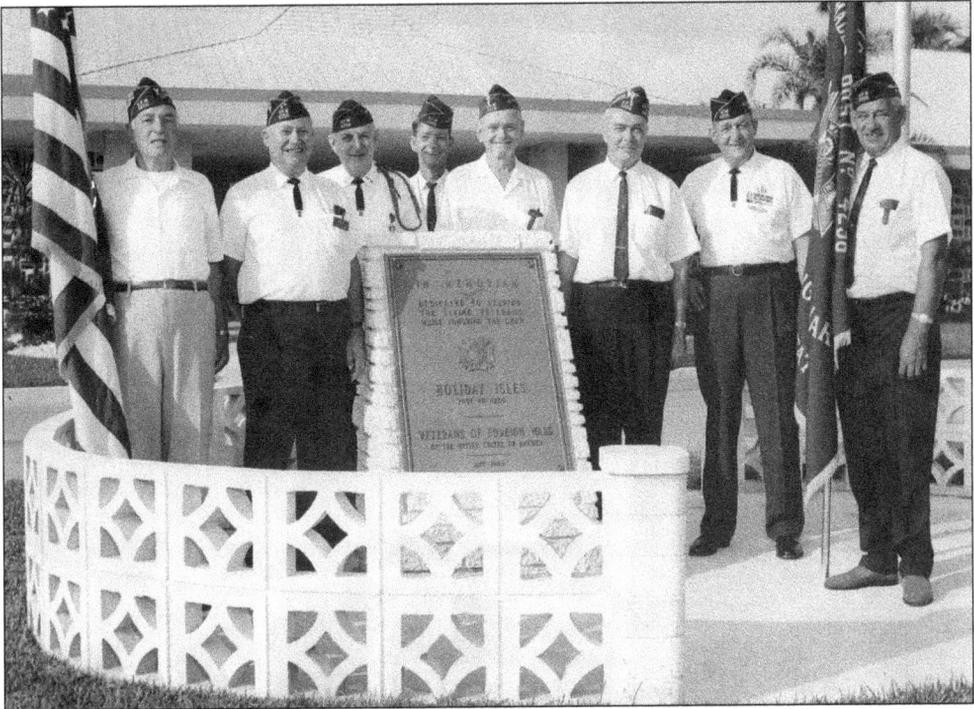

The close proximity of the Bay Pines VA Hospital made Madeira Beach a popular destination for retiring veterans. A local post of the Veterans of Foreign Wars (VFW) became very involved in community affairs. Above, members of the Holiday Isles VFW Post 4256 stand alongside a memorial erected in May 1965 in front of the municipal building. Below, VFW members pose in front of their meeting hall in the 1960s. The organization continues to maintain a facility in Johns Pass. Another national organization, the American Legion, also has a post in Madeira Beach, Post 273, which originally built a clubhouse at 14700 Gulf Boulevard in the early 1950s. After Post 273 moved to its current building at the tip of American Legion Drive, its earlier structure became the popular bar and restaurant The Deck. (Both, GBPL.)

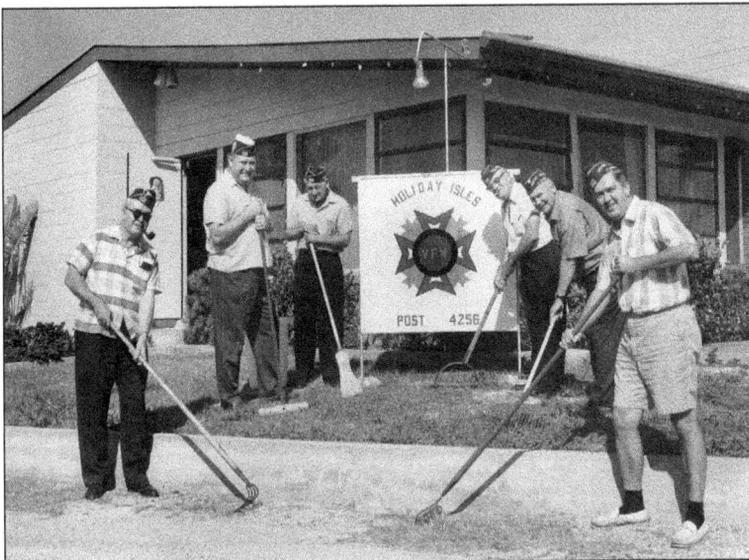

A stroll along Municipal Drive near the current intersection with Rex Place looked a little different in 1965. With Kirk Field on the left and the new city hall straight ahead, the area on the right soon became the new home of the Gulf Beaches Public Library. Local fundraising efforts and a 1968 federal grant allowed for the opening of the new library facility in 1969. (GBPL.)

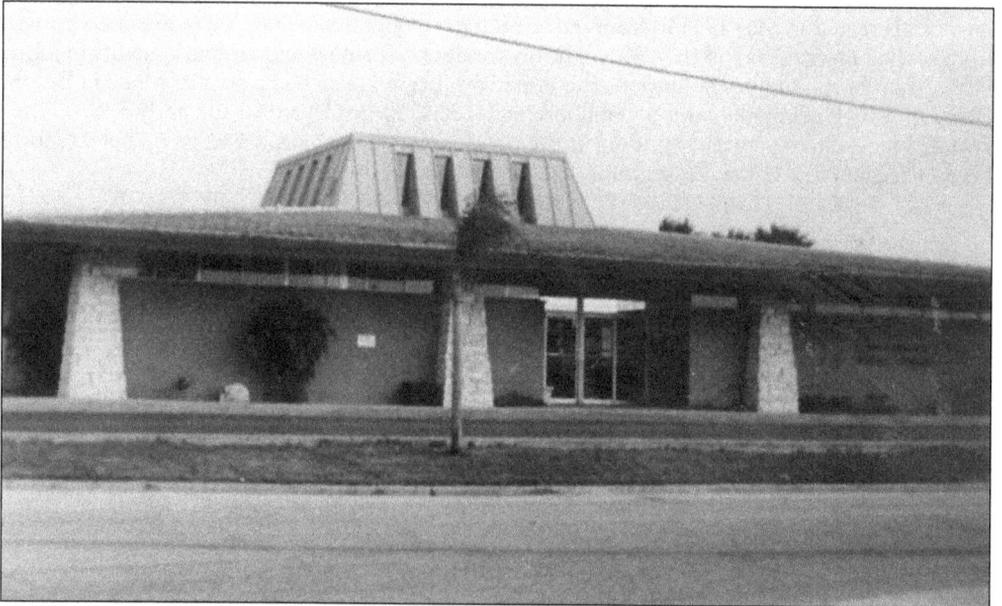

The library has continued to serve Madeira Beach, Treasure Island, and the three Redington municipalities. A 1988 expansion during Karilyn Jaap's tenure as library director added 3,600 square feet, bringing the structure to 10,000 square feet. A year later, the Gulf Beaches Public Library joined the Pinellas Public Library Cooperative, a consortium that allows for shared access to print and electronic collections. (GBPL.)

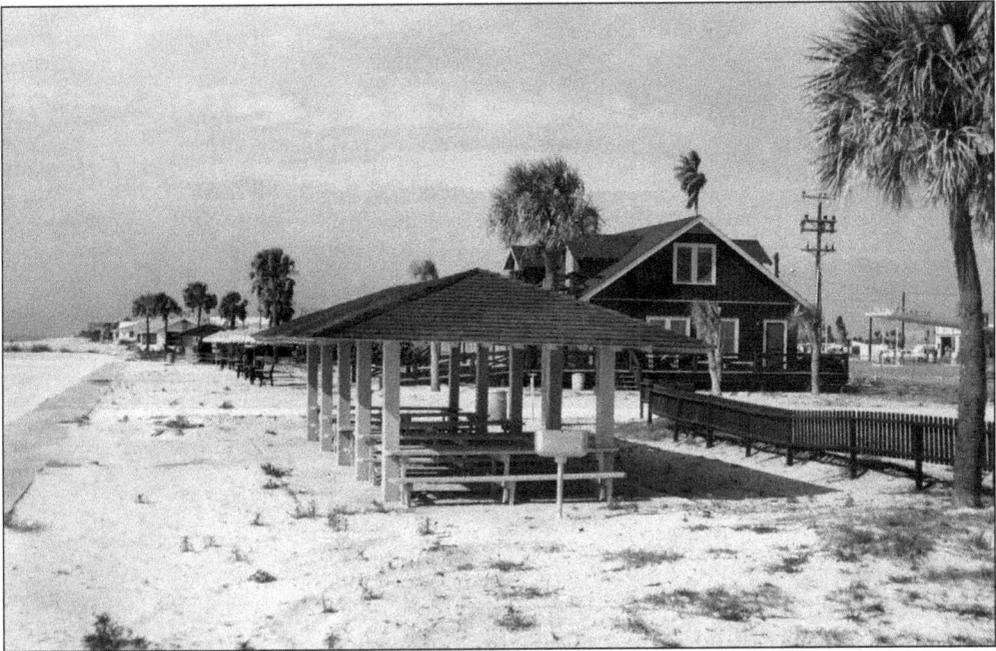

Federal officials decided to transfer to Madeira Beach the land that Albert Archibald and David Welch had originally donated to the VA in 1931. By the late 1960s, the wooden building constructed by the VA in the summer of 1935 was surrounded by tall trees, a chain-link fence, and "No Trespassing" signs. Workers and volunteers labored diligently to clear the area and make it available for public use. Once reserved only for veterans from Bay Pines, the wooden cabin took on new life as the Snack Shack after a local chapter of the Disabled American Veterans opened the site to the public in the mid-1970s. Crowds soon flocked to the beach. The image above looks at the facility and the San Souci Cottages just north of it in the late 1960s. Efforts to prepare the site are seen below. (Both, GBPL.)

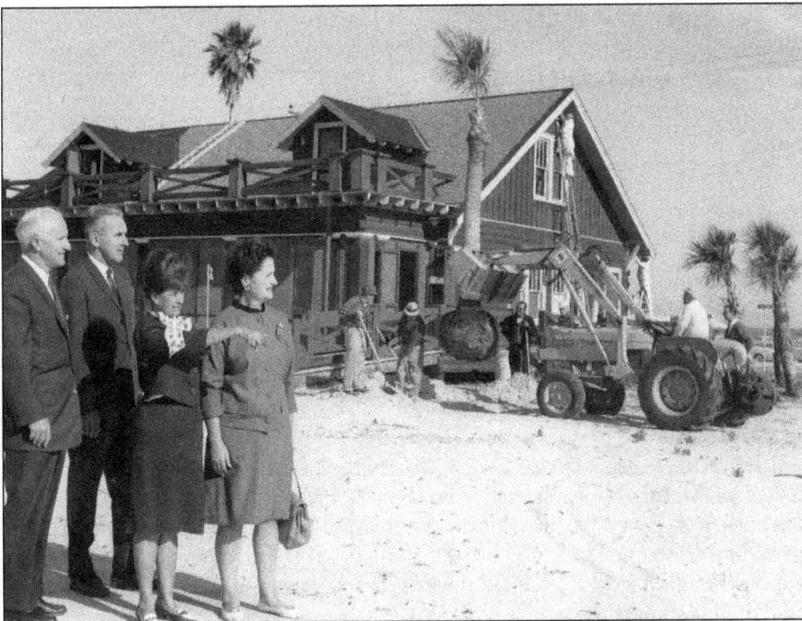

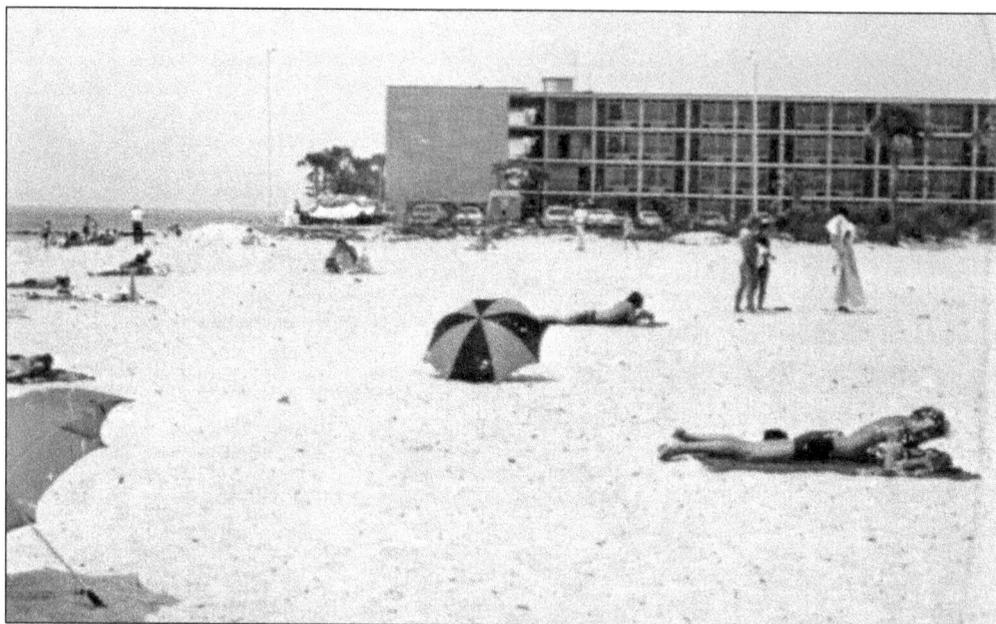

Known as Archibald Beach Park in the 1970s, the former VA property attracted crowds. While veterans from Bay Pines continued to visit the cabin, the Snack Shack also became a popular place to buy hamburgers, hot dogs, and other provisions. This postcard view from the mid-1970s shows bathers at the park. The Holiday Inn that had recently replaced the Sans Souci Cottages appears in the background. (HV.)

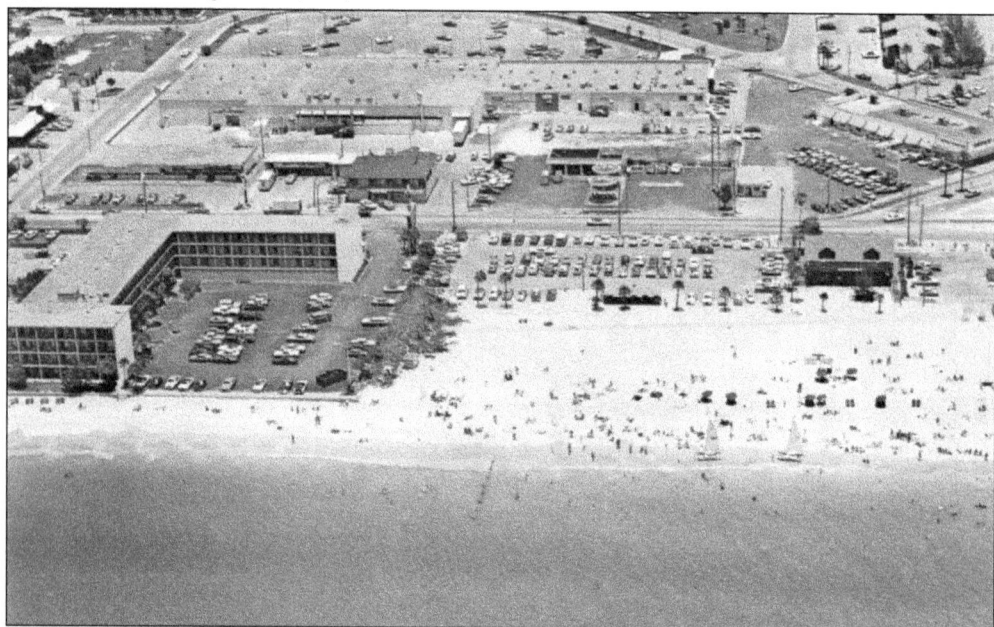

This aerial view of Archibald Beach Park from the late 1970s illustrates dramatic differences from just 15 years earlier. A paved parking lot and municipal beach surrounded the original wooden cabin. Carter Plaza, Olympic Plaza, and other commercial establishments occupied the former site of Kirk Field on the other side of Gulf Boulevard. What was sand in the early 1960s had become asphalt and concrete a mere decade later. (HV.)

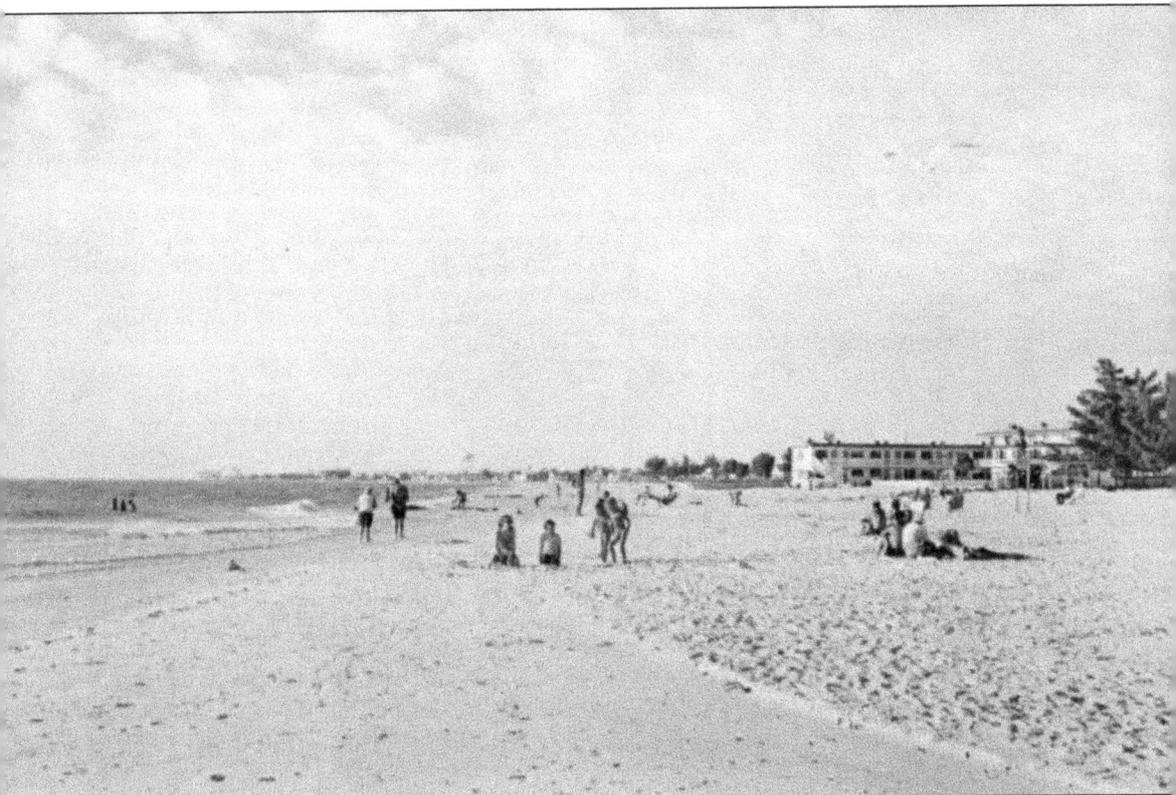

This view looking from the area just north of Johns Pass towards the northern part of Madeira Beach captures a landscape on the cusp of change. Although the water tower along 150th Avenue remains the tallest feature on the horizon, many of the one- and two-story cottages and hotels along this section of the Gulf of Mexico soon met the wrecking ball. In some cases, longtime owners received an offer they could not refuse; at other times, escalating property values, ad valorem taxes, and insurance costs forced landowners to sell against their will. The nature of tourism also changed as the beach cottages, motels, and smaller hotels disappeared. In their place rose condominiums and time-share resorts that provided more amenities but often at much greater expense and frequently with less flexibility. As real estate became more expensive, other businesses that tourists patronized, such as restaurants and gift shops, also had to find new strategies to stay afloat along the beach. (HV.)

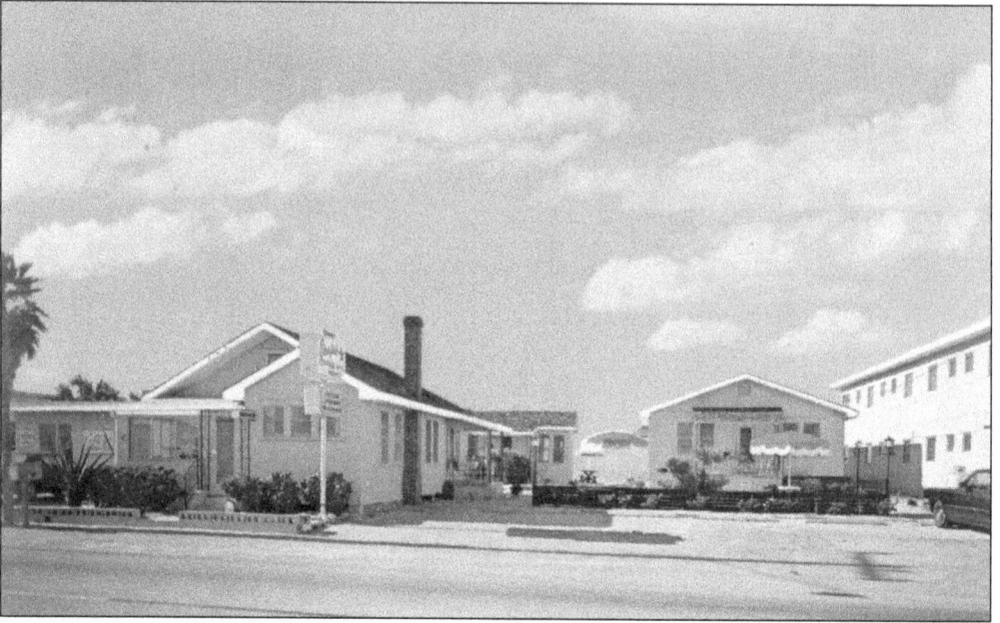

A few of the older hotel and apartment complexes remain in business. Their footprint along Gulf Boulevard may seem small when compared to their taller and newer neighbors, but their presence ensures a diverse array of accommodations in Madeira Beach. The Starfish Cottage Apartments, located along the beachside of Gulf Boulevard, was one of the earliest developments halfway between John Pass and Archibald's Madeira Casino. Built in 1936, the dwellings look the same today as they do in the late-1960s postcard above. Located a mile north on the bay side at Gulf Boulevard, the Holiday Isles, built in phases between 1950 and the mid-1960s, also retains its original architecture. It is seen below in the 1960s and still welcomes weary travelers seeking sand in their toes. (Above, HV; below, GBPL.)

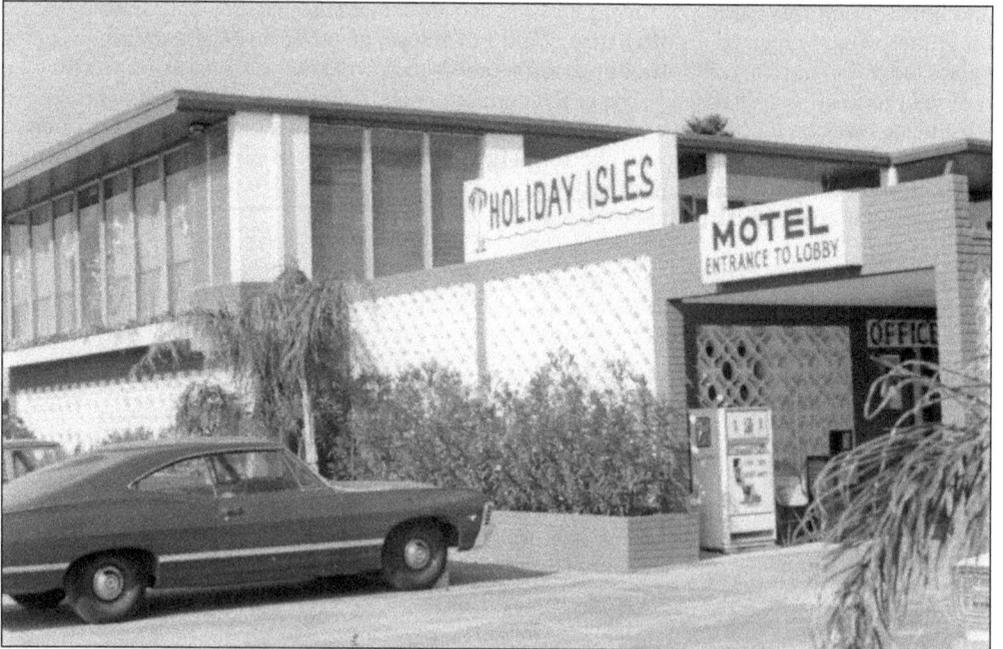

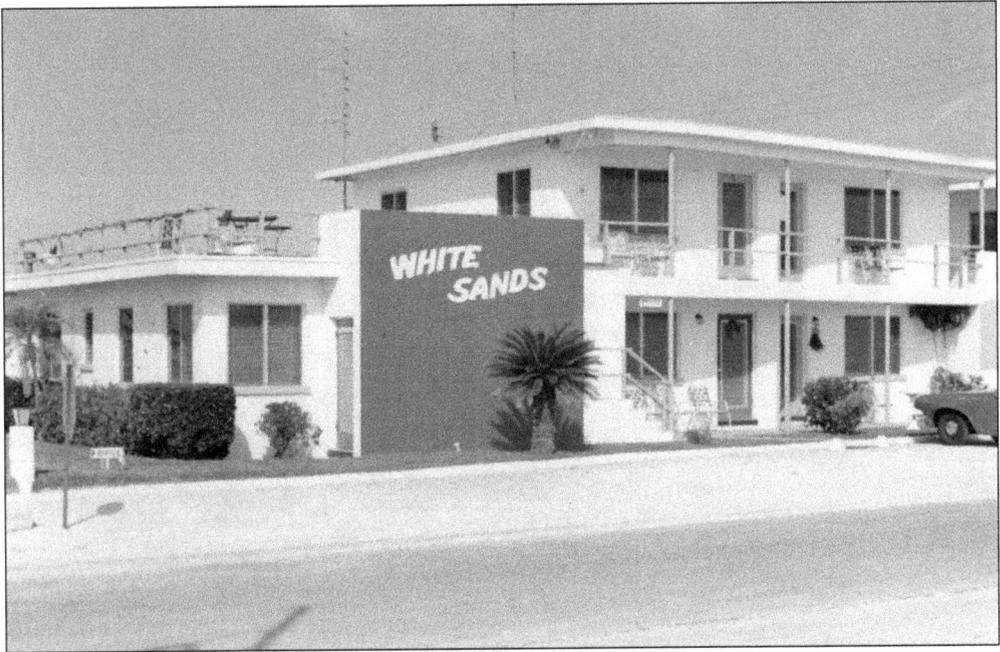

Some structures remain but now serve a different purpose. The White Sands, located at 13701 Gulf Boulevard and seen here in the 1960s, hosted tourists and snowbirds for many seasons. Today, the two-building complex originally constructed in 1952 provides office and storage space for the Church by the Sea and is also the home of the church's thrift shop. (GBPL.)

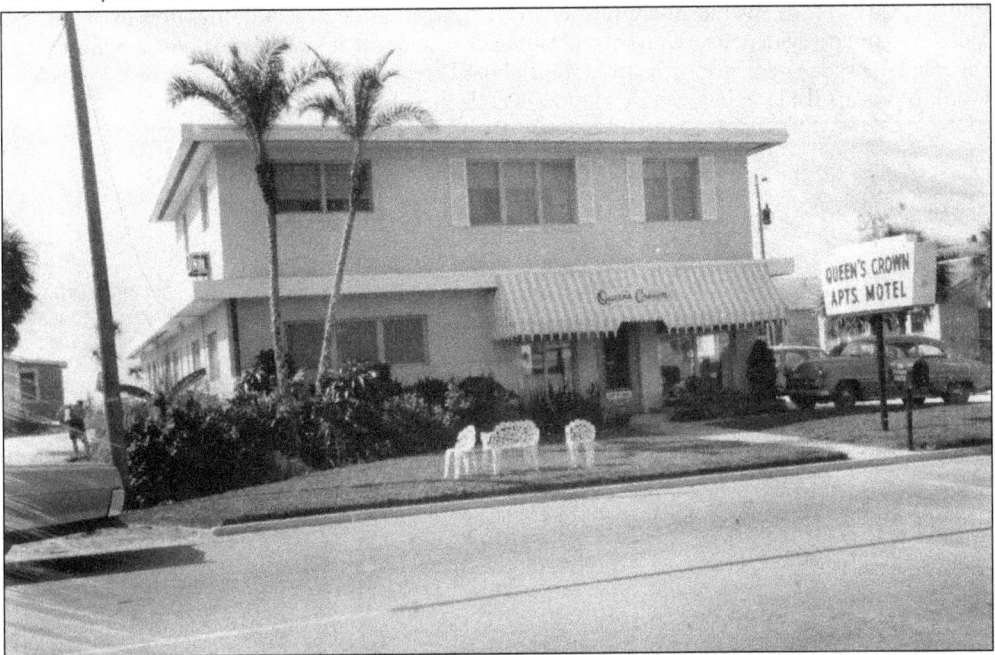

The former Queen's Crown, located in the Lone Palm subdivision near 154th Avenue, has not operated as a motel for decades; however, this structure originally constructed in 1956 continues to serve residential purposes under private ownership. The cottages on the right disappeared more than 30 years ago. (GBPL.)

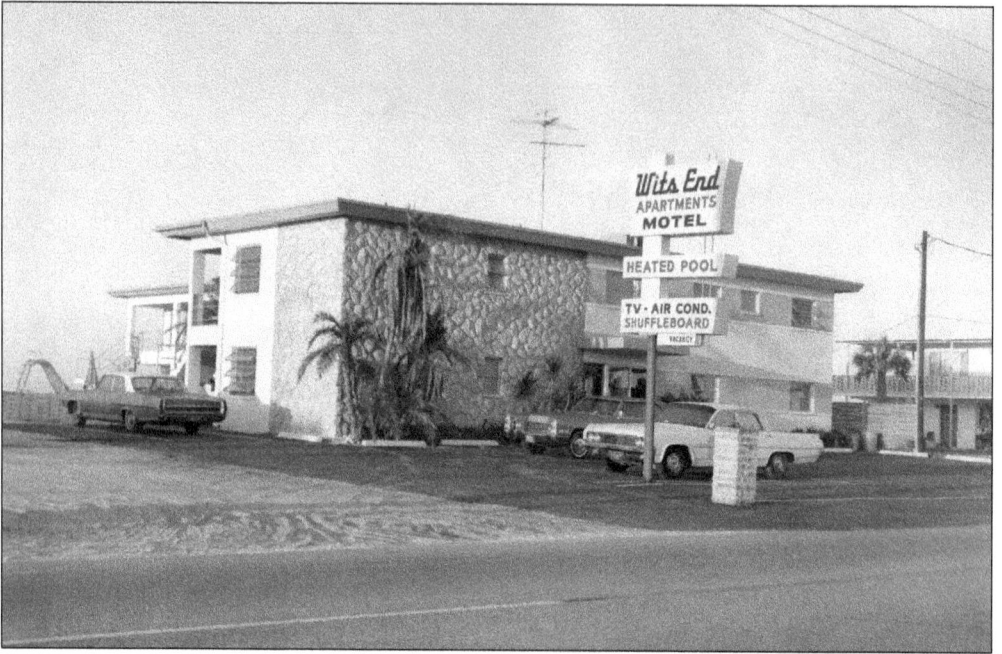

Although some of the 1950s and 1960s–era hotels continue to thrive along Gulf Boulevard in nearby Treasure Island, most of the hotels and motels built before the 1970s have disappeared from Madeira Beach. Two structures demolished years ago are the Wit's End (above), once located at 13600 Gulf Boulevard, and the Skyline (below), a motel that once sat on the bay side at the intersection of 140th Avenue and Gulf Boulevard. Larger residential buildings now exist at these locations, and no evidence remains of the motels that once sat at either site. Some amenities that appealed to bygone generations, such as shuffleboard courts, have disappeared from larger resorts today. (Above, GBPL; below, Sandy Holloway collection.)

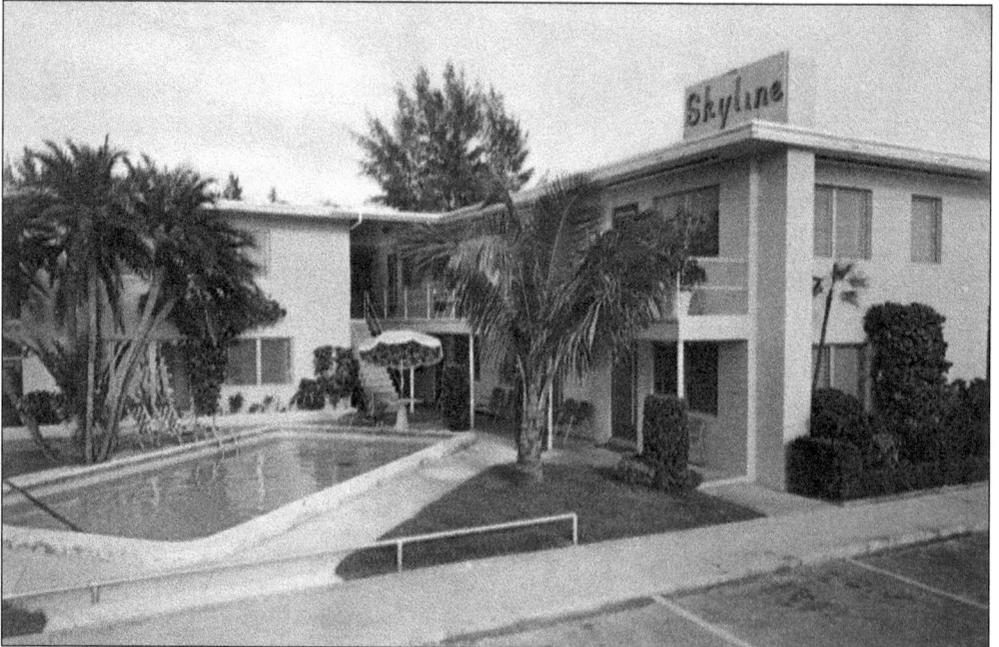

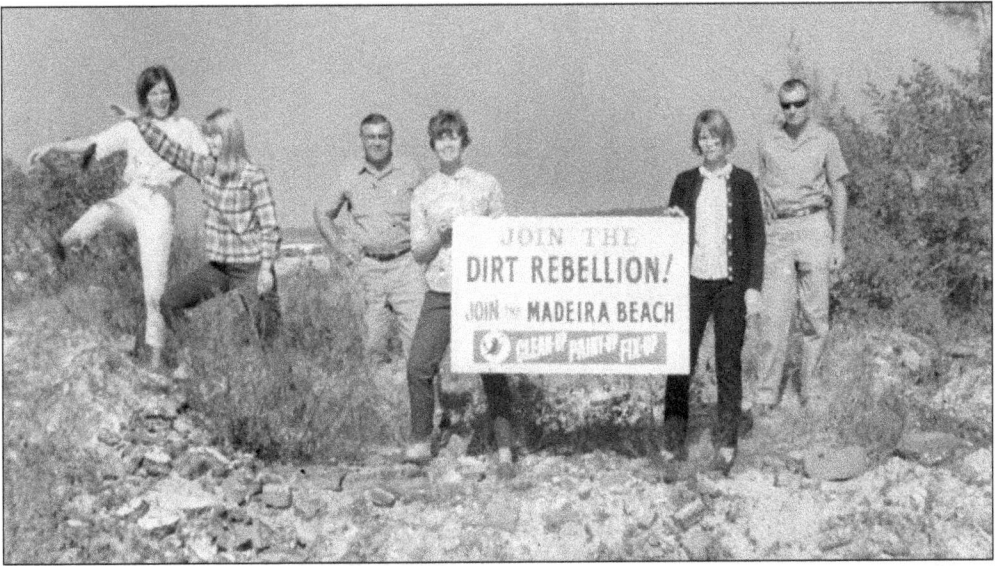

In addition to gardening and landscaping along city streets and parkways, members of the Island Garden Club sponsored other cleanup activities along the beaches. This publicity photograph, taken along an undeveloped area near Johns Pass in the 1960s, encouraged others to volunteer their efforts to help in the "dirt rebellion." (GBPL.)

A familiar sight to anyone living on or visiting the Pinellas Gulf Beaches in the 1960s and early 1970s, this image shows Municipal Drive at the intersection with Gulf Boulevard looking towards the water tower that dominated the skyline until the early 1980s. Winn-Dixie still operated out of its original 1949 store (left), and Madeira Rexall Drugs, the Riptide Bar, June's Florida Fashions, and a variety of other businesses welcomed customers. (GBPL.)

A railroad dining car replica built in New Jersey arrived in Madeira Beach in 1952. Prominently perched at the intersection of 150th Avenue and Madeira Way, the Cajun Diner became a popular restaurant and round-the-clock gathering place. George and Patricia Shontz expanded the menu in the 1960s, attracting regular customers. Seen above in its early years, the diner also hosted fundraising events for groups such as the Beach Boosters, as seen below on the left. In November 1978, the original diner was moved to the Johns Pass area and became Cajun South, while Pat and George Shontz developed a larger restaurant on the original site, first known as Cajun North and then as the Cajun Apple. The restaurant at Johns Pass later became the Village Landing Restaurant. (Both, GBPL.)

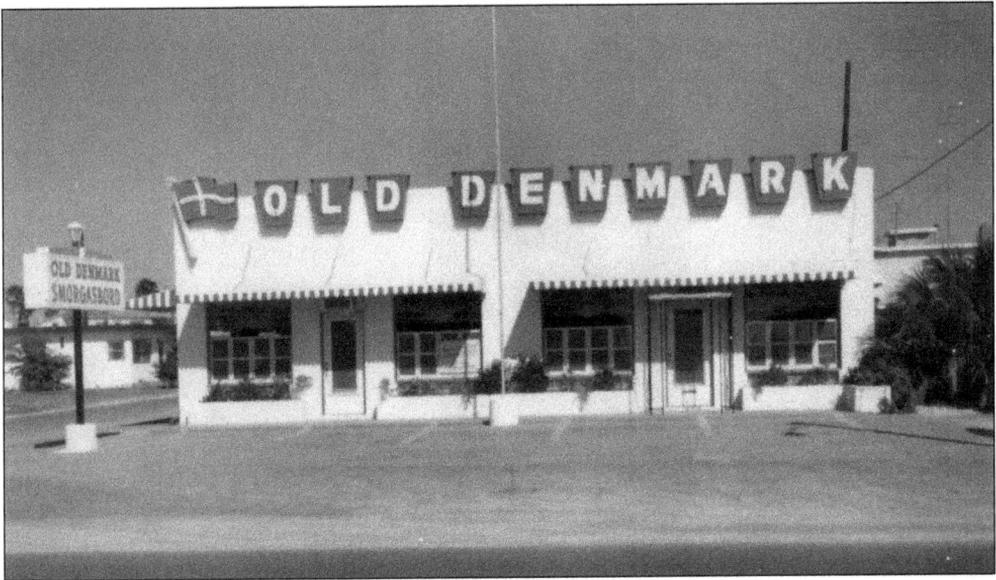

From the 1950s through the 1970s, the Old Denmark served popular Scandinavian smorgasbord and off-the-menu dinners just south of 147th Avenue along Gulf Boulevard. Niels and Anki Kjeldgaard closed every summer from mid-August through September before reopening for the season. After the Kjeldgaards retired, Poul and Carol Madsen operated the Old Denmark and later opened the Scandia Restaurant in Indian Shores. Both restaurants have since closed. (GBPL.)

Eugene "Gene" Mueller invested $300,000 to build Gene's Lobster House next to Welch Causeway. Opened in January 1965, the 6,500-square-foot building had a 90-foot-long window view across the Intracoastal Waterway towards the mainland. This upscale restaurant also included a "necessity house" in its early years for boaters who wanted to shower and change into formal attire before dining. The restaurant closed many years ago. (HV.)

Seafood as only Gene Mueller serves it. Great steaks and cocktails, too.
Entertainment in the lounge nightly.
Free parking for car or boat.
Open noon till very late.

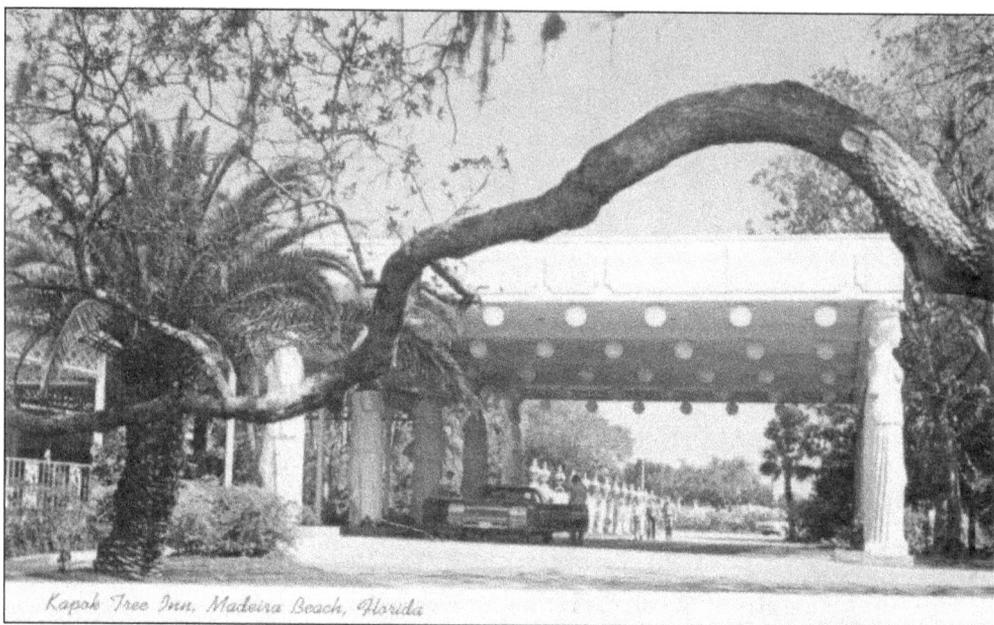

Kapok Tree Inn, Madeira Beach, Florida

An elaborate and exotic restaurant opened along Duhme Road in the early 1970s. Similar to its older sibling on McMullen-Booth Road in eastern Clearwater, the Kapok Tree Inn of Madeira Beach offered an over-the-top dining experience. The restaurant sat along a large parcel at 5001 Duhme Road, less than a mile from the Madeira Beach city limits, on lands acquired by Frank Duhme in the early 1900s. Duhme planted elaborate gardens before passing away in 1920. Other family members maintained the property before the Kapok Tree opened. Known for its relish trays and apple butter, the Kapok Tree offered signature entrees and exaggerated décor. One might have described the Rajah Lounge as garish, though beautiful gardens, seen below in their later years, did adorn the site during its heyday. (Above, HV; below, Lyn Friedt collection, HV.)

The dining rooms in the Kapok Tree had quite an amazing flair, and those who ate at the restaurant enjoyed an experience one would never encounter in a fast-food establishment or standard restaurant chain. This view looks at the entrance from the gardens. The building on the right, closest to the parking lot, originally served as a ticket window, where parties ordered their meals before walking towards the waiting area and the dining rooms on the left side of the image. After the restaurant closed, the Jewish Community Center (JCC) acquired the property in 1988. In the 1990s, the Tampa Bay Holocaust Memorial Museum and Education Center, the forerunner to the Florida Holocaust Museum, temporarily operated here before opening a permanent venue in downtown St. Petersburg. The JCC sold the property to a developer in 1998. (Lyn Friedt collection, HV.)

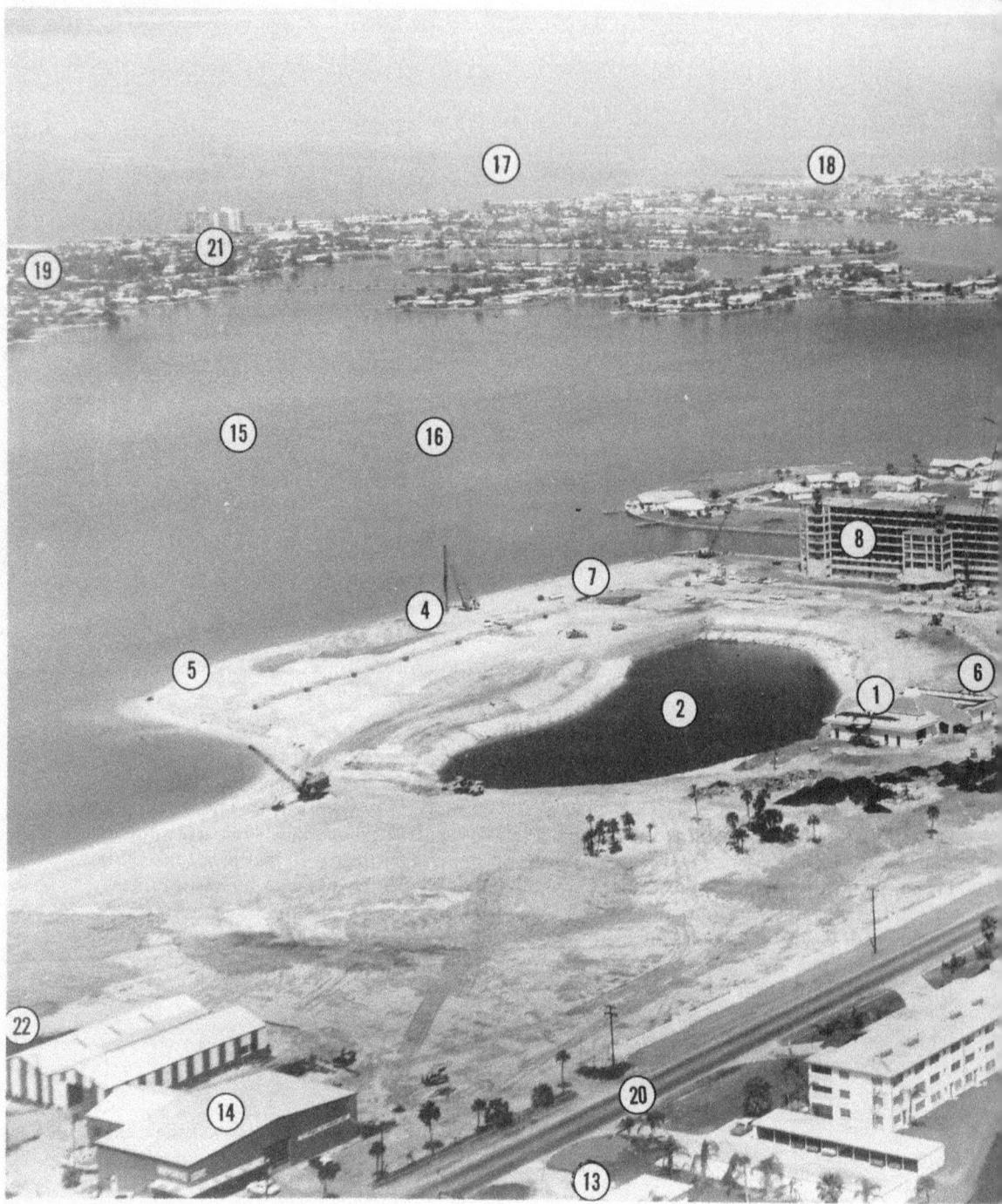

1) RECREATION CENTER • 2) LAGOON • 3) COURTESY HOUSE • 4) PRIVATE BEACH • 5) FISHIN
8) COLUMBIA TOWERS • 9) HAMILTON HOUSE • 10) JEFFERSON HOUSE • 11) MADRIGAL • 12) LAR
MAINTENANCE CENTER • 15) INTRACOASTAL WATERWAY • 16) BOCA CIEGA BAY • 17) GULF
20) DUHME ROAD • 21) REDINGTON REEF • 22) INDEPENDENCE COVE MARINA

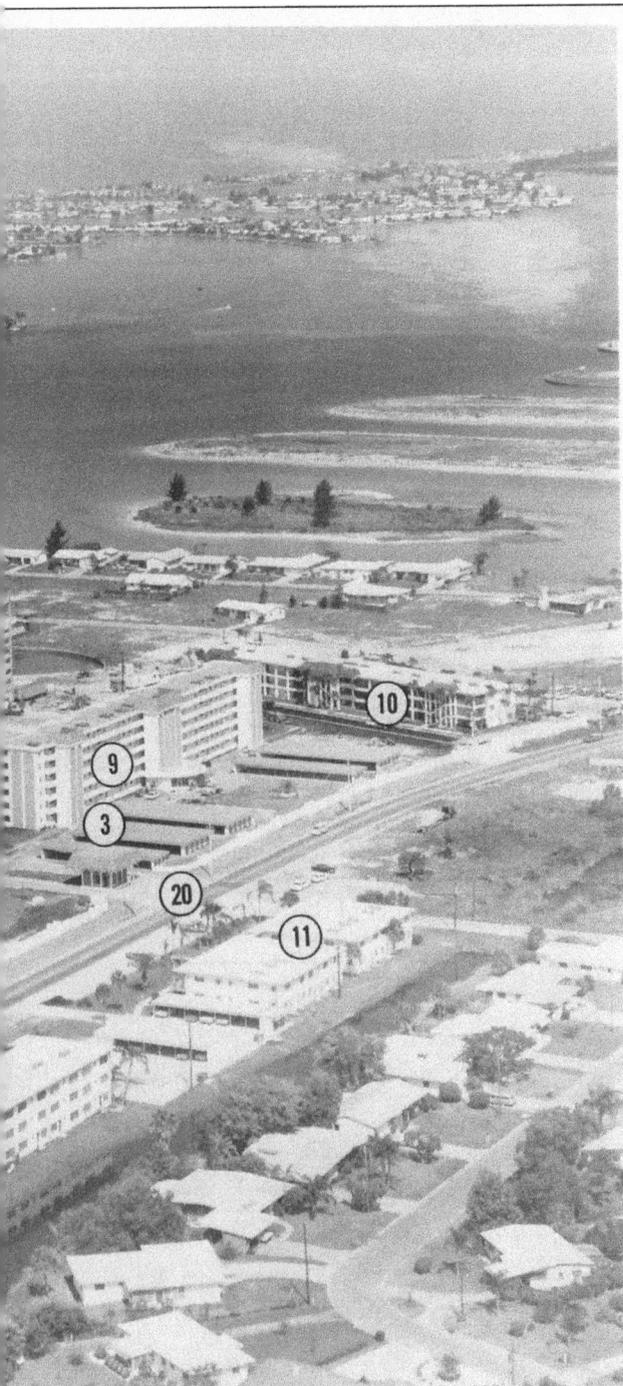

Constructed in the early 1970s, the Sea Towers condominiums dominated the skyline on the mainland. Although located just outside of Madeira Beach city limits, most who live there consider themselves part of the island community. The success of the Sea Towers, along with the widening of Gulf Boulevard in Madeira Beach, encouraged developers to purchase older properties along Gulf Boulevard and build condominiums along the shoreline. This promotional photograph shows the site under construction in the early 1970s on land dredged a decade earlier. Redington and North Redington Beach appear in the background. During a 1973 sales promotion, units with "moderate prices" ran from $13,690 to $38,490. (USFSP.)

TE • 6) POOL - TENNIS • 7) LEXINGTON TOWERS
• 13) MODEL APARTMENTS • 14) INDEPENDENCE COVE —
CO • 18) FISHING PIER • 19) GULF BOULEVARD

Above, workers and volunteers are seen in the 1960s installing trees in front of the sign on the island side of the Welch Causeway welcoming people to Madeira Beach. Often, members of Madeira Beach Cub Scout Pack 354 assisted with cleanup efforts at the sign, as seen below, as well as at other locations on the island. Many of the homes built along the barrier islands between the 1950s and the 1970s attracted growing families. For example, homes of approximately 1,200–1,500 square feet that were not directly on the waterfront could be purchased for under $20,000 in the mid-1960s. Escalating property values and insurance costs—including the mandatory wind and flood damage endorsements—had not yet made island living out of the reach of working-class families. (Both, GBPL.)

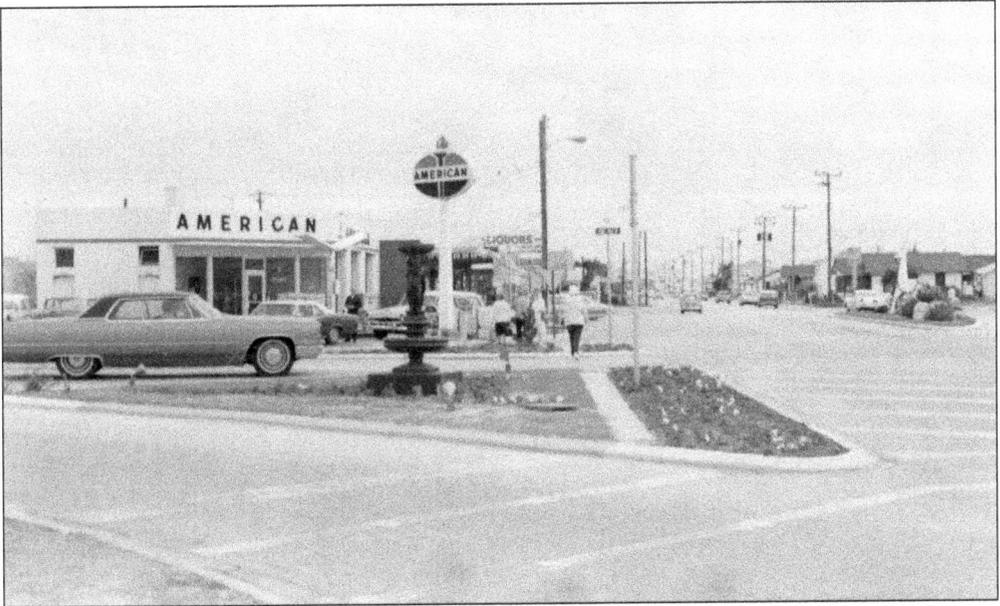

This late-1960s view of the intersection of 150th Avenue and Gulf Boulevard looks south along a two-lane boulevard with one-story structures. After many appeals and nearly 18 years of unfulfilled—and unfunded—promises by the Florida Department of Transportation, Gov. Reuben Askew's office approved plans to widen Gulf Boulevard from Johns Pass through Madeira Beach on June 3, 1974. This project was worked on during the second half of the 1970s and required the purchase of land from 107 property owners. The newly expanded roadways allowed condominium developments to sprout along the expanded roadway by the end of the decade. The same intersection is seen below in 2013. (Above, GBPL; below, author.)

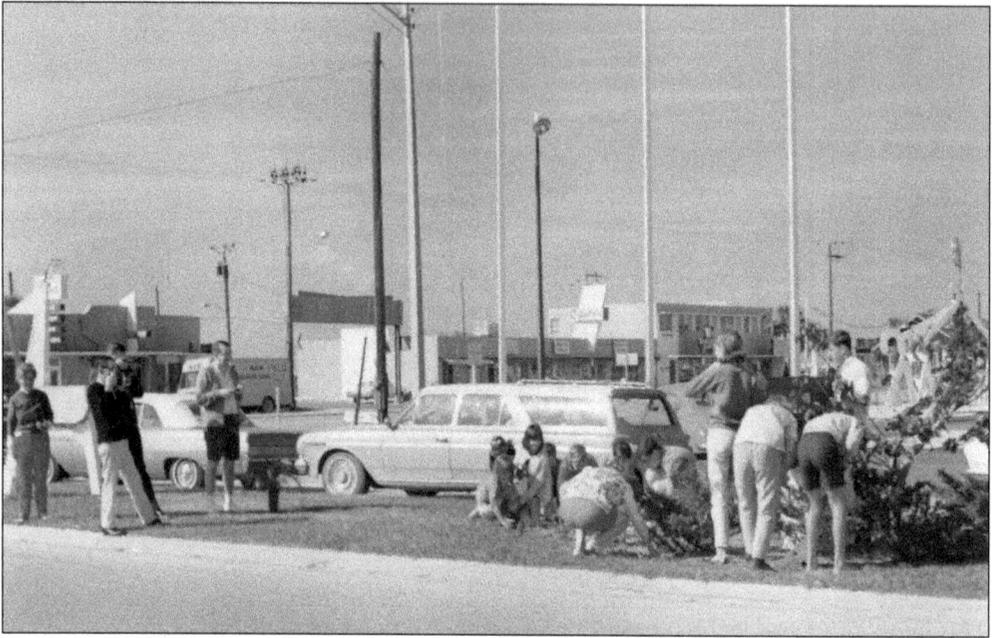

Above, Island Garden Club members and their families have gathered along the median at the intersection of 150th Avenue and Gulf Boulevard in the 1960s. The view across Gulf Boulevard shows some of the older Madeira Casino buildings, which formed the heart of the shopping district in the mid-1960s. The view below, from a slightly different perspective, shows in the background the beachfront parking behind the former Casino properties. Merchants often had to contend with those who parked a few steps from the beach but never purchased anything in the stores. The Texaco, seen below in the foreground during a 1960s remodeling, occupies the spot where one of the first gas stations appeared along the Pinellas beaches. In November 1936, developers announced plans to build a "$12,000 modernistic service station" there. (Both, GBPL.)

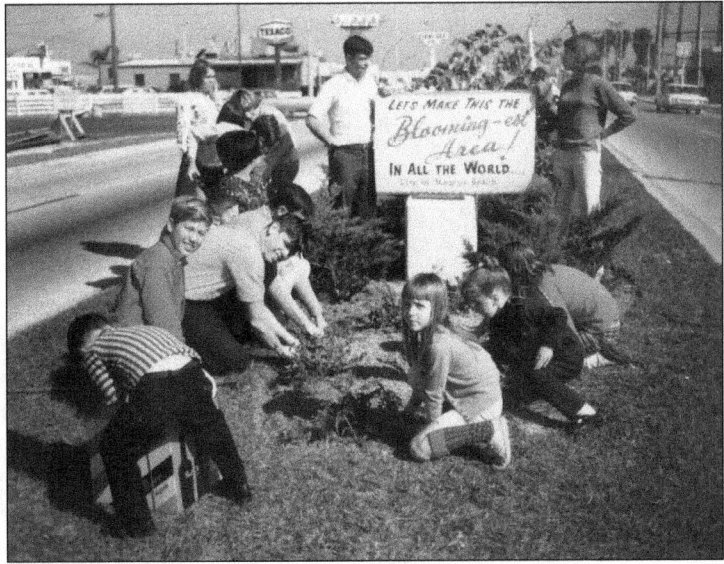

This photograph shows those gathered on the opposite page from the perspective of 150th Avenue looking towards the Welch Causeway. Throughout the 1950s and well into the 1960s, members of the Island Garden Club and other groups worked diligently to create their version of a "city beautiful" along a landscape that many had considered a sandy wasteland just a half century earlier. (GBPL.)

Two popular clothing stores in Madeira Beach that occupied prime real estate on the former casino property were Rinez and Larrie's menswear stores, seen here in the mid-1960s. These stores catered to snowbirds during the tourist season and residents throughout the year. In addition to the parking lot adjacent to the beach, customers could also park along Gulf Boulevard at the time. (GBPL.)

Shoppers often visited the Isle Variety Store for various supplies and sundries. Located on the east side of Gulf Boulevard just south of 150th Avenue, this shop carried all of the items beachgoers might expect, such as suntan lotion and beach towels. Tourists could also purchase "canned sunshine" made in Florida, though only a dark and empty can remained for those who grabbed the can opener. (GBPL.)

Residents enjoyed having a hometown bank during this era as well. The Madeira Beach Bank occupied a prominent place along Gulf Boulevard just a few steps to the south of Isle Variety. Tellers at the original drive-through windows, seen here in the late 1960s, passed out lollipops to parents for their children. By the 1980s, the bank merged with other financial institutions and the name disappeared. (GBPL.)

102

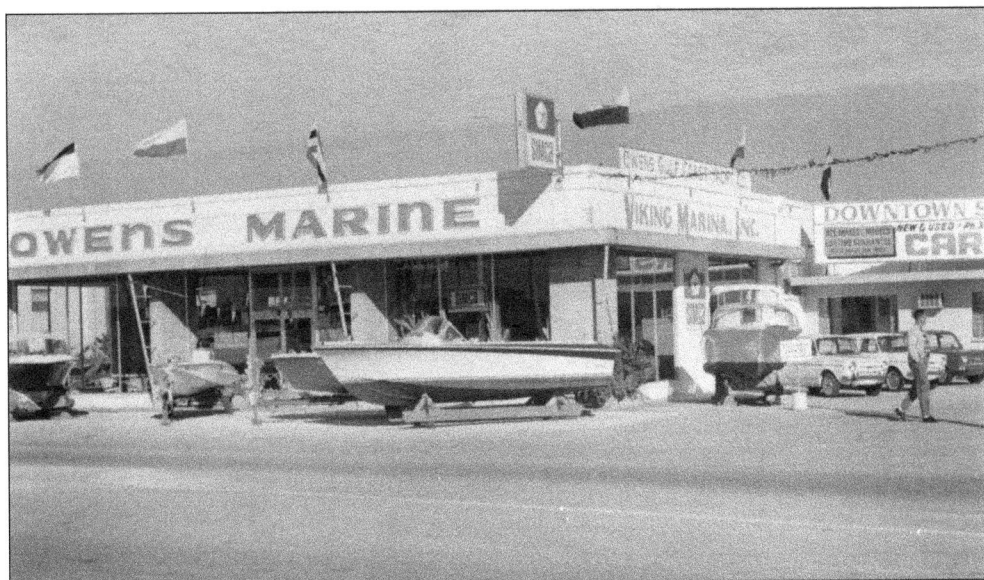

Many of the older structures along Madeira Way have changed tenants. The larger building above, adjacent to the post office and across the street from the site of the Cajun Diner, served as a boat dealership for many years. Although the names changed on the outside, the newest boat models continued to attract gawkers in the interior showroom. For a time in the late 1960s, a car dealership even offered compact vehicles, a rarity when most automobiles built in the United States had much larger profiles. Other merchants, including antique dealers, have sold merchandise from this facility since the last boat sailed away. Just to the south where Madeira Way meets 150th Avenue, the Madeira Beach Garage, seen below, kept vehicles in top shape. A gas station has occupied the spot for more than 50 years. (Both, HV.)

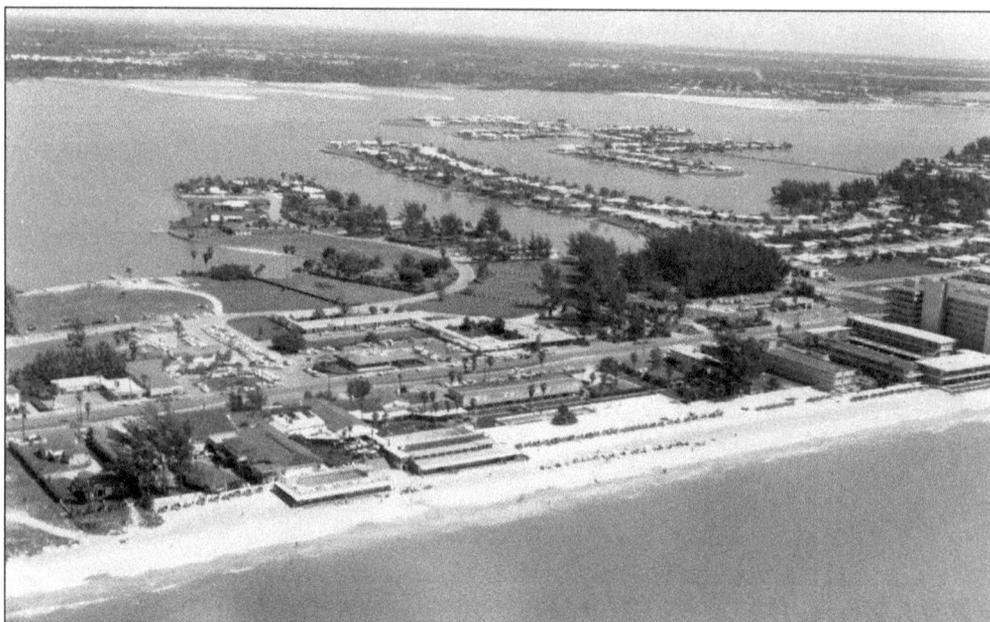

In the late 1960s, the Tides and Bath Club remained a popular destination, while the Bath Club Estates development of North Redington Beach took shape. The tall pine trees across Gulf Boulevard from the Redington Reef, seen here in the center right, obscured a tennis court facility that also was part of the Tides Hotel. Condominiums and townhomes now occupy large portions of the bayside and beachfront portions of this image. (GBPL.)

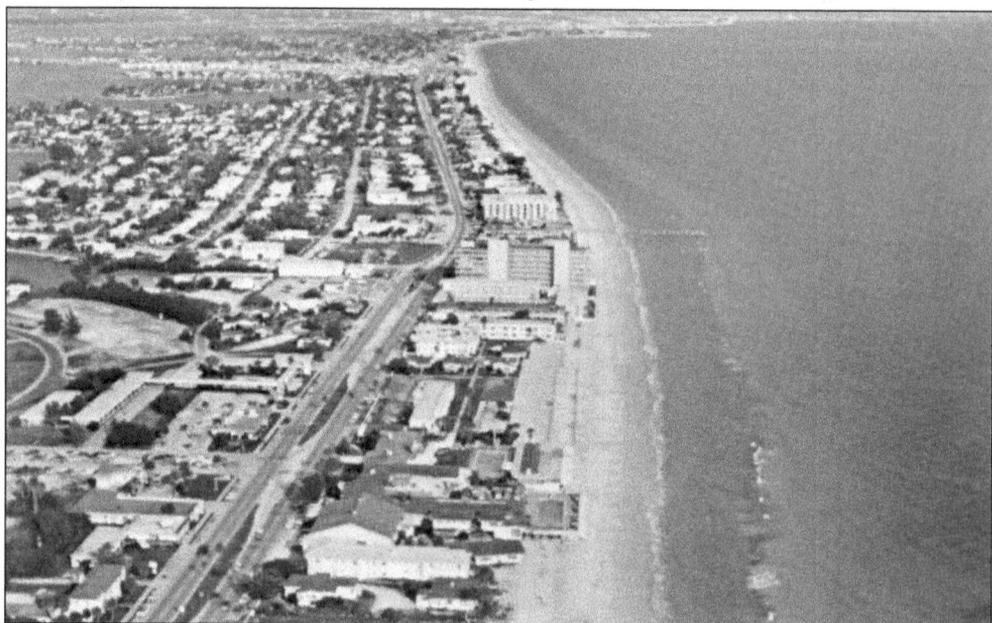

This aerial view from a different perspective looks from the Bath Club, with its two swimming pools, southward towards Redington Beach and Madeira Beach. Note that Gulf Boulevard remained a narrow, two-lane road through Redington until the 1980s. Aside from a few businesses and larger developments north of 163rd Avenue, Redington Beach has maintained its residential character. (HV.)

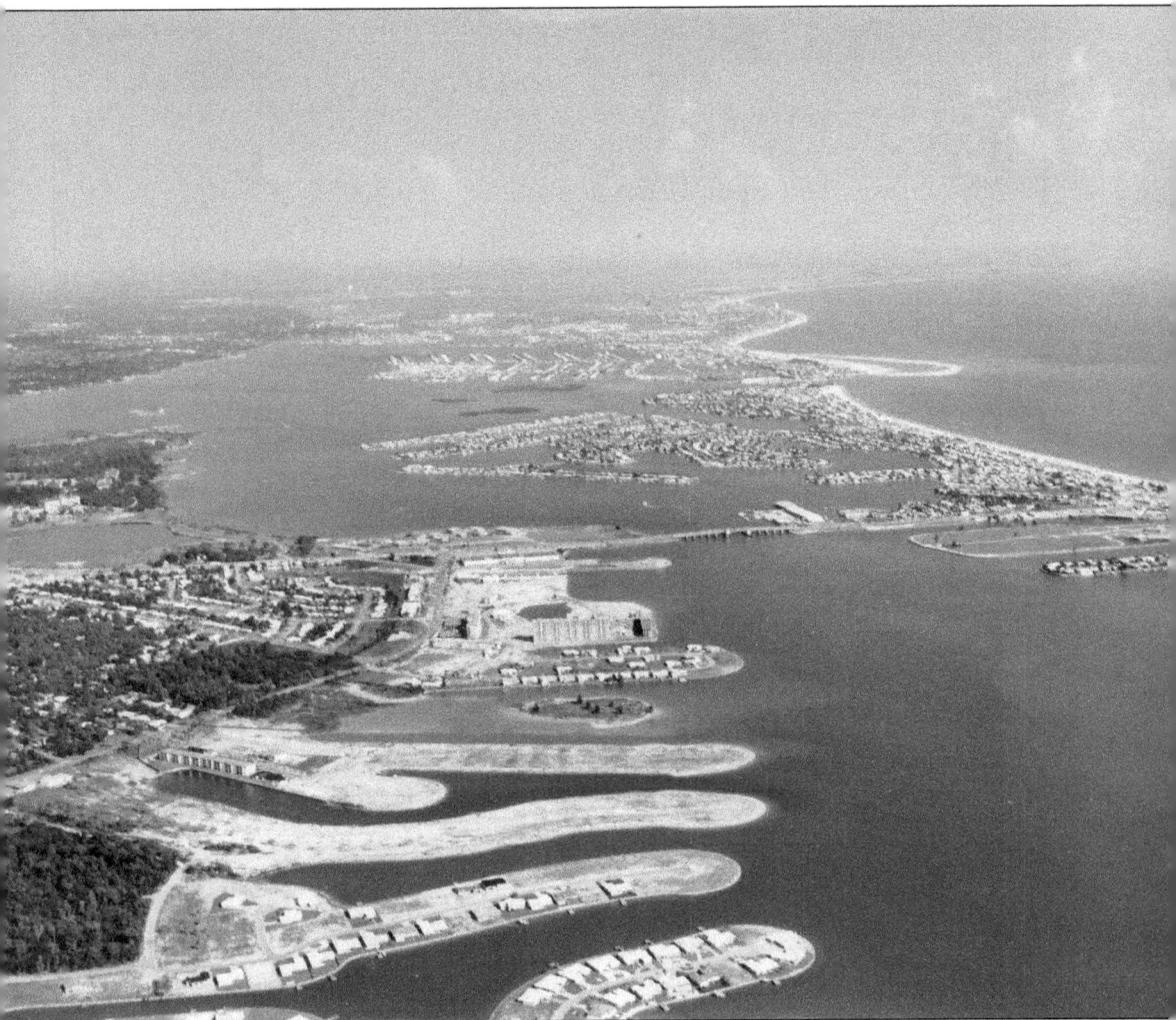

By the early 1970s, dredging operations had ended in Madeira Beach. Although the sites of the recreation center and the adjacent apartment complexes (center right, now the Madeira Beach Yacht Club condominium) remained undeveloped, most of the other properties along the beach had tenants, occupants, or forthcoming building permits. During the latter part of the decade, some developers turned their attention to Seminole and the unincorporated areas on the mainland adjacent to Seminole. With lower land prices and fewer flood concerns, investors carved up the remaining citrus groves and other parcels. Strong ties connect the mainland communities of Seminole with Madeira Beach and the Redingtons. Children from both sides of the causeway frequently attended the same schools in the 1960s and 1970s. Today, as they have for decades, Seminole residents enjoy sunsets along the beach, while those who live on the barrier islands frequently shop in nearby stores on the mainland. (USFSP.)

The sandlot above, which was truly not much more than sand, became a popular recreational field in the 1960s. The recently dredged field, seen here in 1961, became the Carter Plaza shopping center 15 years later. The tall pines on the right mark the Bay Palms Trailer Park, and a tall crane indicates that construction of the new bridge across Boca Ciega Bay had begun. From 1975 to today, customers leaving the shops of Carter Plaza, standing at the same point as the perspective of the image below, would see a parking lot and cars. In the early 1960s, however, civic leaders stood upon a lush "field of dreams" just a few years removed from its earlier existence as a submerged estuary. (Both, GBPL.)

In March 1949, the Winn & Lovett Grocery Company announced plans to open a Lovett's store at the intersection of Gulf Boulevard and the recently completed Madeira Way. S.Q. Carter managed the store when it opened, and he later became a vice president of stores along Florida's west coast. Renamed Winn-Dixie by the 1960s, the store sought to expand onto the site of Kirk Field as it outgrew its original 11,000-square-foot facility. Negotiations in 1970 led municipal and company officials to investigate whether the original landowner would waive a deed restriction calling for the baseball field site to be used for public purposes only. In January 1972, the city sold the 5.5-acre site to Winn-Dixie for $228,000. The ground-breaking for Carter Plaza, named in honor of the first store manager, was held in April 1974. After Carter Plaza opened in the mid-1970s, crews subdivided the original 1949 structure, and businesses continue to operate in that space today. (GBPL.)

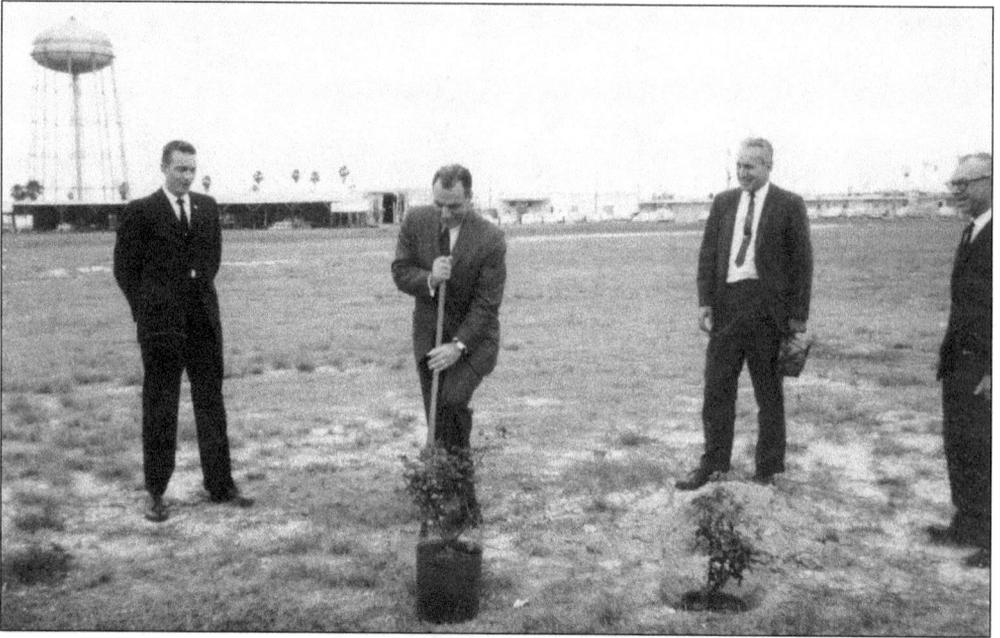

The creation of the original baseball field in the 1960s and plans for enhanced facilities along Rex Place to replace it in the mid-1970s required broad community support. While cameras often captured poses with civic leaders dressed in suits not usually worn for outdoor labor, such as in the view above near Municipal Drive, most of the work involved in these efforts required less formal attire, as seen below. Between the mid-1960s and the late 1970s, an organization known as the Beach Boosters raised funds for improvements to Madeira Beach's recreational facilities. Residents of neighboring towns like Redington Beach also became involved with the Beach Boosters. After Mike Maxemow assumed responsibilities as the city's recreation director in the mid-1970s, he and his staff expanded programs and events at what was known as the "rec center." (Both, GBPL.)

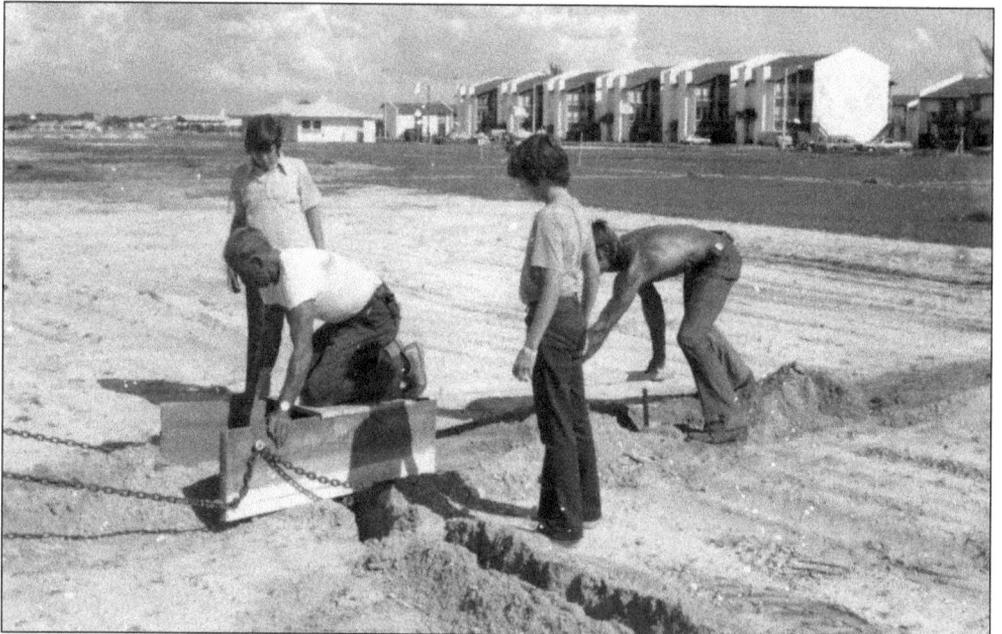

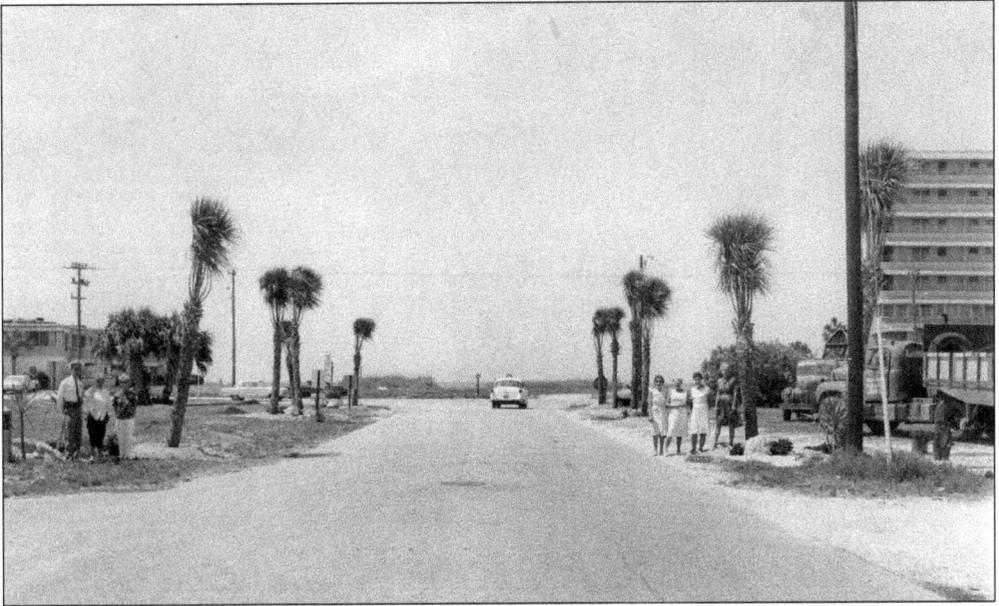

The Island Garden Club and other groups brought their beautification efforts to the adjacent communities as well. This view along 164th Avenue at First Street East near the Redington Beach Town Hall shows palm trees planted in the early 1960s. The site of the future town park is on the left, with the La Playa Apartments in the background. The eight-story Redington Reef is on the right. (GBPL.)

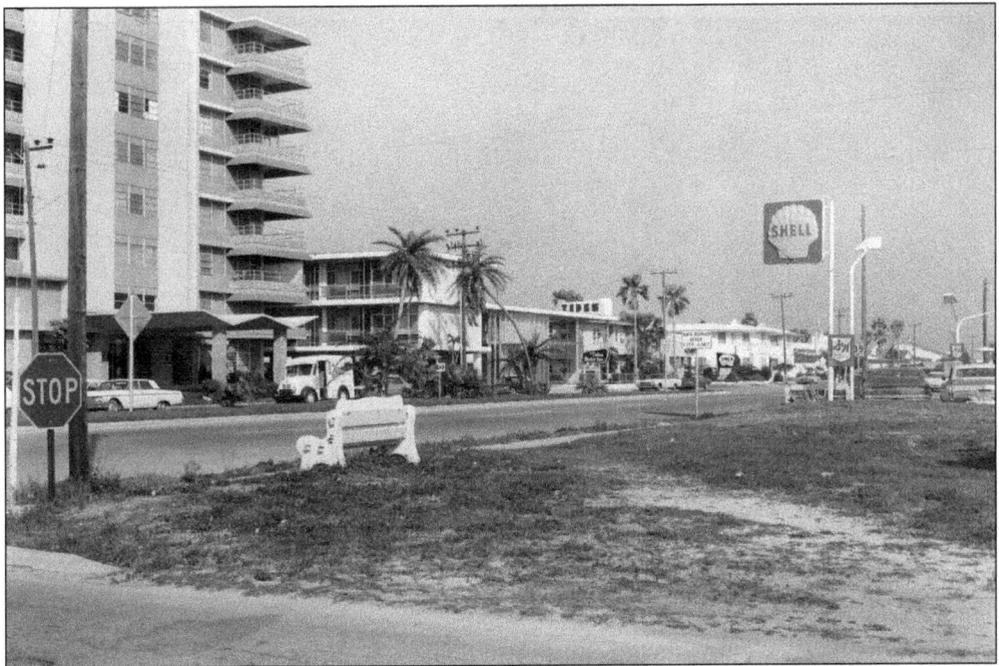

While Gulf Boulevard remained a two-lane thoroughfare in most of Madeira Beach until the late 1970s, drivers passing the Tides and Bath Club in North Redington Beach enjoyed traveling on a four-lane divided highway. Portions of Gulf Boulevard north of 153rd Avenue in Madeira Beach and the entire roadway in Redington Beach remained two lanes until the 1980s. (GBPL.)

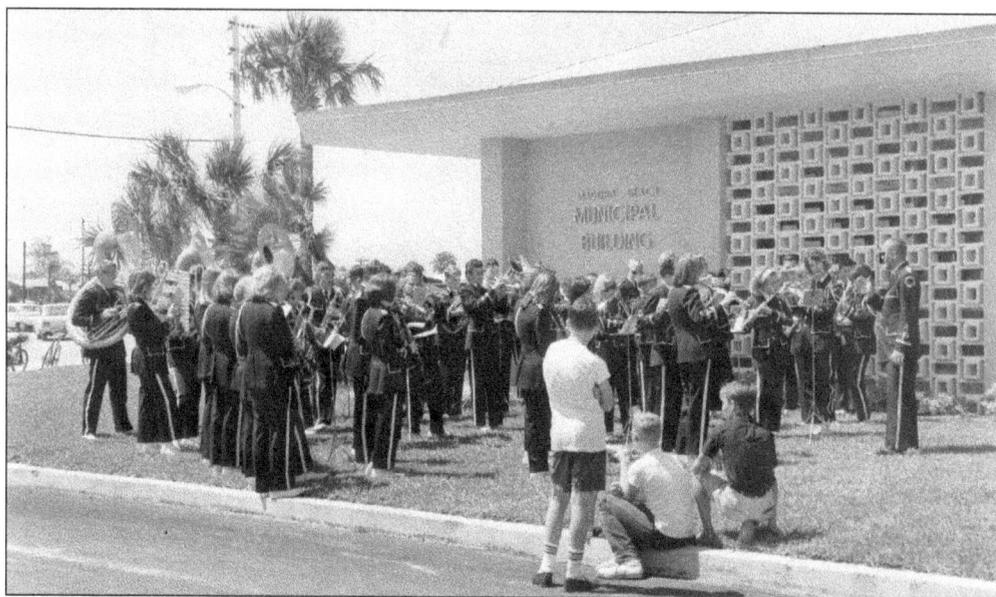

As dredging operations ended, a strong sense of community spread across Madeira Beach. The new municipal complex opened in the mid-1960s and became a popular gathering place for a variety of events. The hospitality industry thrived, with hotels, cottages, and restaurants enjoying banner years. When the first condominiums appeared, the balance of residential and commercial establishments remained strong; however, new opportunities and challenges soon appeared on the horizon. (GBPL.)

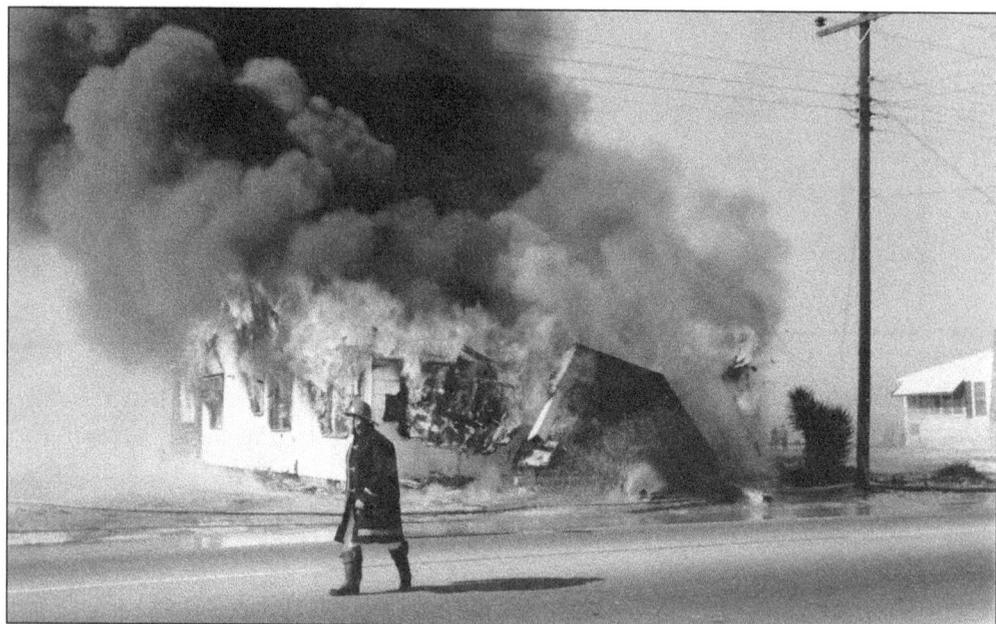

The first volunteer fire company in Madeira Beach organized in January 1948. For many years thereafter, firefighters practiced their skills on older cottages slated for demolition, such as this beachfront property at 13712 Gulf Boulevard. Their practice made for a perfect way to clear the landscape for the next generation of development. By the 1980s, cottages and bungalows faced extinction as condominiums reached new heights. (GBPL.)

Five

"CONDO MANIA" AND AN EVER-CHANGING COASTLINE
1981–2000

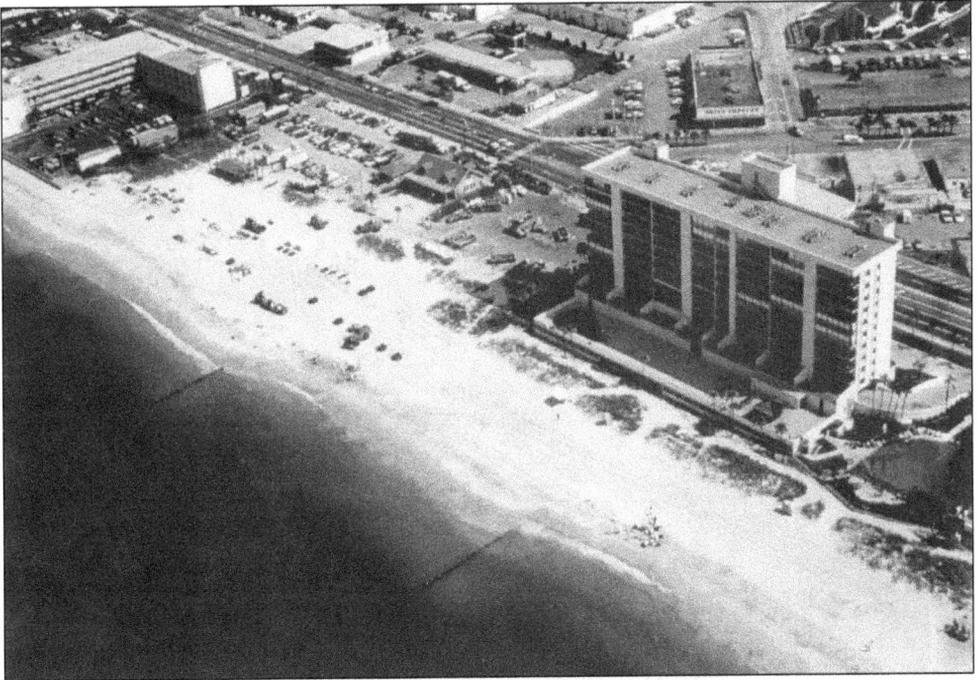

When the Holiday Inn (far left) opened north of Archibald Beach and the Snack Shack in the early 1970s, it was one of the largest structures in Madeira Beach; however, nearby condominiums dwarfed the hotel by the summer of 1993 when this aerial photograph was taken. In the 1980s and 1990s, condominiums appeared along both sides of Gulf Boulevard as cottages and smaller stores disappeared. (Skip Davis collection, USF.)

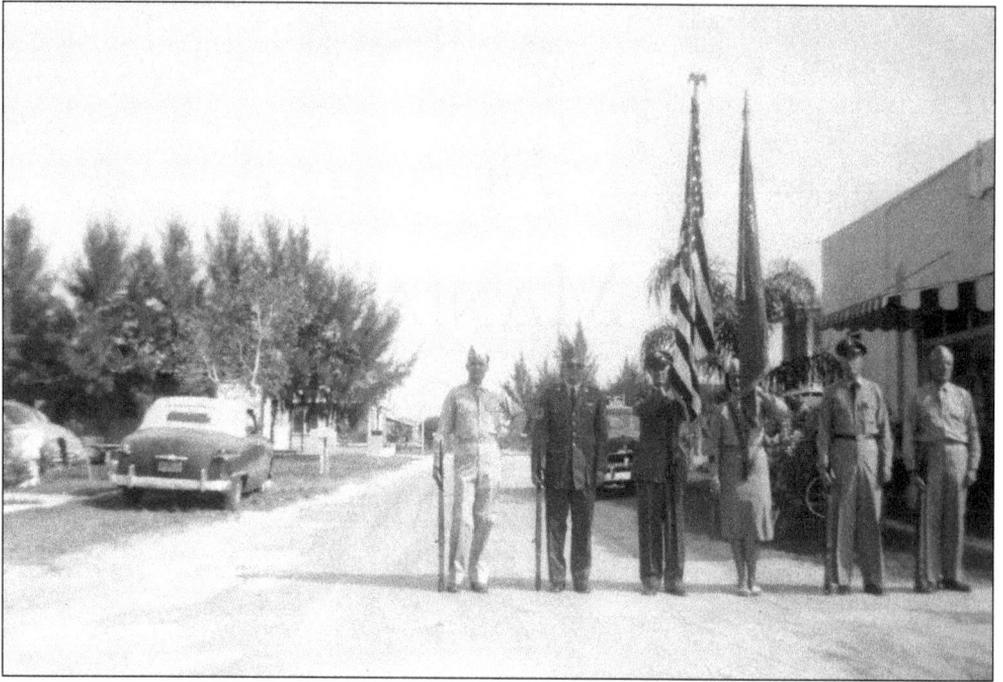

This early-1950s image shows members of American Legion Post 273 gathering in the middle of a then-quiet Gulf Boulevard near 147th Avenue. Gulfview Sundries, on the right, opened in 1949. Post 273 was on the beach, just behind the tall trees on the left. By the 1960s, the former post had become the popular restaurant and bar The Deck. (Sandy Luger collection.)

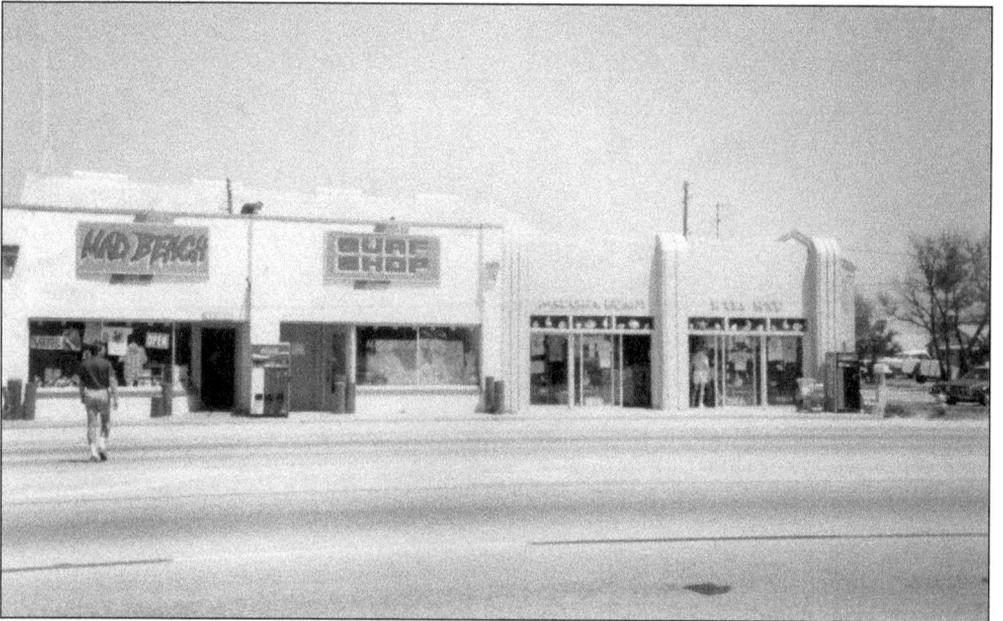

The Mad Beach Surf Shop, originally opened in 1976, occupied a prominent spot along Gulf Boulevard for nearly 25 years. Lorraine Porter started the business when she learned that the baggy swimsuits her son Rob loved to wear had become popular. Rob acquired the business in 1993 when his mother retired and moved it to St. Petersburg in 2001. (Lyn Friedt collection, HV.)

The Kingfish Cottages, once located a short distance away from the Mad Beach Surf Shop at 133rd Avenue, originally served as a barracks in the 1940s. This establishment continued to attract solid business in the 1970s, when Gulf Boulevard remained a two-lane highway north of the Johns Pass Bridge. The cottages are seen above in the early 1970s, while the photograph below shows the rear side of the units in October 1985. By 2002, the property had declined, and investors purchased this site as well as the adjacent stores, including the former surf shop. Condemned in 2003, these parcels are now the location of the Madeira Bay Resort. (Above, GBPL; below, Lyn Friedt collection, HV.)

Hurricane Elena wreaked havoc on Pinellas County coastal communities on Labor Day weekend in 1985. Although the full force of the storm never hit the Tampa Bay region, the hurricane stalled in the northern Gulf of Mexico and pounded the coastline with high waves and rain for days. Within Pinellas County, nearly 300,000 people evacuated, and mandatory evacuation orders covered all of the beaches. As residents returned to their homes, they drove past checkpoints staffed by the National Guard, found sand and debris along most roadways, discovered some instances of looting, and dealt with flooding in many homes. Even as the hurricane drifted towards the upper Gulf Coast, waves continued to pummel the shoreline, as seen in the image above looking towards Madeira Beach from the beach access near 160th Avenue in Redington Beach. The image below looks northwest along Redington Beach. (Both, author.)

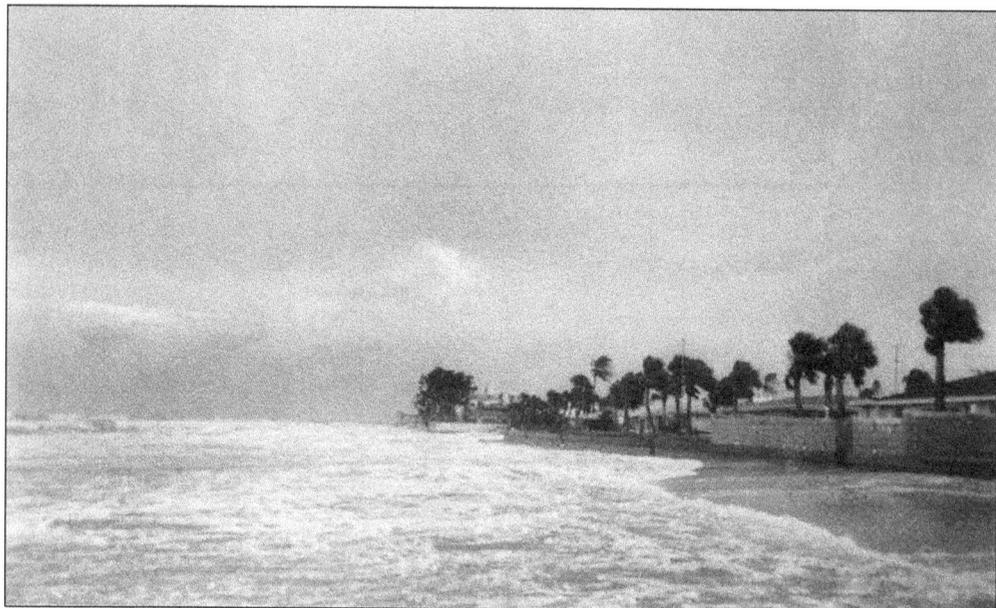

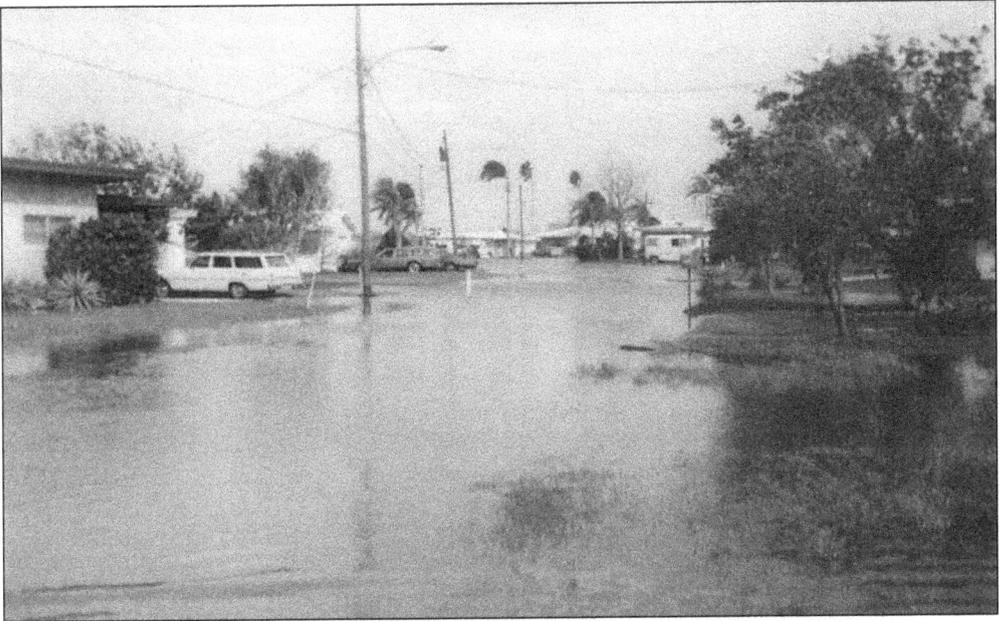

Flooding persisted along some of the barrier islands for days after Hurricane Elena. Madeira Beach and the Redingtons suffered their share of damage. The image above shows water starting to recede at the intersection of 161st Avenue and Redington Drive after Elena moved away from Florida. Below, saltwater continues to obstruct the 161st Avenue Causeway in Redington Beach after Elena. Other hurricanes and tropical storms, such as Hurricane Agnes in June 1972, have also caused extensive flooding. During Agnes, some streets had enough saltwater from the gulf and the bay on them that people used canoes along the roadways. The low elevations along the Pinellas Gulf Beaches and the consequent flooding concerns have transformed building codes since the 1970s. (Both, author.)

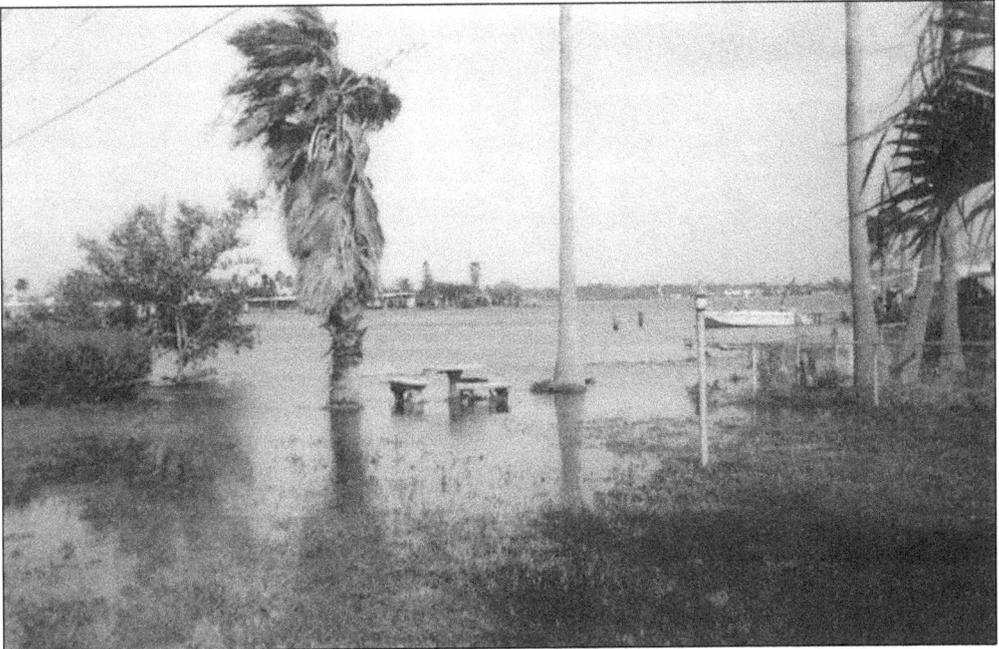

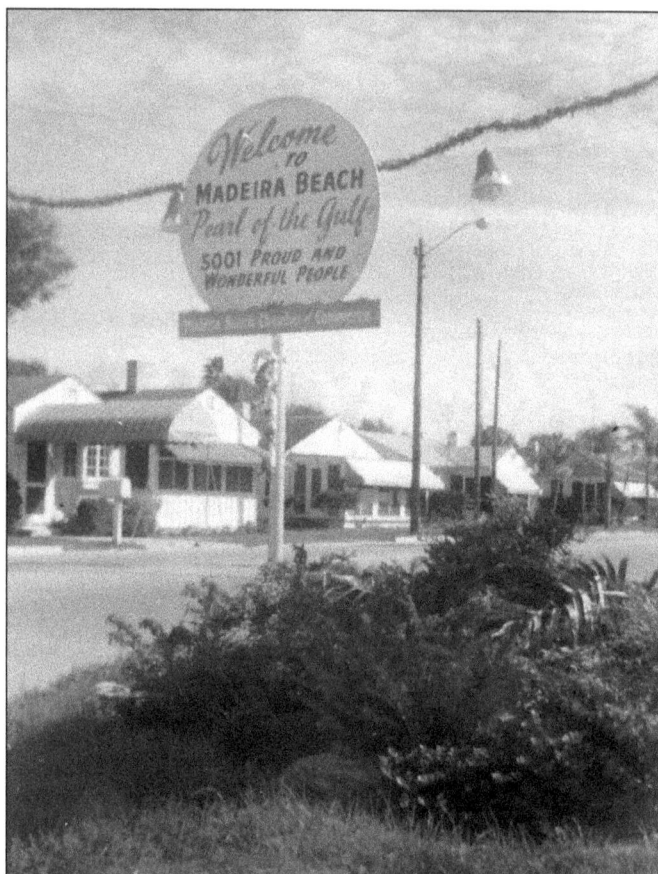

Larger developments replaced many of the small beach cottages that once dominated the area. In the Lone Palm Subdivision of Madeira Beach, north of Madeira Way, the Eden Garden Cottages sat alongside Gulf Boulevard near 155th Avenue. Small, simple wooden cottages, these buildings offered guests relaxing accommodations a few footsteps away from the beach on both sides of Gulf Boulevard. The view of the bayside cottages at left in the mid-1960s shows the office on the left and a few of the cottages near the Madeira Beach-Redington Beach town line. By the 1970s, a condominium replaced the gulf-side cottages. The office and the remaining bayside cottages, seen below in April 1987, also faced demolition. (Left, GBPL; below, Lyn Friedt collection, HV.)

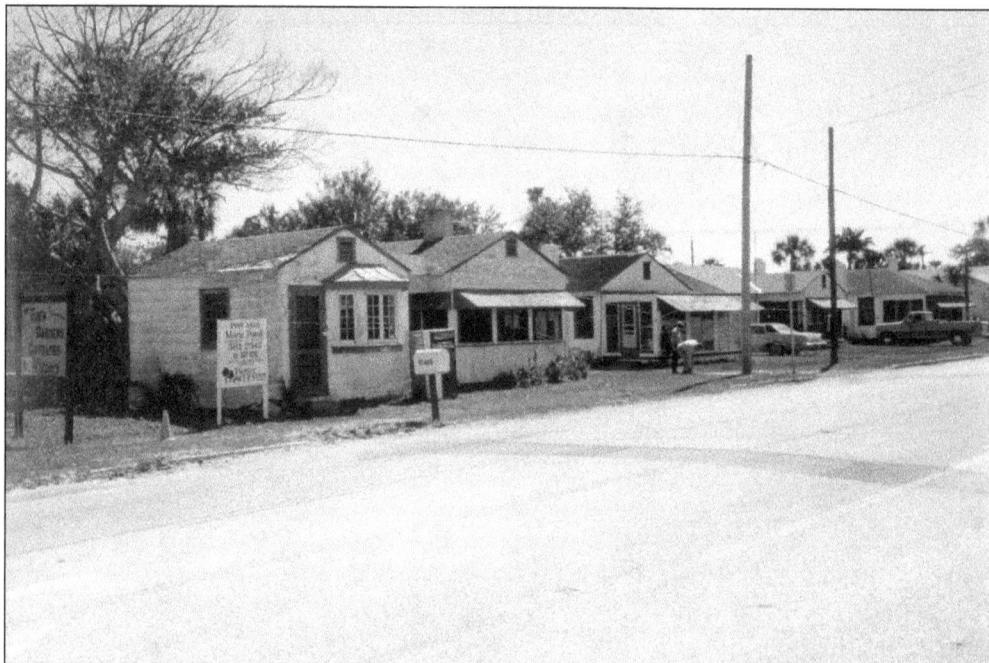

Surfside Tower, on the right side of the December 1989 image seen above, had replaced beachside bungalows a decade earlier in 1979. The area in the foreground, along First Street East near 155th Avenue, became ripe for development as well. Large multiunit structures now sit on both sides of the block, facing both Gulf Boulevard and First Street. Open spaces, especially waterfront lots, disappeared in the 1980s and 1990s, at the same time that many larger, multistory homes replaced smaller dwellings built between the 1940s and 1960s. Below, the former office at Eden Gardens awaits demolition, bringing an end to the cottages that so many had visited years earlier. (Both, Lyn Friedt collection, HV.)

Not all cottages and bungalows faced imminent demolition. In some areas of Madeira Beach, especially along Palm Street, Miramar Drive, Parsley Drive, and Marguerite Drive north of 140th Avenue, smaller homes built from the 1940s through the 1960s still adorn both sides of the road. The duplexes along much of 147th Avenue, seen here, survived the frenzied real estate markets of the 1980s and 1990s as well. (Author.)

One beach cottage from the late 1930s found a new home in a place of historical significance. Moved in 1997 from its beachfront location near 153rd Avenue, the cottage at Heritage Village now serves as the gift shop for the Pinellas County Historical Society, an organization that supports Heritage Village's efforts to preserve local history. (Pinellas County Government.)

While dredging and overdevelopment have adversely transformed the environment, other disasters have required immediate mobilization. On August 10, 1993, three ships collided near the mouth of Tampa Bay. Two of the boats were tankers transporting fuel, and the third was freighter with a shipment of phosphate. More than 330,000 gallons of fuel oil and 32,000 gallons of high-grade jet gasoline and oil leaked from the damaged vessels. While currents initially took most of the leakage away from the shoreline into the Gulf of Mexico, a storm system brought large deposits of oil back to the coastline of Madeira Beach and into Boca Ciega Bay during the next week. These images illustrate the immediate impact of the spill. The photograph above looks south from approximately 141st Avenue towards Johns Pass. The photograph below looks north towards Archibald Park from the same general area. (Both, Skip Davis collection, USF.)

Some construction projects have had a positive and lasting impact. In the early 1980s, crews finished work on the Bay Pines Triangle interchange, where Tom Stuart Causeway merges with Bay Pines Boulevard and Seminole Boulevard. The overpasses replaced a series of dangerous intersections. Beginning in the 1980s, federal officials also expanded the Bay Pines Veterans Administration facilities. This 1984 perspective looks toward the VA hospital from Hurricane Hole. (HV.)

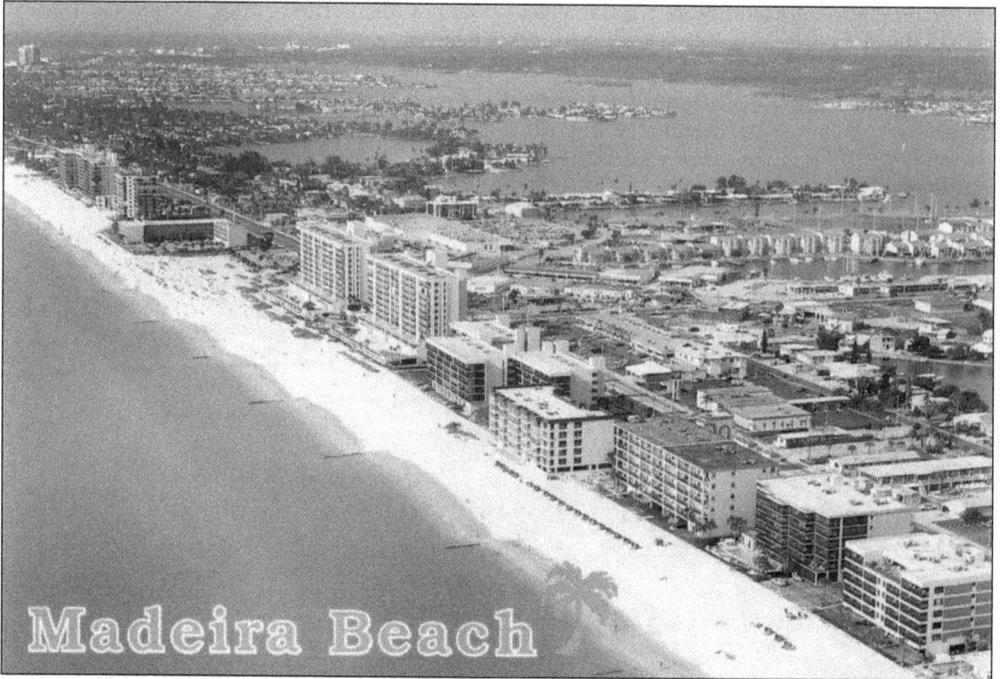

This aerial view looks northward from 148th Avenue towards Seminole and the Redingtons in the late 1990s. By the end of the century, developers had built upon nearly all of the vacant land on the barrier islands. The only empty lots were sites that once had smaller homes and would soon have larger structures. (HV.)

Six

A PERFECT SUNSET
2001–2013

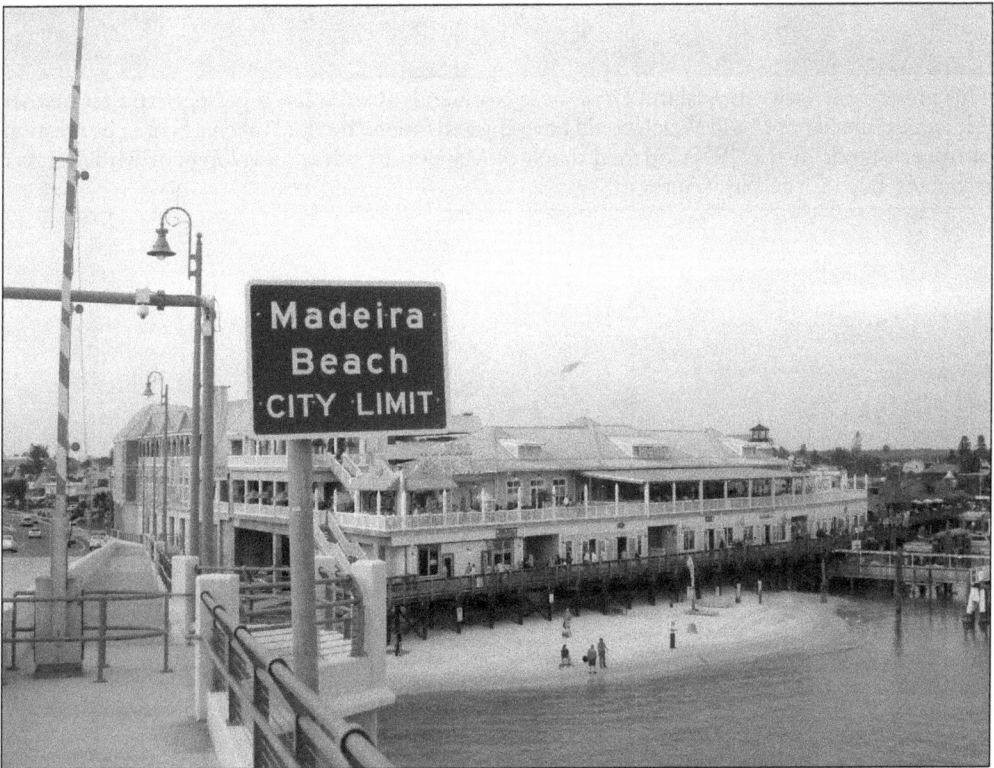

The landscape of Madeira Beach looks much different today than when George Roberts first homesteaded here just after 1900. Johns Pass, then an isolated and rough channel between the Gulf of Mexico and Boca Ciega Bay, has become a popular tourist destination. Although Noel Mitchell's plans for a resort development never materialized during his lifetime, crowds visit Johns Pass Village in great numbers today. (Author.)

This present-day view from Island Drive near Normandy Road offers a perspective that neither Albert Archibald nor David Welch could have enjoyed unless they had taken a boat. The creation of finger islands in the 1950s opened much of Madeira Beach to development while forever reshaping Boca Ciega Bay. (Author.)

A few older establishments remain today. The Candy Kitchen opened in 1950 on a spot that was not incorporated by Madeira Beach at the time, south of 140th Avenue; others, however, have disappeared. On the bayside just north of 140th Avenue, Leonard T. Harshbarger opened the Mister H. Drive-In in the 1950s, a popular gathering place for nearly 20 years. After selling his establishment in the mid-1970s, developers built a condominium on the site. (Author.)

Gulf Lane, a narrow road between 130th and 135th Avenues, Gulf Boulevard, and the beach, harkens back to a time when the beachfront had wooden beach cottages and one- or two-story hotels. Noel Mitchell's original plat in this area originally called for a Gulf Avenue to run along the shoreline, allowing for unobstructed views of the water, similar to those now found along Gulf Way in Pass-a-Grille. (Author.)

Today, roads wider than David Welch could have envisioned bring traffic from the Pinellas mainland to Madeira Beach. Looking southwest from the pedestrian overpass near Madeira Beach Fundamental School, this view shows the intersection of Tom Stuart Causeway/150th Avenue and Duhme Road in the foreground. The slight curve in the road on both sides of the bridge was added when the 1962 bridge replaced the original 1926 span. (Author.)

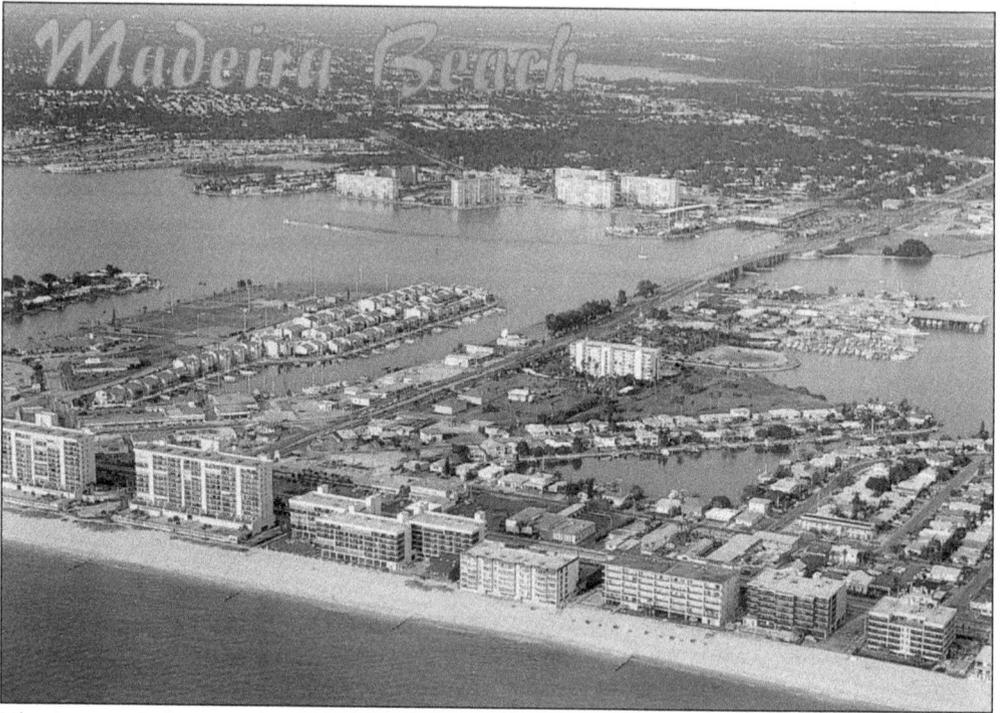

These two aerial images show the fully developed landscape of Madeira Beach shortly after 2001. The view above, looking northeast towards Seminole, reveals the row of condominiums between the spots where 147th Avenue and Madeira Way intersect with Gulf Boulevard. On the mainland, between the Sea Towers and the Madeira Shopping Center, a full parking lot indicates that diners enjoyed one of the last meals at the Santa Madeira, a large ship-shaped restaurant along American Legion Drive that could seat more than 500 diners when it opened in 1977. Demolished in 2003, the Santa Madeira site remains undeveloped a decade later. Below, condominiums tower over much of the western side of Gulf Boulevard to Johns Pass. The 1971 span of the Johns Pass Bridge (lower left corner) was replaced a few years ago. (Both, HV.)

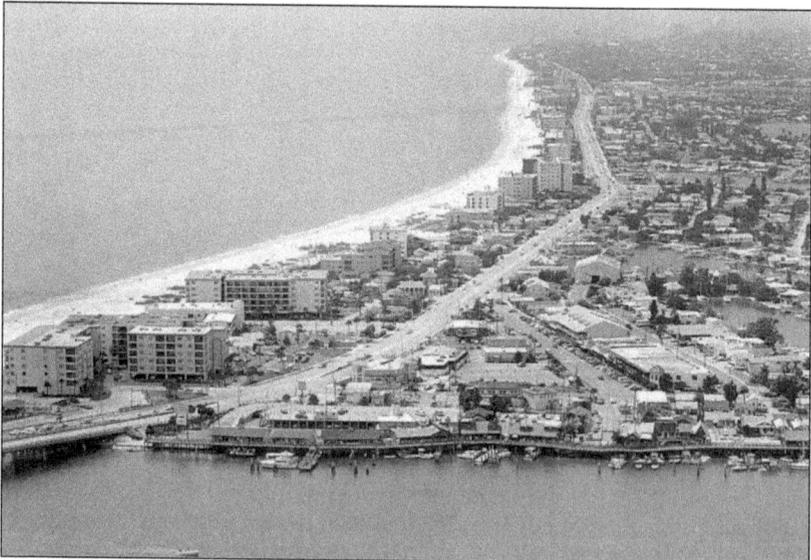

The Madeira Beach Causeway Park, along Tom Stuart Causeway, offers a popular recreational and fishing location on Boca Ciega Bay. Funds to create the park came from a settlement reached after the August 1993 oil spill near the mouth of Tampa Bay that caused notable damage along Pinellas beaches. (Author.)

Two- and three-story homes have replaced many of the dwellings originally built along Bay Point Drive in the mid-1900s. In designated areas prone to flooding, federal emergency management guidelines and insurance regulations require that all new construction and older homes receiving substantial renovations meet strict building codes that elevate living spaces above the ground level. (Author.)

For four decades, the Madeira Beach Recreation Center on Rex Place has served as a popular location for softball, Little League baseball, and pickup basketball games, as well as the city's summer and after-school recreation programs. With concerns about the aging municipal complex, city officials and residents will soon decide if plans for a new city hall and fire building will also include a redesigned recreation area. (Author.)

In 1912, the year Pinellas County gained its independence from neighboring Hillsborough County, George Roberts lived a solitary life as the lone homesteader along Johns Pass. A century later, more than 4,250 residents call Madeira Beach home. Boats and bridges have brought many visitors to this island since Roberts first arrived—and most never want to leave. (Author.)

BIBLIOGRAPHY

Ayers, R. Wayne. Images of America: *Tampa Bay's Gulf Beaches*. Charleston, SC: Arcadia Publishing, 2002.

—————. Images of America: *Tampa Bay's Gulf Beaches: The Fabulous 1950s and 1960s*. Charleston, SC: Arcadia Publishing, 2004.

————— and Nancy Ayers. *Then & Now: Tampa Bay's Beaches*. Charleston, SC: Arcadia Publishing, 2008.

Daubert, Peggy and Patty Keohane. *Treasure Island, Florida: A History*. Treasure Island, FL: Bicentennial Commission of Treasure Island, 1976.

Fuller, Walter Pliny. *This Was Florida's Boom*. St. Petersburg, FL: Times Publishing Company, 1954.

Hurley Jr., Frank T. *Surf, Sand, and Post Card Sunsets: A History of Pass-a-Grille and the Gulf Beaches*. St. Petersburg, FL: F.T. Hurley, 1977.

Shontz, Patricia. *50 Years of Madeira in a Minute . . . Semi-Centennial Celebration, 1947–1997*. Madeira Beach, FL: Semi-Centennial Committee, Madeira Printing, 1997.

Stephenson, R. Bruce. "A 'Monstrous Desecration': Dredge and Fill in Boca Ciega Bay." *Paradise Lost? The Environmental History of Florida*. Gainesville, FL: University Press of Florida, 2005.

Straub, William L. *History of Pinellas County, Florida: Narrative and Biographical*. St. Augustine, FL: The Record Company, Printers, 1929.

Williams, Bonnie L. *The Treasure Island Story*. Unpublished manuscript, 2003.

In addition to the publications above, those wanting additional information about the history of Madeira Beach should visit the Archives and Library at Heritage Village, the Gulf Beaches Historical Museum on Pass-a-Grille in St. Petersburg Beach, and the Gulf Beaches Public Library.

Visit us at
arcadiapublishing.com

www.ingramcontent.com/pod-product-compliance
Lightning Source LLC
Chambersburg PA
CBHW050652110426
42813CB00007B/1989